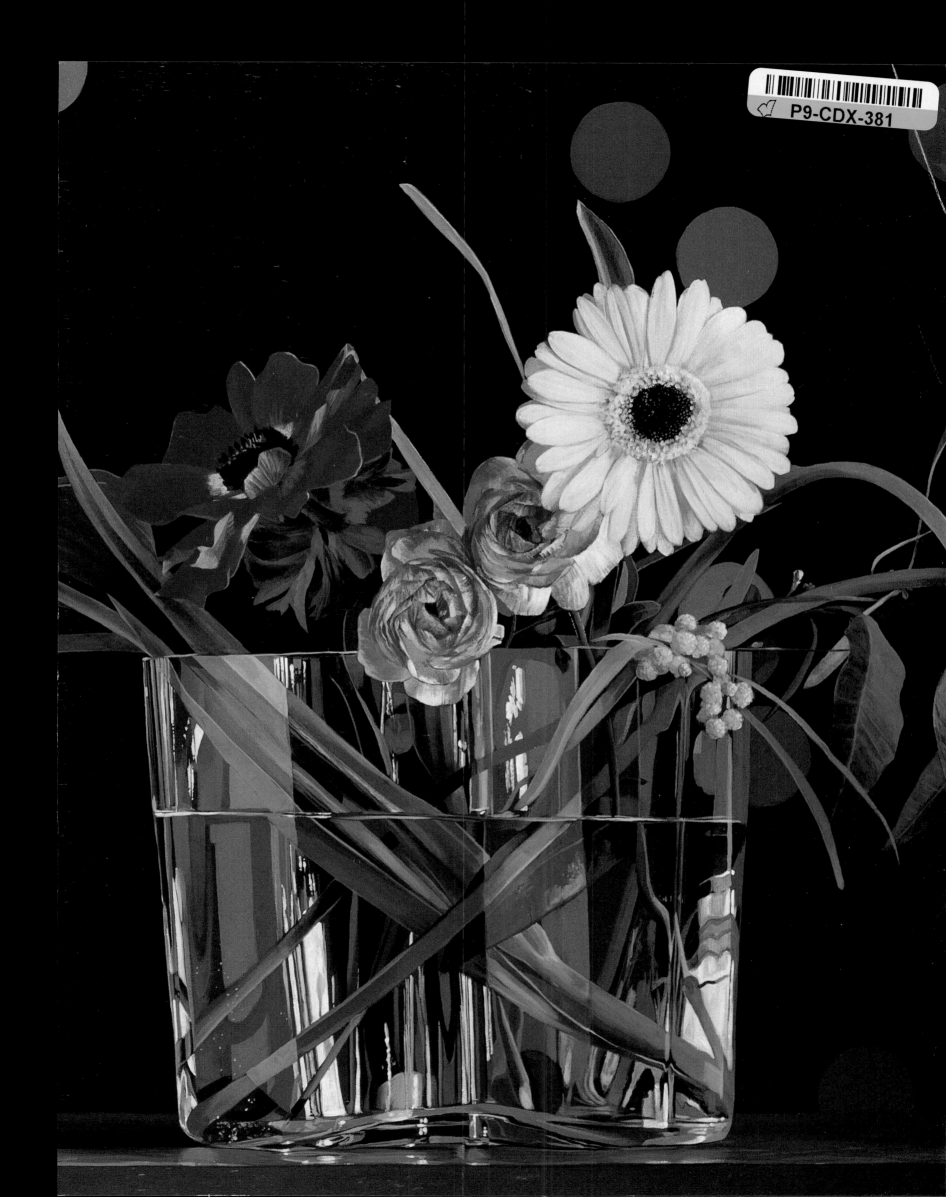

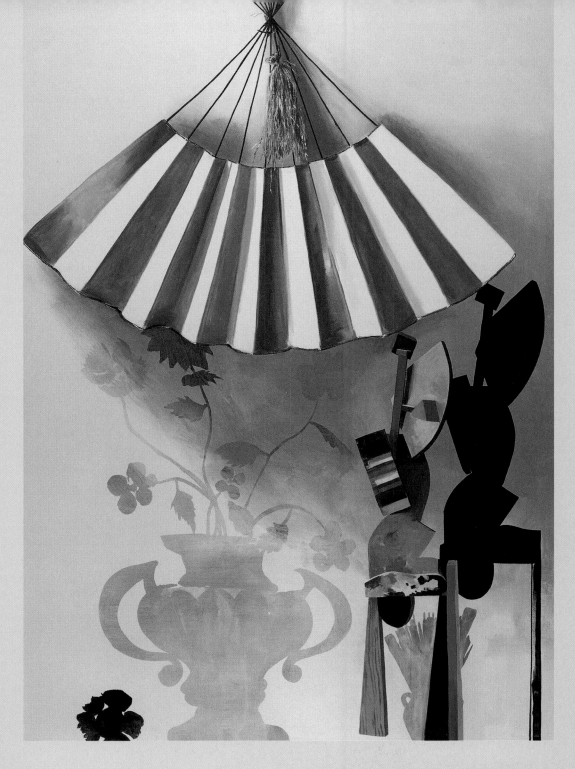

Ben SCHONZEIT

Paintings

Ben SCHONZEIT
Paintings

Text by Charles A. Riley II

Harry N. Abrams, Inc., Publishers

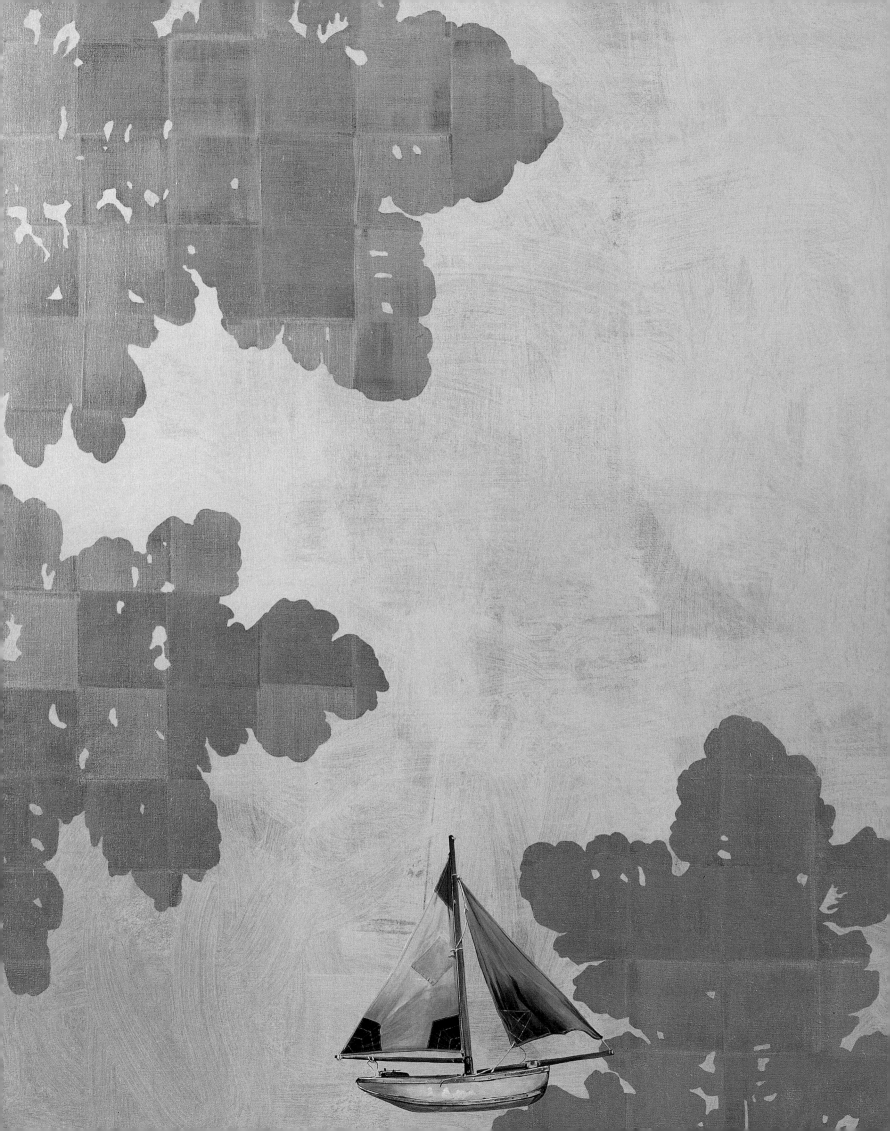

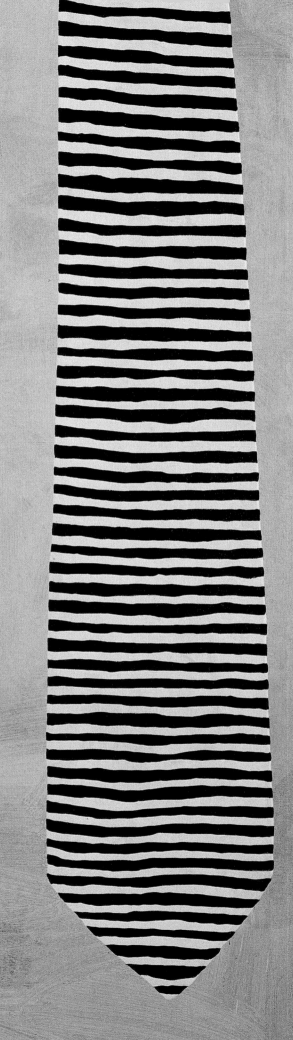

CONTENTS

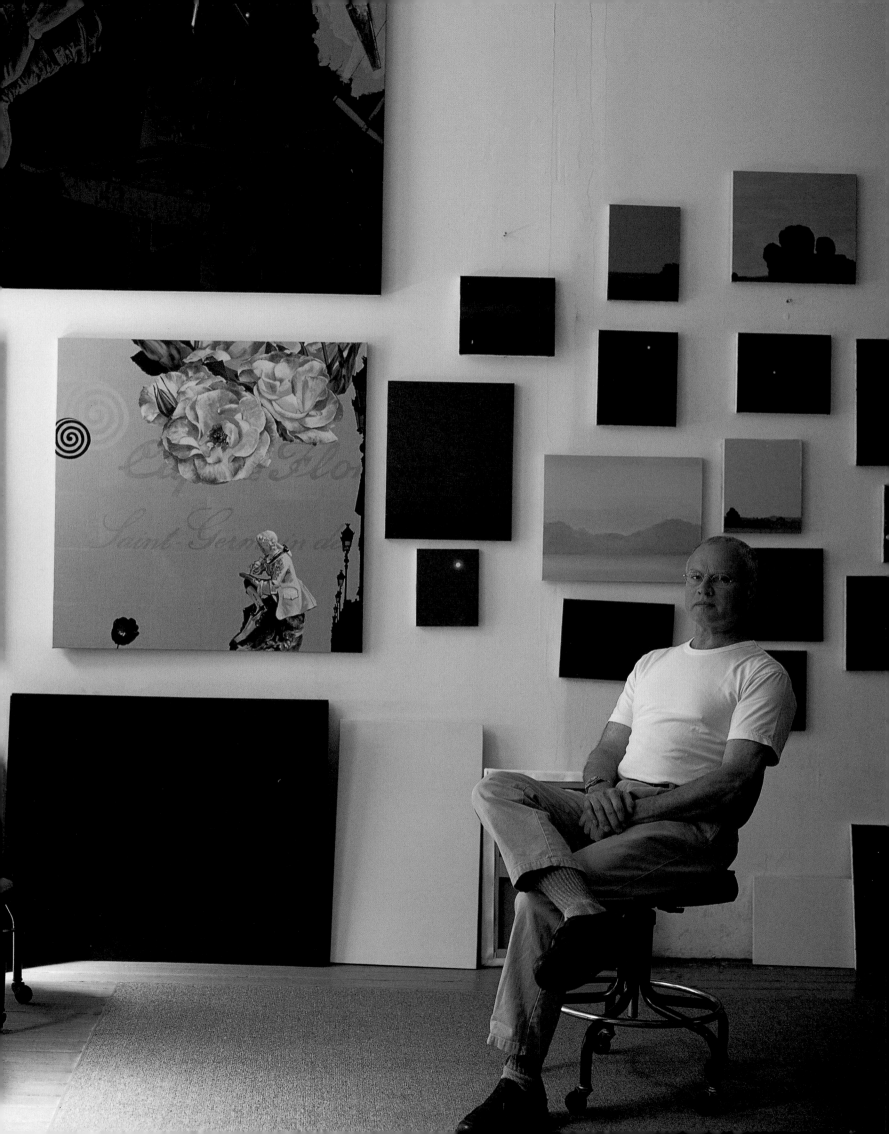

ACKNOWLEDGMENTS

Ben Schonzeit's wonderful studio is such a blissful retreat that I might have felt an intruder each of the many days I spent there in conversation with him for this book, except that he always made me feel welcome. Candid and open, generous in his explications of those moments in the paintings I did not immediately grasp as well as in opening notebooks, sketchbooks, and files teeming with invaluable material, he provided the type of access that is an art writer's dream. Through that open door we are all invited to share the excitement of his creative process.

This was, in many ways, a collaborative project between artist and writer, and no work of this scope is completed without the support and advice of many talented individuals. I would like to thank in particular the editor at Abrams, the incomparable Margaret L. Kaplan, her fastidious assistant Deborah Aaronson, and the designer, brimful of ideas, Darilyn L. Carnes.

In the studio, many helpful points came from friends of the artist long familiar with the work, especially Jane Lahr and Toni Green, whose insights and practical assistance are much appreciated. Studio assistants Jennifer Thorsen and Ariel Chou helped with the organization of the material and illustrations. Hannes von Goesseln offered invaluable help with the European museums and collectors.

Most important, I want to thank the artist's wife, Miriam Hsia, for her expert help with the selection of the work and the finer points of its presentation, and for her constant support.

Charles A. Riley II
New York City
August 2001

PAGE 1:
The Studio
1994. Acrylic on linen,
90 x 66 inches.
Collection the artist

PAGES 2–3:
Japanese Garden BBG
1998. Acrylic on linen,
42 x 84 inches.
Mr. and Mrs. Leonard Friedman,
Boca Raton, Florida

PAGES 4–5:
My Favorite Tie
1999. Acrylic on linen,
39½ x 39½ inches.
Collection the artist

OPPOSITE:
With **Café de Flore**, 2000

PROLOGUE

The magic begins the moment the lights and music come on in the cavernous studio Ben Schonzeit enjoys in Manhattan's SoHo district. Standing at a drafting table by tall windows, the artist warms up with a few deft watercolors. The inspiration to record some studio notes strikes, and he flips open a journal to jot down a phrase or memory. From a wall near the stereo and the vast library of rock and classical compact disks, a Roland electric keyboard and amp tempt him.

But now the darkened corner where the big easel cradles the main work in progress beckons. The slide projector whirs quietly under the music and the artist steps in close to pick up where he left off the day before. It is early in the game, a phase he relishes, and there is no need

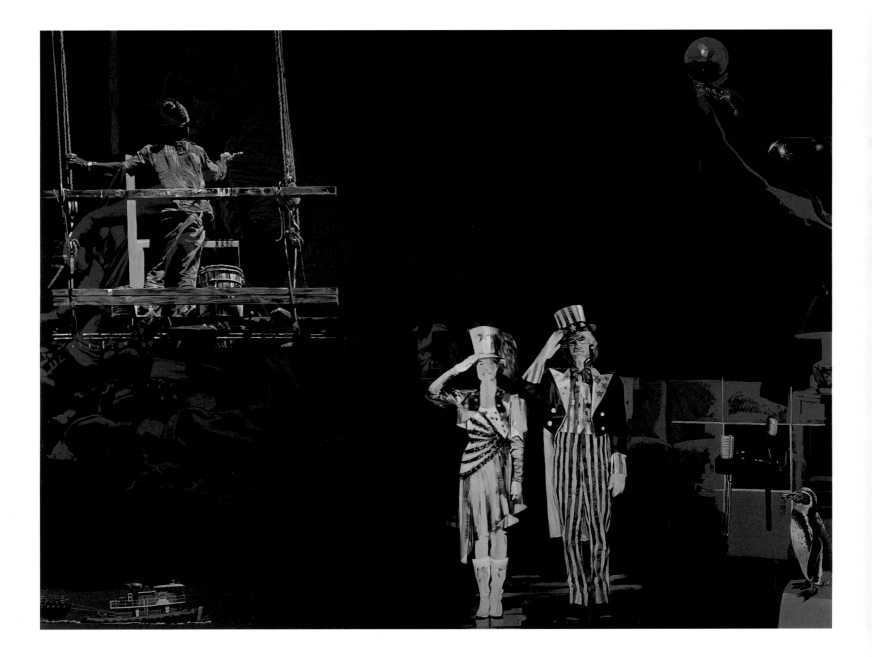

yet to confine his movements to the kind of surgical precision his sharply focused finishing touches will require later. Large and loose is the order of the day. A flick of the wrist, a sweep of the biggest brush, and suddenly the drooping fronds of a massive palm spring from the primed canvas. Oblivious as yet to the effect, or accustomed by a long career to the way this goes, the artist does not even step back to admire his handiwork. Painting without the pain seems the motto, delightfully allegorized in the major picture **Like Ringing a Bell** (the reference is to Chuck Berry's "Go, Johnny, Go," and specifically to effortless performance— "He could play a guitar just like ringing a bell"). In that work, the artist's stand-in is a Rastafarian billboard painter on a scaffold, swaying to his music. A trained seal appears across the canvas, gleefully balancing a ball on its nose, another reference to show-stoppers at play.

As with many virtuosi, for whom the impromptu (or its semblance) is the wellspring of fresh material, Schonzeit finds that spontaneity is an essential part of his modus operandi. To be too calculating is to impede. There is a fostering of innocent devotion that allows the response to follow the stimulus where it will. This impulsive sensitivity to anything and everything, coupled with the ability to translate a poetic response into paint, lends Schonzeit's work an inexhaustible variety that is in itself breathtaking. The possibilities are endless. Nothing is out of bounds.

Schonzeit gained a wide reputation as one of the dozen or so Photorealists who, in the 1970s, discovered the aesthetic potential of everyday objects in exquisitely painted, large-scale translations of photographs. Among his subjects were light bulbs, Coke bottles, candy in its wrappers, even lettuce. "Coming from the experience of the simple common in life through the engine of art," he calls it. He was the youngest of this popular group of painters—which included Chuck Close, Richard Estes, James Rosenquist, and Malcolm Morley—whose work was initiated by photos and which culminated in painted approximations so tight and exact as to appear photographic themselves. Wildly popular in the 1970s, they offered a conceptual and witty answer to the gestural, abstract painting that reigned at the time. One of the main characteristics of the movement was the artist's uncanny ability to use "low" subject matter, such as commercial packaging or even garbage, for works of heroic dimensions. Schonzeit's ability to spot a particular color within a pile of debris, for example, photograph it, and create a painting from it made his work a paradigm of this procedure. As composers use folk melodies (Liszt, Chopin, Dvorak, and Bartók among them), or as architects incorporate bits of the vernacular preserved by urban archaeologists, he captures and releases the glimpsed fragment. The constantly moving mirror he holds up to nature is kept polished and clear by a willed resistance to self-reflection:

Like Ringing a Bell
1983. Acrylic on linen,
90 x 120 inches.
Collection Klaus Lueders,
Cologne, Germany

This artist is better off not knowing too much about what he's doing. I act . . . period. The less time spent with why, what, and how, the easier it is to work. Choosing is torture. A good day is to wander about subjects, the brush always moving. One of the wonderful things about the airbrush was that you never had to dip it. Like a singer with endless breath, or the miracle of the fountain pen after the steel nib.

The fluidity of his invention, nearly rhythmic in its uninterrupted and unself-conscious momentum, coupled with the ease with which he glides across the floor from one medium to another, impart a dancelike polish. If there is a secret to Schonzeit's spectacular success on canvas and on paper, it is embedded in the why of this intimate connection between mind and hand, idea and realization—uncommon in any art. We recognize in him an example of that rare and justifiably prized species, the virtuoso. Panache and sprezzatura are his privilege. The charmed audience willingly submits to his effects. As in music, where ensemble players roll their eyes as the soloist takes off on the long flight of a terrifyingly difficult cadenza, there are those who find the excesses of scale, color, drama, physicality—not to mention beauty itself—out of synch with the taste of the times. Some even question the musicality of the virtuoso in that the break from the mainstream is too dramatic to retain the integrity of the whole. As with Liszt, however, Schonzeit's unshakable compositional sense holds it together. The quality lends an organic coherence to his individual works and career. He plays on, undaunted, as he has since his art school days, when the fashion in painting held little interest for him.

There has always been a position in the avant-garde for the virtuoso. He is by nature an envelope-pusher and iconoclast. He is also a standard-bearer for the very qualities that we mere mortals have always revered in the special class we call artists. Among the twentieth-century artists we most admire for their prodigious draftsmanship and capacious powers to use many media and materials with dazzling ease are Picasso, of course, as well as Salvador Dalí, Gerhard Richter and Robert Rauschenberg. This is the lineage of virtuosity in our time, and Schonzeit takes his place within this company. Without that prestidigitator's dazzling speed and cool confidence, and, most important, without the rock-solid technique that distinguishes the true painters of all ages, the whole enterprise falls flat.

Schonzeit relies upon the same technical methods, including the use of the camera, that have supported his kind of painterly seductiveness for generations. The impossible becomes a target for the next tour-de-force. He also, almost paradoxically, considers himself to be part of that fraternity of craftsmen or artisans who create the delightful objects that do not always command attention as art, and recalls with

Working on **Dancers** with an airbrush. The blank card in his right hand enables the artist to see the projection, 1980

In Cologne, Germany, 1981

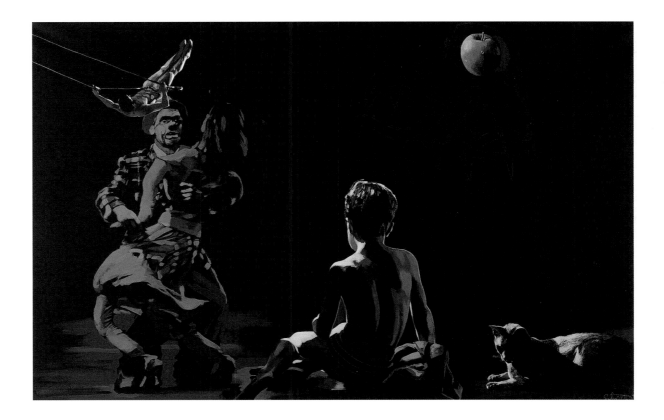

fond pleasure his own fascination with the figurines or lamps that his father collected for their Brooklyn home. Whether as an acrobat of the avant-garde, testing his own high-wire limits, or as a classicist participating in the craft of the tradition, Schonzeit is equally an anachronism, a figure whose present is different from our own. His own meditations on time reflect this:

We are always in the sliding present, riding the crest of now. The more I am of my time, the more I hope that my work will be part of the constant present. It is always now, always was. Photography is always in the now as well as always in the past by freezing the instant, and the way time is used in the process of painting makes it different. A painting has history—long, slow time and the moment concurrently because of the process. Viewing is always in the present, in the now, connected to viewers past and present by context and content.

Ironically, Schonzeit's work is rigorously anchored in the present, although it plays one time reference against another to create anachronisms in paint (fresh-cut flowers in a twentieth-century vase set against the backdrop of a Degas or Corot), as we shall see. The fluidity of technique and accessibility of imagery make the contrast far less abrupt. The logic is his own. "Unlike most rational beings, I abandon success for a new challenge, for the unknown and perhaps impossible. I like the surprise of discovering that an idea can be realized, overcoming the difficulties of the unknown subject or technique," he explains. The possibilities become endless.

Perfect Partner
1997. Acrylic on paper,
44 x 68 inches.
Private collection

12

Pewter Peonies
1996. Acrylic on linen,
66 x 44 inches.
Collection Mr. and Mrs. Steve Weiss,
New York

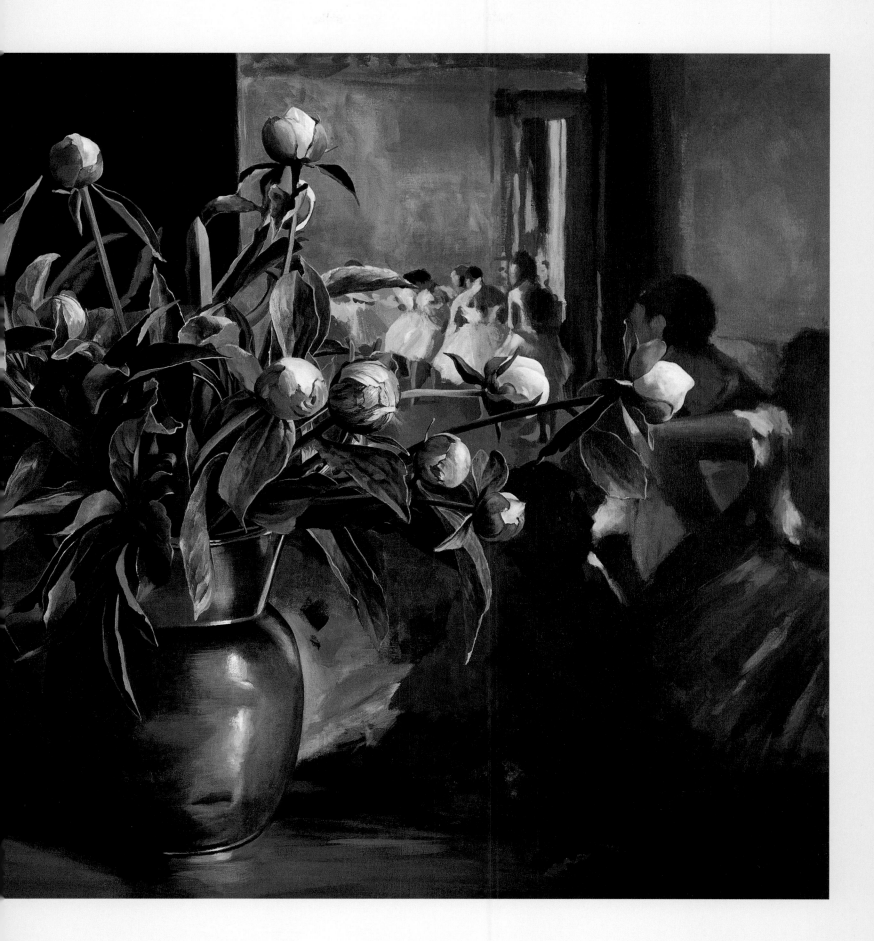

I. The PRODIGY

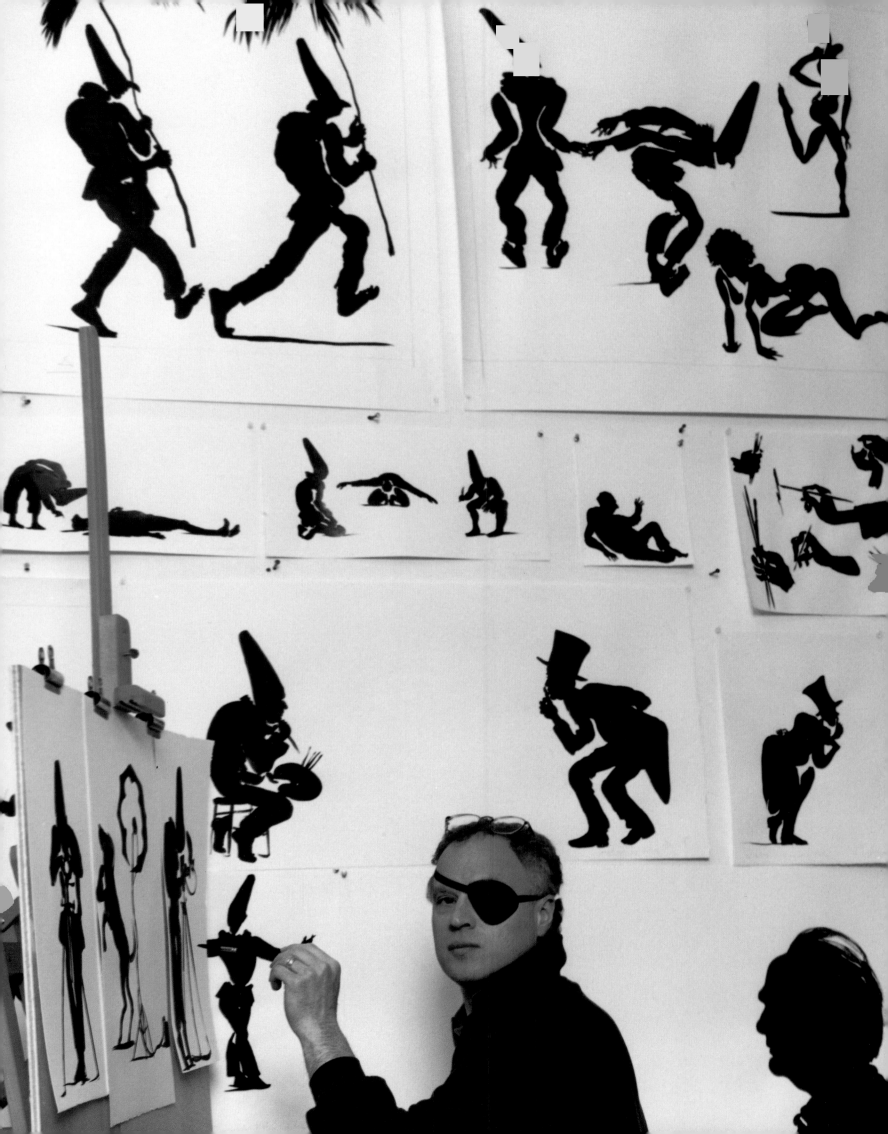

I. The PRODIGY

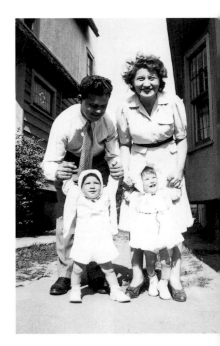

Apprehending the full scope of Schonzeit's wit is like trying to catch a plane that is halfway down the runway. It is imperative to understand where, literally, he is coming from. He and his twin sister, Risé (REE-suh), were born in May 1942 in the Flatbush section of Brooklyn. The artist's memories of the place and time are almost bucolic. He recalls streets lined with elm and sycamore, laundry gently popping in the breeze on clotheslines in backyards, and the glories of the Brooklyn Museum and Botanical Garden, where he went to draw. His father, David, was a city fireman who ran a used furniture store on the side, and had a marvelous eye for collectibles. He picked out the most intriguing objects and paintings for his own home, and Ben, surrounded by these curiosities from his earliest years, remembers standing on a chair to peer delightedly at Dutch landscape paintings, pendulum clocks, or Hummel figurines. This absorption in contemplating commonplace decorative objects surfaced later in the paintings of toys or architectural details that became part of the lexicon of his paintings.

Schonzeit grew up on the same street as Woody Allen, and Risé played together with Allen's younger sister. Goldye Schonzeit, the artist's mother, was a nightclub singer who performed under the name Goldye Shaw (a variant of her maiden name, Schor) at Sammy's Bowery Follies in Manhattan, where Allen's father worked. During Schonzeit's childhood, entertaining meant dinner parties. In addition to his mother, his younger brother Hank was a fine singer, and young Ben was a flamenco guitarist, though a reluctant performer, as well as the gifted draftsman whose latest work was brought before the guests to be admired. The sardonic Brooklyn sense of humor that became the calling card of Mel Brooks and Woody Allen is also a dynamic force in Schonzeit's paintings, many of which have a cinematic quality that also recalls his boyhood neighbor.

A child prodigy, the pint-size, six-year-old Schonzeit would take a stick and draw thirty-foot-long figures on the beach at Belle Harbor in the Rockaways, where an uncle, who was a judge, had a house. Crowds of admirers would watch him at his herculean task. When a wave came and washed away an arm, he redrew it. "These were not stick figures like the ones children draw—they were contour drawings. I developed the ability to make things just to amuse myself." He also had a knack for thinking big. Later in his childhood, as the house artist of his school, he

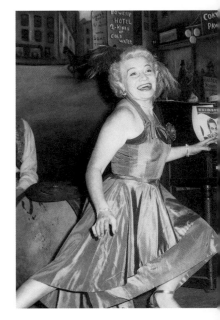

Goldye and Dave (Schonzeit's parents) with twins Ben and Rise

Goldye Schonzeit, Ben's mother, at Sammy's Bowery Follies in New York, 1957

16

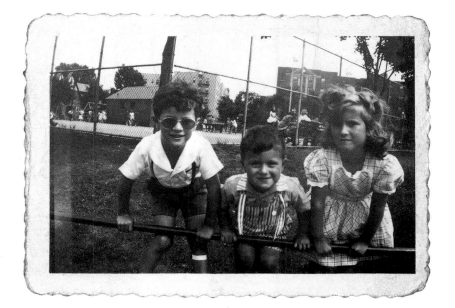

directed other children in creating a vast Santa Claus who filled all the classroom windows of the school. Later yet, at Midwood High School, he spent one Christmas vacation painting a mural in the student government office with the future congressman from Brooklyn, Steven Solarz. Making the backdrops for school plays, he learned not only to paint rapidly but to conjure illusion with broad gestures that would read a certain way from a distance.

Goldye Schonzeit is a theatrical presence in his paintings, and their moments of overt showmanship are in part attributable to her. More important, she is the direct inspiration of several elegiac works painted after her death in 1982, and of an element of Schonzeit's work that is fundamental to his distinctive role in contemporary art: his unabashed devotion to beauty. In an age (beginning in the late 1960s) when traditional notions of beauty were under siege, led by the "anti-aesthetic" stance of critical theorists, Schonzeit's insistence on the need for the aesthetic was an act of defiance. The major work of mid-career, **The Music Room** (pp. 52–53), began as a drawing for Mother's Day in 1977. The unforgettably vivid flower paintings for which he is perhaps best known were also made in her honor. As the artist recalls:

The afternoon before my mother died, I saw her in a chair at my sister's house. She had been destroyed by emphysema and would die early the next morning. I didn't know if she knew I was there, nor if she was even awake. She motioned me closer and with the little breath she had said in a whisper, for that was all she had, "bye." If I painted pretty things, I would always survive. The persistence of the beautiful to satisfy the eye. My mother loved pretty pictures. THE MUSIC ROOM began as a Mother's Day card. After she was gone, the flower pieces sustained me and stemmed from that desire to make something beautiful for her.

Ben in sunglasses, with
Henry and Risé, c. 1947–48

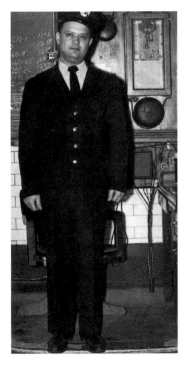

Davey (Last Picture of My Father) III
1982. Acrylic on paper,
38 x 30⅛ inches.
Solomon R. Guggenheim Museum.
Gift of Jeanne and Arthur Cohen, 1984
Photograph © Ellen Labenski

Dave in his fireman's uniform

An incident from childhood, transpiring in a flash, changed the way Schonzeit would see and shaped the way he would paint. He was five years old. As he recalls: "One day, a bunch of kids were playing together and one was this really cute girl. I wanted to impress her. I found an icepick in a neighbor's basement." He pauses. "At that age, you know nothing and think you know everything. I told her I was going to show her how to carve a tree." Chopping upward, he stabbed his left eye. After two operations, it was removed. He spent the next few months in a dark room or wearing dark glasses. His clear memories of the time include the sixty-four colors of the Crayola crayon set his mother gave him, which he meticulously kept in order, a way of holding his world and emotions together. His reflections on the effect of his monocular vision, and the experience, add depth to the emotional and intellectual resonance of his work:

After the operation when I lost my eye, I had to stay in a darkened room for some time. I don't know why, but isn't it interesting that as an artist I am in a darkened room almost all the time, longing for the light sometimes, dreaming of a large silent skylit room often? A room that a real artist would use. I paint with blinders on. I don't look at what I have done while I am doing it. Partly because I work in such dim light. Partly owing to the size of many works, which cannot be seen from up close. Partly from the state that I am in to paint automatically and quickly. I step back to take a breath, then I see whole and dive back in to paint what I cannot see. I've had to develop a way of dealing with spatial problems, and I've had to reeducate my mind. That may be the reason that I paint real, not realistically. I build things in paint.

Another seminal experience involved the novel phenomenon of media saturation. Schonzeit notes that it is important to realize that his generation was the first to grow up with glossy color magazines and television, CinemaScope movies, Walt Disney's phantasmagorias, and rock 'n' roll. They have been the avid consumers of the explosion of media over the past fifty years, and its impact upon his work is manifold. He was twelve years old when Elvis appeared on the Ed Sullivan Show and precipitated the generational split over rock music that separated his age group from its parents, although, ironically enough, his father brought home some of the very first R&B records from the predominantly African-American neighborhood where his store was located. He offered them to his son with the comment, "This is interesting. You might like it."

Schonzeit was particularly taken with the justifiably renowned color photography of **National Geographic** and **Life** magazines, then considered the benchmarks for print quality. This passion for photography shows in everything from the sharply focused, intensely colorful

imagery of his Photorealist works to the cinematic grisaille paintings—which take on not only the cool blue-black palette of television, but the layered imagery of ghosting (superimposing a figure in focus over its fuzzy shadow) that a poor television set would produce. As Schonzeit observes, the distance from Disney to Damien Hirst or Jeff Koons and their lavish installations is not all that great: "I have often felt that the contemporary painter must compete with the other media for attention. The influence of film on painting is enormous—pushes huge works, conceptual works, installations that are more theater than picture."

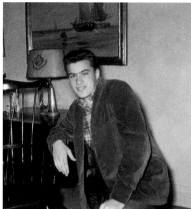

The eventual trajectory of Schonzeit's talent was subtly spelled out in the early sophistication of his draftsmanship. He went to Midwood High School, still one of the elite public schools in the city (the brilliant opera composer John Corigliano was one of his contemporaries). As teenagers, he and his precocious friends read Dostoyevsky, Sartre, and Camus on the leafy campus of nearby Brooklyn College, or hopped the subway into Manhattan to listen to Bob Dylan in the bohemian coffee houses along Bleecker Street in Greenwich Village or to peruse the latest volume of Beat poetry at the Eighth Street Bookshop. There was a frisson of excitement about the artists who were known to frequent the Cedar Tavern, a watering hole for Willem de Kooning and the Abstract Expressionists, as well as the presence at openings and other gatherings of Mark Rothko and Barnett Newman. These were not remote figures known only through their exhibitions and press clippings, but heroic role models whose studios were on the streets the young aspiring artists walked.

19

In high school, I painted stage sets for theater and decorations for school dances. The work was fast and efficient. It had to look right from far away. In my painting, I aim for this effect of suggesting complete reality with a minimum of detail. The life of my work comes in part from the quick hand I have with a brush. It is in fact an illusion, for there is very little detail, and this lack of detail separates me from the realists.

Schonzeit scored a place at The Cooper Union, a prestigious college of architecture, engineering, and the arts that provides a tuition-free education to those who can meet its rigorous entrance requirements. Bowing to parental pressure to pursue a practical course of study leading to a profession, he began his studies in the architecture program. Asked to render a plan for his dream house, he drew a huge painting studio with a minuscule house beside it. The perceptive teacher urged him to change majors.

In the studio classes, Abstract Expressionism was all the rage. The art students admired the early figural works of Richard Diebenkorn

Ben Schonzeit as a high school
student in Brooklyn, 1959

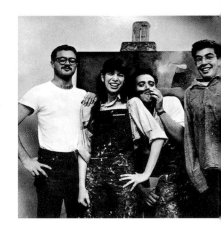

as well as the paintings of Nathan Olivera, and the use of photography in David Parks's studio practice. Drippy, gestural painting and heavy brushwork were considered marks of power and technical expertise. Schonzeit experimented with everything, including such historical approaches to composition as Cubism. Perhaps because he held to his own rigorous standards of draftsmanship and because of his secure sense of composition, he found himself under attack by peers and even faculty. Their label for him was "facile," a left-handed compliment that would be echoed by grudging admirers in later years. Schonzeit demurs:

I never had any difficulty with the clear, simple representation of a subject. I do struggle with many works. Things are not that easy, and often I fail, but in general I have a natural ease with materials. The invention of original styles has been a problem in that I come up with too many. Yet there is a looseness, a quick freehand in the way I apply paint, that I feel gives life to my paintings. Part of the pleasure of doing very large pieces is that the process is like a dance, up and down ladders, arms flying, swooping and stabbing at these things. It is said that dance is the way the body escapes the mind. So it is with the process of making huge paintings. A total, exhausting thrill. What remains of my training by Abstract Expressionist teachers is the insistence on showing the way a painting was made. How paint is used should be obvious. Early on, the close-ups came as much from Warhol as anything. Later, when the still lifes became more conventional in format, it was more a rejection of the Modernist past than an embrace of the traditional format of a vase on a table. I am involved with how to change that tradition, how to confound the order with odd contrasts in subject and setting. See the obvious! Connect the dots from within your own experience and the intent and meaning of my work becomes clear.

The iconography of **Like Ringing a Bell** (p. 8) once again applies, and the limpid connectedness of his narratives stands the test. The soldiers are kicking back and drinking beer, completely relaxed, as is the Rastafarian painter, carefree ("he has a natural grace," says the artist) as the seal playing with the ball on its nose. Schonzeit likens the emotional quotient of the painting to "home and comfort," affirmed by the his-and-hers toothbrushes in their rack, a reading lamp on an end table, the tugboat with the "B" on its smokestack heading back to port. But down in the right corner, there is a disconcerting figure, a staring penguin who takes in all this idleness. A dialectical point of reference is established:

While considering an additional element for a painting I become a spectator, an outsider, an observer, a navigator, someone who watches, a narrator. The artist needs to be two people. One to do and the other to watch. I

With Arlene Slavin, Lee DeJasu, and Howard Buchwald in front of a Schonzeit painting, at The Cooper Union, 1964

am best off not knowing what, why, where. Having a place to make something is enough, being a studio painter. The artist is often an outsider, an observer. Art comes from the bending of materials into life. Art comes from the binding of materials into life.

It was the 1960s, and the buzz of stimuli was becoming a roar. From space exploration to the Vietnam War and the establishment of the Peace Corps, from the rise of the civil rights movement (as well as riots in Harlem) to the assassinations of John F. Kennedy and Martin Luther King, Jr., a slew of societal changes surrounded the traditionally hermetic art scene. The excitement sweeping through the art studios became public most notably with the Pop Art exhibition at the Guggenheim Museum in 1963 and an explosion of new galleries that made Andy Warhol, Jasper Johns, Robert Rauschenberg, and other artists into celebrities. The broadening of the audience for painting was evident in the vast crowds that lined up at museum entrances to see masterpieces by Rembrandt and Leonardo da Vinci, the monetary value of which was suddenly a cause célèbre in the media. Graduated from The Cooper Union in 1964, Schonzeit enjoyed his version of the **Wanderjahr** or Grand Tour, romantically booking passage on a Cunard liner to England, then spending ten months traveling to London, Amsterdam, Paris, Florence, Athens, Istanbul, and Madrid. He experimented further with Cubism. An analytic engine never to be entirely eradicated from his repertoire, it would make a resurgence in his watercolors of the 1980s and 1990s.

I was off to see the world. If you wanted to be an artist, you had to be in Paris, but since I spoke no French I thought it best to practice my wanderings in England. To my surprise, I was just as shy on the road as I had been at home, but I learned. I became an artist in Amsterdam, sitting by a window of the pension every morning doing Miro-esque watercolors. In a Parisian garret for a few months I found that European art came from the places where artists lived. Before that, I had thought art came from museums and art books. The international vision that is rampant in the modern world became mine in those ten months. In Europe I discovered America, that I was an American and ached to be somewhere that I understood, that was mine.

21

With artist Stephen Posen in
Hamburg, Germany, 1972

II. PHOTOREALISM

II. PHOTOREALISM

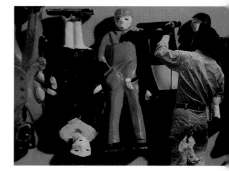

When Ben Schonzeit returned from Europe, he became one of the pioneer artists moving into SoHo's lofts in the mid-1960s. Exciting ideas were stirring in the New York art scene. So many styles, so little time. His first forays in oil on canvas in the loft were strongly influenced by Arshile Gorky. Soon he turned to hard-edged painting. Today, flat files in a studio corner contain Schonzeit's early experiments in high-toned geometry on paper, along the lines of Frank Stella. Some are by Schonzeit, others by talented colleagues who moved on to their own modus operandi. Color field was all the rage for a time. Yet the aesthetic did not jibe with one aspect of painting that Schonzeit still insists upon: "I was very attached to how things look. Seeing is important. I like to make things up. They are not dreams, but ways of giving substance to experience."

Then came Photorealism, and for a while Schonzeit found his métier in the dual nature of the process. As revolutionary as it seemed at the time, today we recognize the movement's place in Modernism. The art historian Gregory Battcock explained the significance of the school in the best contemporary survey devoted to Photorealism: "Because our ideas about realism in art are constantly changing, the realism of one art-historical period can be far removed from that advocated by another. Although it is probably safe to say that the kind of realism practiced by many artists today is linked to the realist art created in the seventeenth century by Caravaggio and Georges de La Tour, there are equally important connections to be revealed with recent Minimalist and Nonobjectivist art." Battcock, now known as one of the great advocates of Minimalism and Conceptualism, avers that Photorealism's frankness regarding process links it more directly to Abstract Expressionism than to its perhaps more likely kin, Pop.

The high priest of Photorealism was and is the art dealer Louis Meisel, who included Schonzeit in two major books about the movement. At that time, he did not represent the artist who was one of the original group shown by Nancy Hoffman in her SoHo gallery and had extensive representation abroad in Cologne and Hamburg. In 1979, at the end of the decade during which the Photorealists attained their prominence, Meisel laid out a five-point definition of what makes a Photorealist. Right at its center—after the stipulations that the artist use a camera "to gather information" and a mechanical means of transferring the image to canvas (in Schonzeit's case, the slide projector), and just before chronologically narrowing the group to those who had exhibited

PREVIOUS PAGE:
Tools (Drawing)
1974. Acrylic on canvas,
60 x 48 inches.
Collection Noah and Judy Liff,
Nashville, Tennessee

Painting **Train Family**, 1976

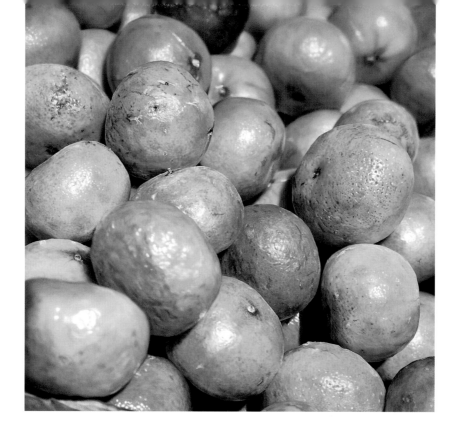

work of this kind by 1972 and devoted five years to the method—is the criterion that best suits Schonzeit and marks his place in the history of the movement: "The Photorealist must have the technical ability to make the finished work appear photographic."

Schonzeit's current studio practice was established at this time, although he has returned from using an airbrush—which never touches the canvas—to conventional paintbrushes. The process is detailed in a statement penned in 1971 for one of many European exhibitions, in which he tended to show more cutting-edge material than that which was on view in American galleries:

I start painting in semidarkness and then turn up the lights as the painting progresses. Where hard edges appear, the outline of these areas is drawn in pencil from the projected slide, then masked with tape. If the painting has a foreground-background situation, the foreground is painted first, so that I can project many slides over the completed foreground and decide which is best. Usually, when I begin a painting I have a pretty good idea what I want the background to be in terms of color and/or texture, but only a vague feeling as to the actual subject matter. This leads to looking at slides (thousands) from accordions to zoos, looking for something that is blue-violet and that will mean nothing or something in relation to the shape, texture, and content of the foreground stuff. After the background has been selected, the foreground is completely covered with masking tape, then the background is painted blurrier, less resolved than the stuff in front. It is painted with a different attitude. Here I try to establish the general space of the painting. For the most part, these spaces are shallow and present a place parallel to the wall the painting is on.

Honey Tangerines
1974. Acrylic on canvas,
72 x 72 inches.
Collection Sydney and Walda Bestoff,
New Orleans

Meisel claimed that Schonzeit is the most adroit of the group, as measured by the sheer control of the airbrush and the crisp, mirror-like effect of details. This was not the only element in his work that set him apart. He was also paramount among them as a photographer, thanks in part to his photographing of fruit or vegetables at neighborhood stores to show his high school students how an artistic eye is involved in even the most mundane activities.

So much of my work has been a cataloguing of the ordinary. In my photography I look for the invisible, the everyday, the common objects we don't see at all. I was teaching art in high school and wanted to bring my students around to some visual understanding of the abstract values in their environment. In teaching design, I would talk about store windows and fruit stands. Many of the things I paint are in the top-of-the-TV category of sculpture. When I go out to photograph, I usually wind up in the midst of cheap colorful trash, looking for some super purple. I want to take my subjects from the now, things that will fall apart tomorrow.

Most of the other members of the Photorealist group had a thing for cars and chrome, or signage and packaging, while Schonzeit was clearly more apt to be delighted by the problem of cropping a still-life composition or floating an image against an anomalous background—such as fish drifting above a blurred dish of cookies in **Fish and Cookies**. With **Birdaid** (p. 33), the lyricism and chromatic inventiveness also

Applying paint to canvas in semidarkness, illuminated only by a projected image of Charlie Parker, 1977

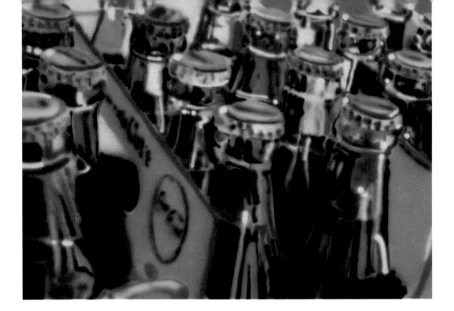

separated him from the cooler, stricter style of his colleagues. There was a sociological edge to his explorations of popular culture. Where they shot casually and painted carefully, he wielded his camera more purposefully and allowed his talent free rein on the image that glowed on the canvas:

When I first picked up the camera as a painter, my goal was to connect to the world in a more immediate way. It was a way to see . . . a way to give substance to experience. This was also an attempt to get closer to the subject. I thought one had to choose between painting and photography. Once I was out of school, I realized I could do anything I wanted, and with light meters built into the cameras and 35-millimeter slide film, the possibilities were endless. I was interested in close-ups and making large paintings. I bought a Rollei SL66 with a built-in bellows, which made macro photography easy. A whole new world opened. This tool allowed me to do the huge close-ups that are often a component of my work. A three-foot tomato is a very different kind of tomato. It becomes this great red thing and the red becomes one great blast of pure color.

Photorealism is an endgame, and it is no coincidence that the word "finish" is one of the key terms in the literature of the school. As the preeminent photographer of the group and the clear-cut winner in the technique contest, Schonzeit was as aware as any of the skeptics of the paradox of returning his painting to the condition of the photograph. His own standards are based on a rejection of the frozen, lifeless nature morte: "I know a painting is finished in two ways," he says. "One, if I do any more, it will be worse. Two, when it gets up and walks away on its own. When it is alive, it is done."

The logical progress of tighter and tighter painting dictates that it reaches a cul de sac. The paintings become ever larger, sharper of focus, brighter of palette until the shock effect wears thin. Schonzeit released himself with a change of style.

Large Cokes
1969. Acrylic on canvas,
30 x 36 inches.
Collection the artist

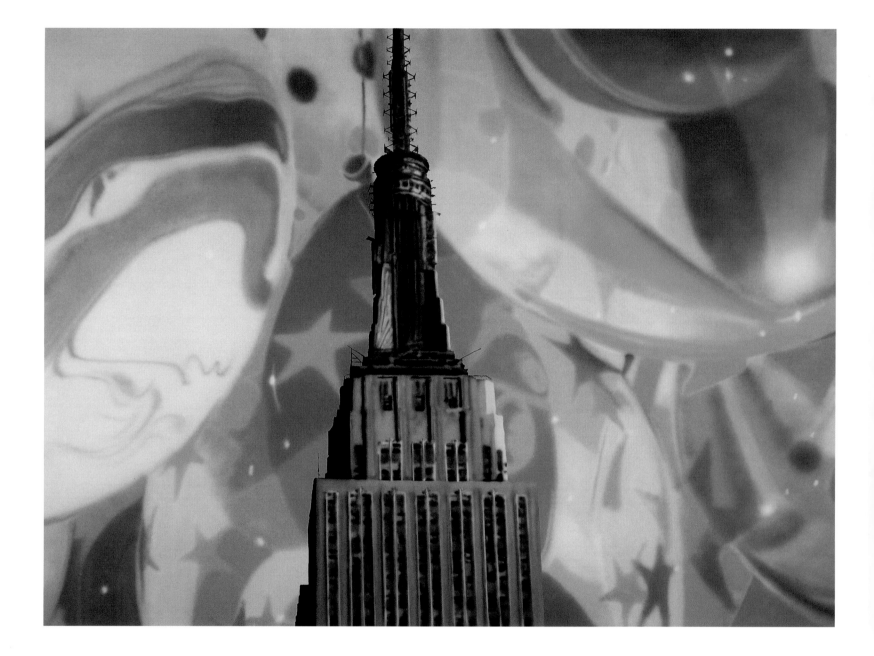

Empire State
1970. Acrylic on canvas,
72 x 96 inches.
Private collection

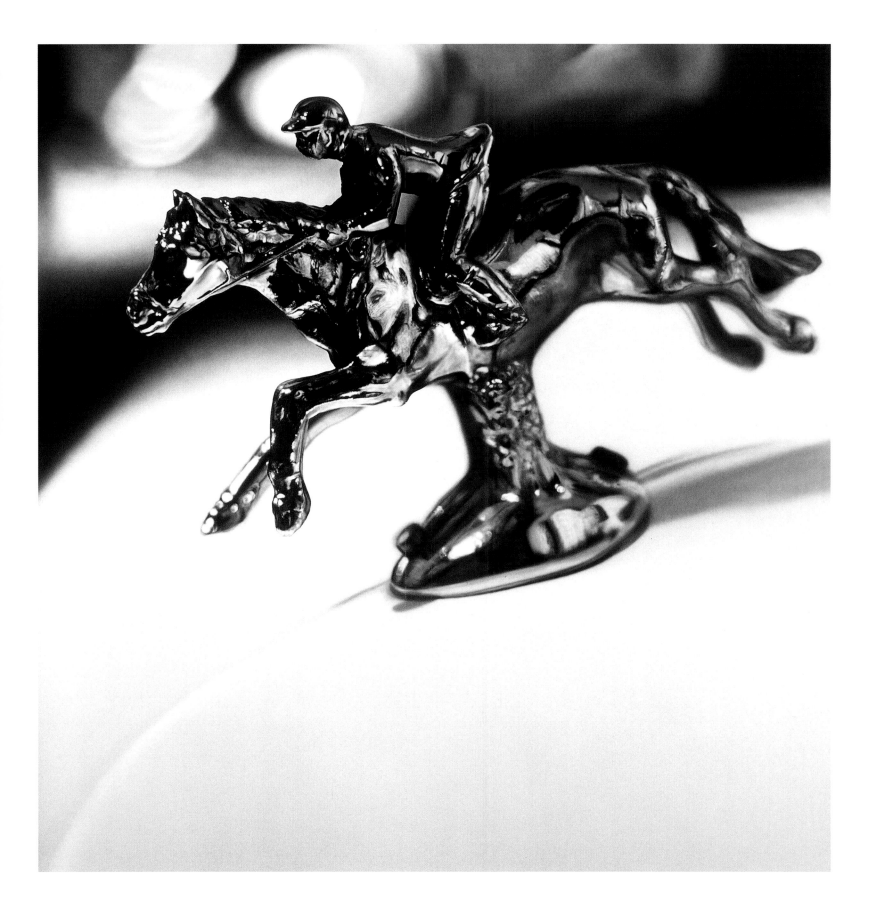

Horse and Rider
1974. Acrylic on canvas,
72 x 72 inches.
Private collection

Sugar
1972. Acrylic on canvas,
96 x 120 inches.
CREX Collection,
Zurich, Switzerland

Catalina Cutouts
1971. Acrylic on canvas,
84 x 72 inches.
Stedelijk Van Abbemuseum,
Eindhoven, Holland

Birdaid
1971. Acrylic on canvas,
84 x 84 inches.
Private collection

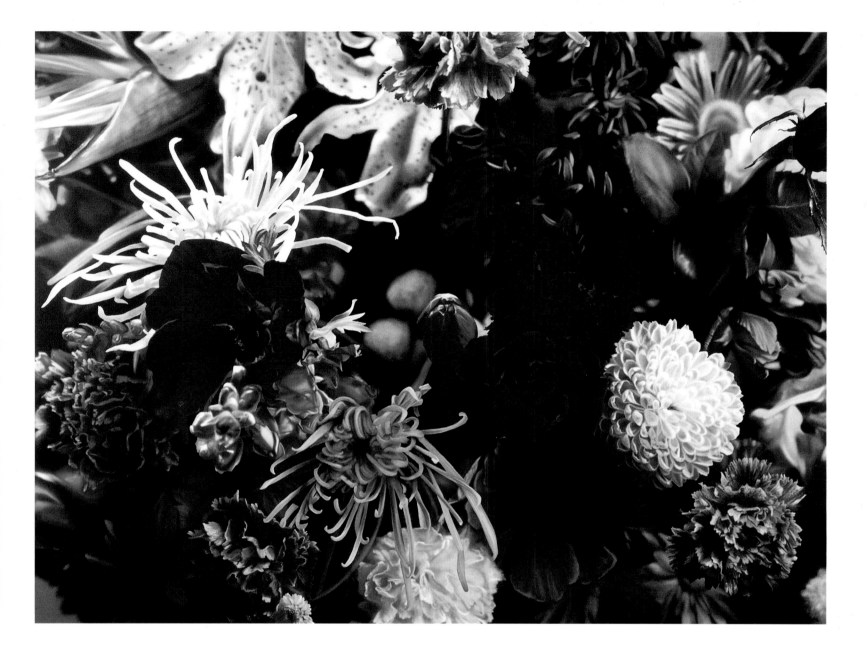

OPPOSITE:

After the Hurricane
1971. Acrylic on canvas,
84 x 84 inches.
Private collection

ABOVE:
Floral
1973. Acrylic on canvas,
80 x 108 inches.
Collection Robert E. Abrams,
New York

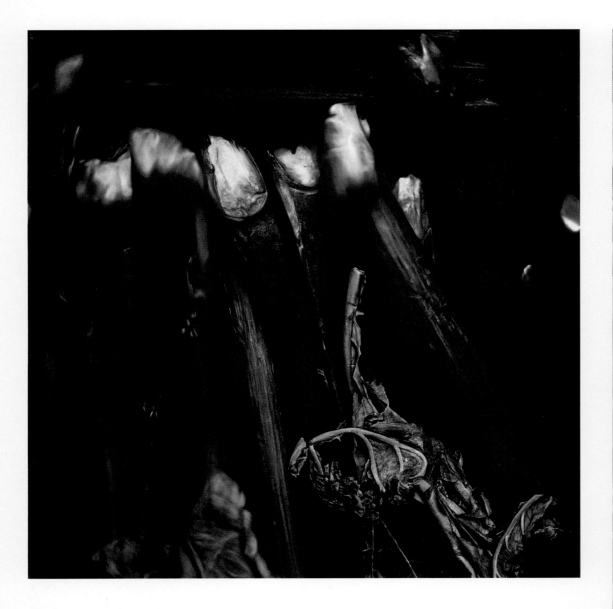

Rhubarb
1975. Acrylic on canvas,
60 x 60 inches.
Delaware Art Museum, Wilmington.
Purchased with funds provided by
the National Endowment for the Arts
and other contributions, 1975

Produce
1972. Acrylic on canvas,
96 x 120 inches.
Private collection, Naples, Florida

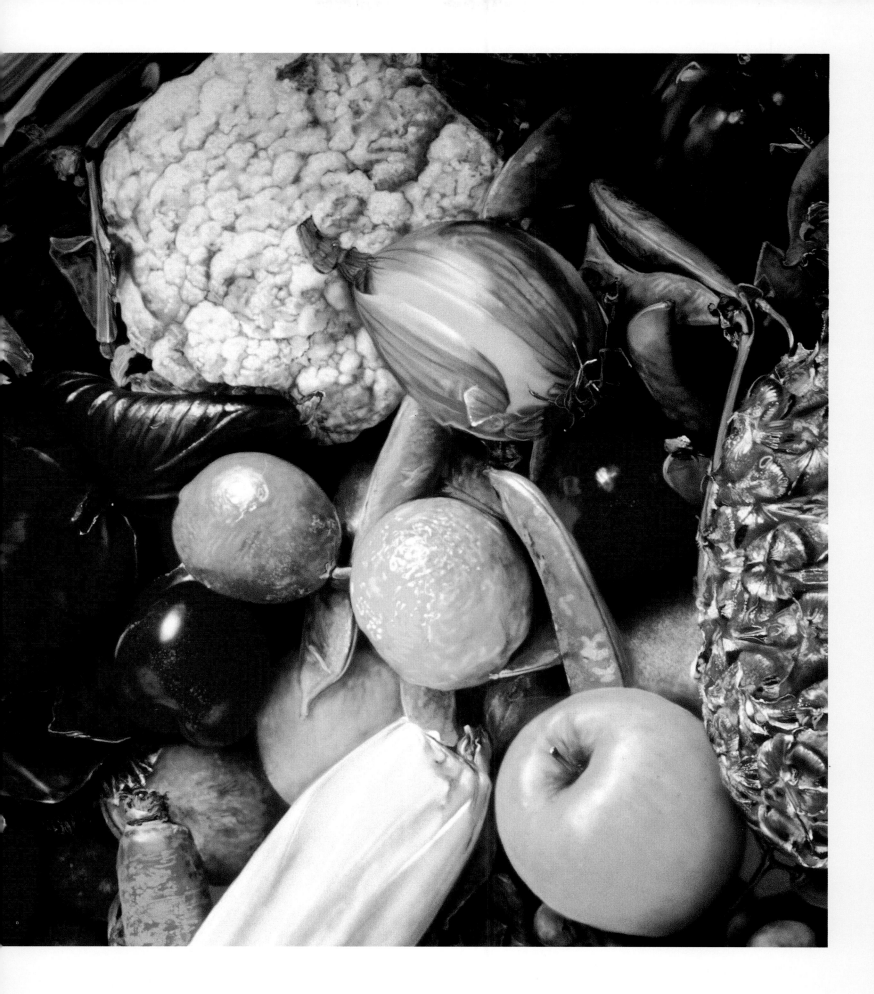

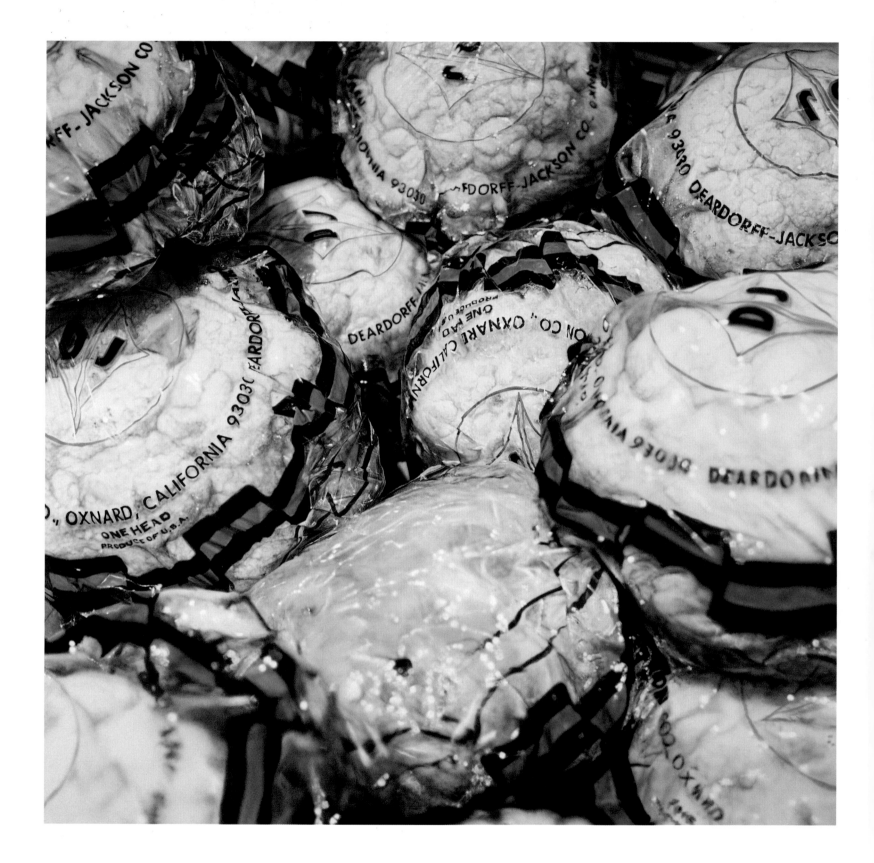

Cauliflower

1975. Acrylic on canvas,

84 x 84 inches.

Private collection,

Connecticut

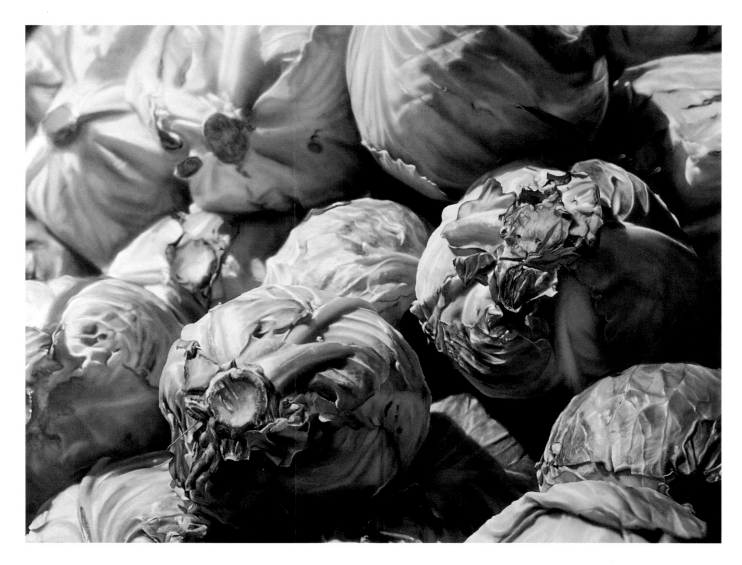

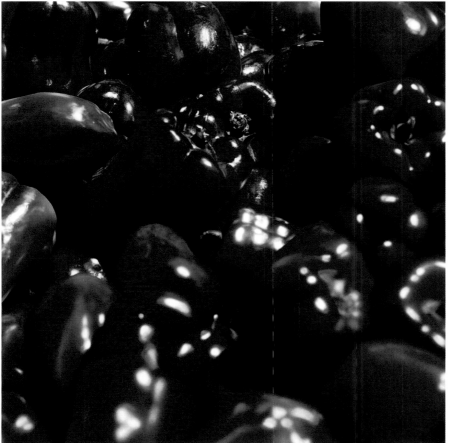

Cabbage
1973. Acrylic on canvas,
90 x 108 inches.
Collection Hubert Neumann,
New York

Peppered
1974. Acrylic on canvas,
72 x 72 inches.
Collection Camille Hoffman,
Naperville, Illinois

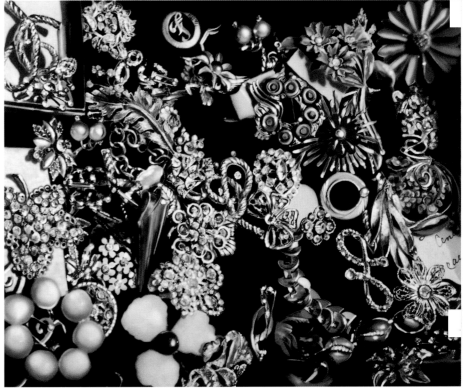

Greenport Sunset
1973. Acrylic on canvas,
90 x 90 inches.
Private collection, London

Englishtown Jewels
1971. Acrylic on canvas,
60 x 72 inches.
Private collection,
Richmond, Virginia

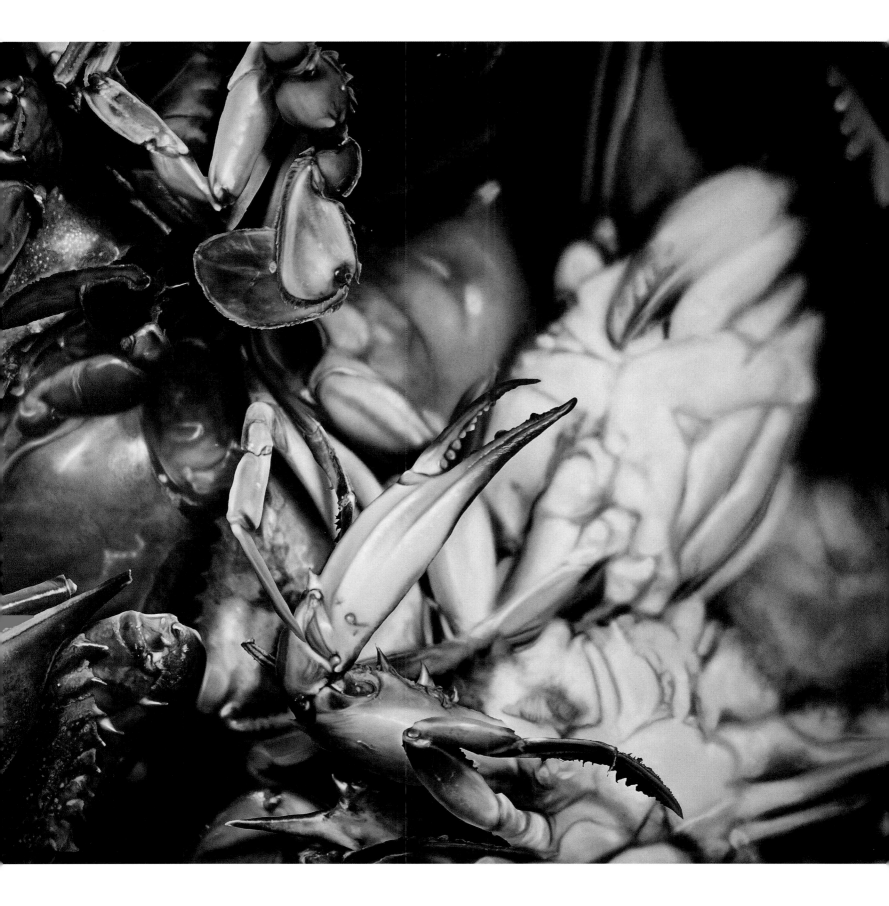

Crab Blue
1973. Acrylic on canvas,
96 x 108 inches.
Worcester Art Museum,
Worcester, Massachusetts,
Eliza S. Paine Fund

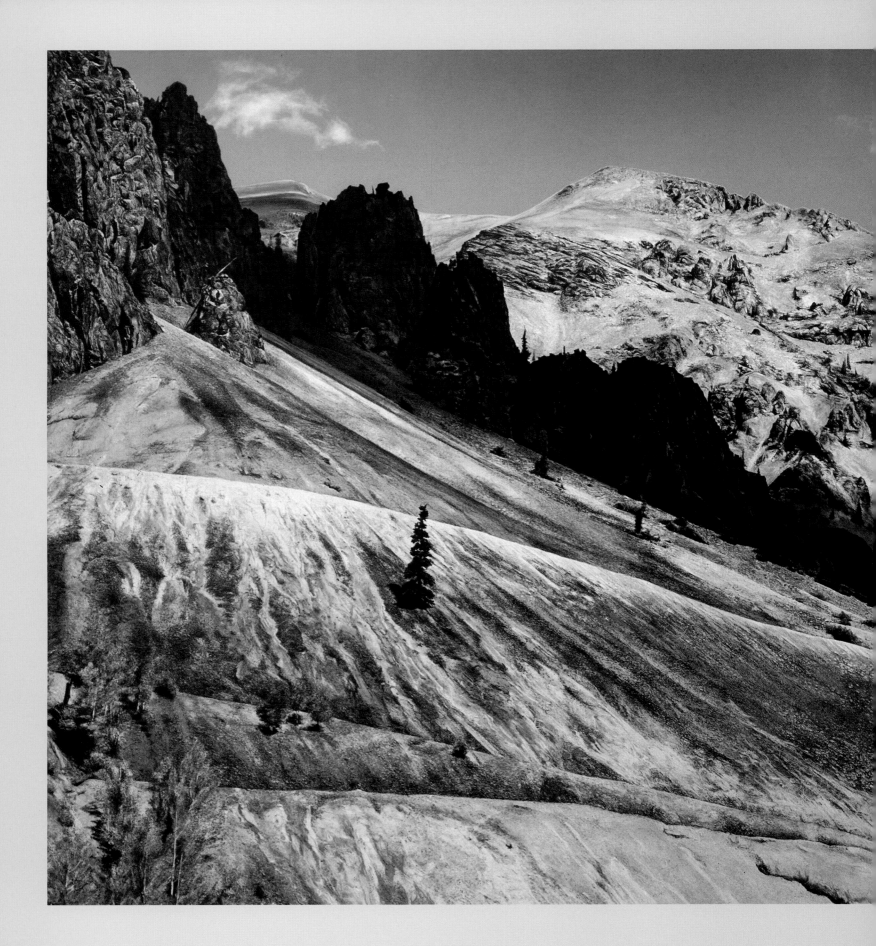

The Continental Divide (diptych)
1975. Acrylic on canvas,
84 x 168 inches.
Denver Art Museum, Denver, Colorado.
Gift of Robert Mulholland, 1980

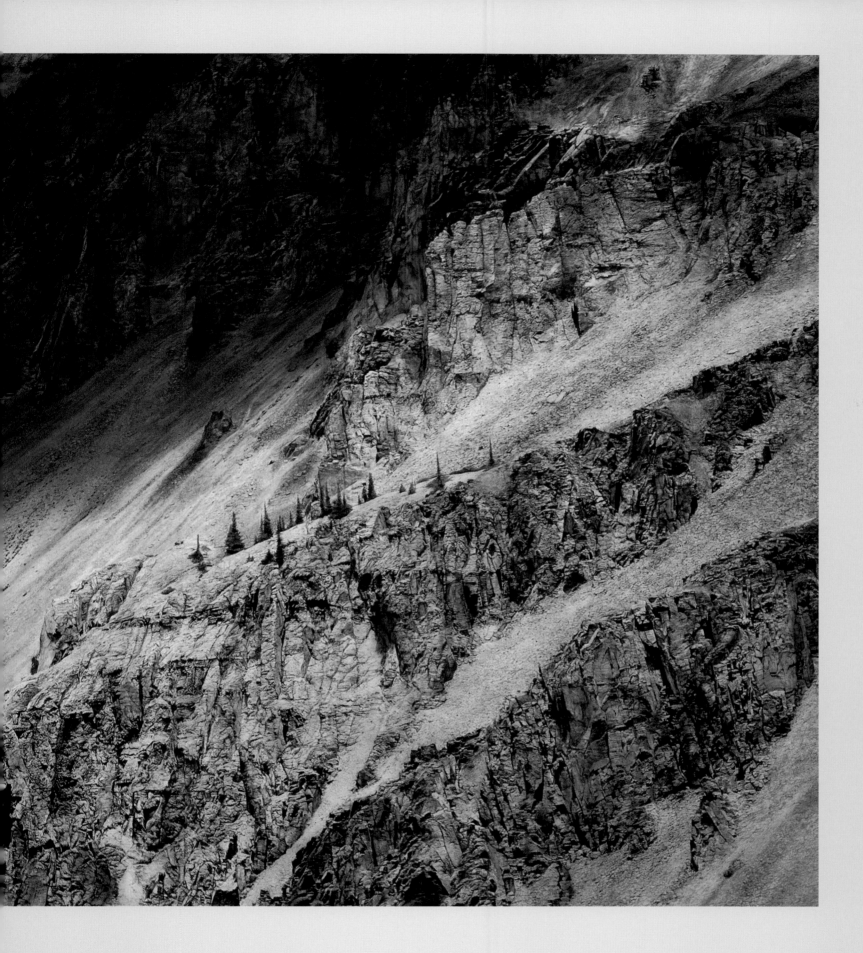

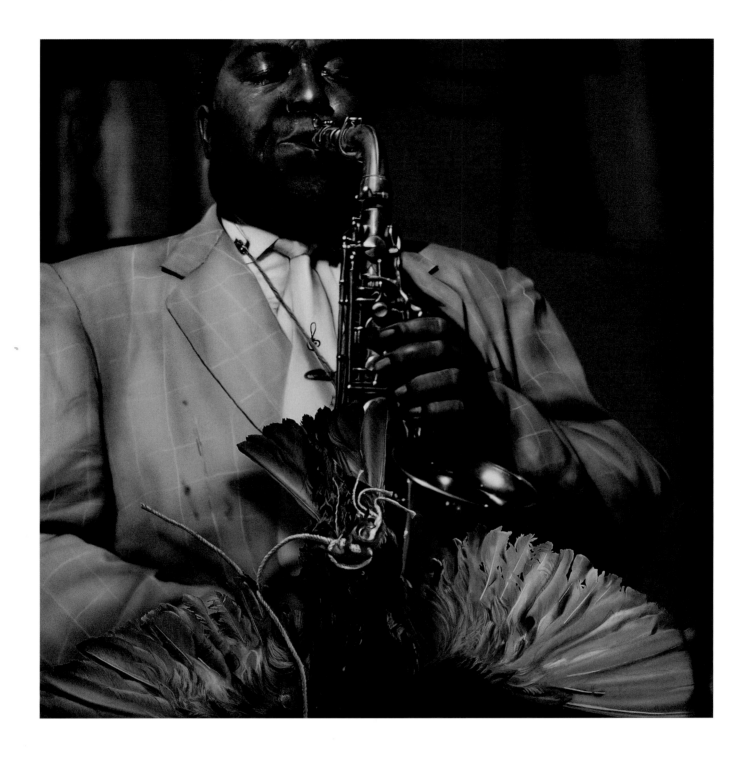

44

Charlie Parker the Bird
1977. Acrylic on canvas,
48 x 48 inches.
Private collection

OPPOSITE:
Clear Jellies
1976. Acrylic on canvas,
84 x 84 inches.
Kunstmuseum St. Alban-Graben,
Basel, Switzerland

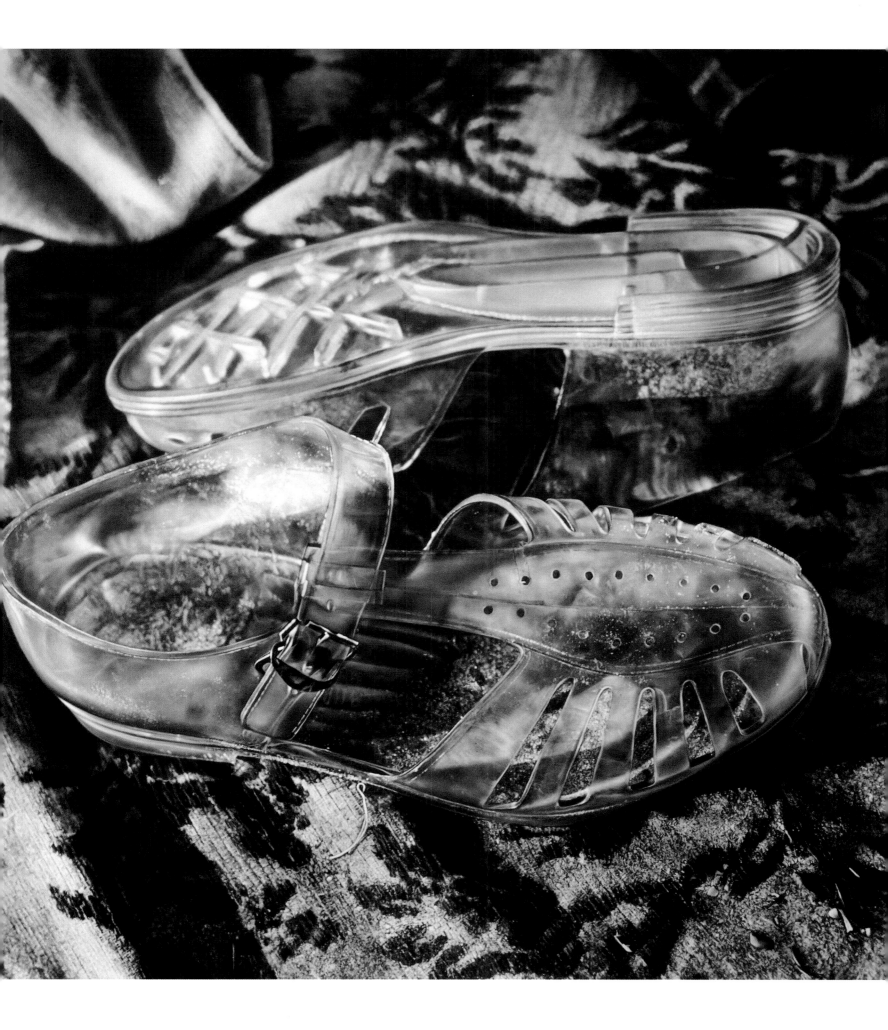

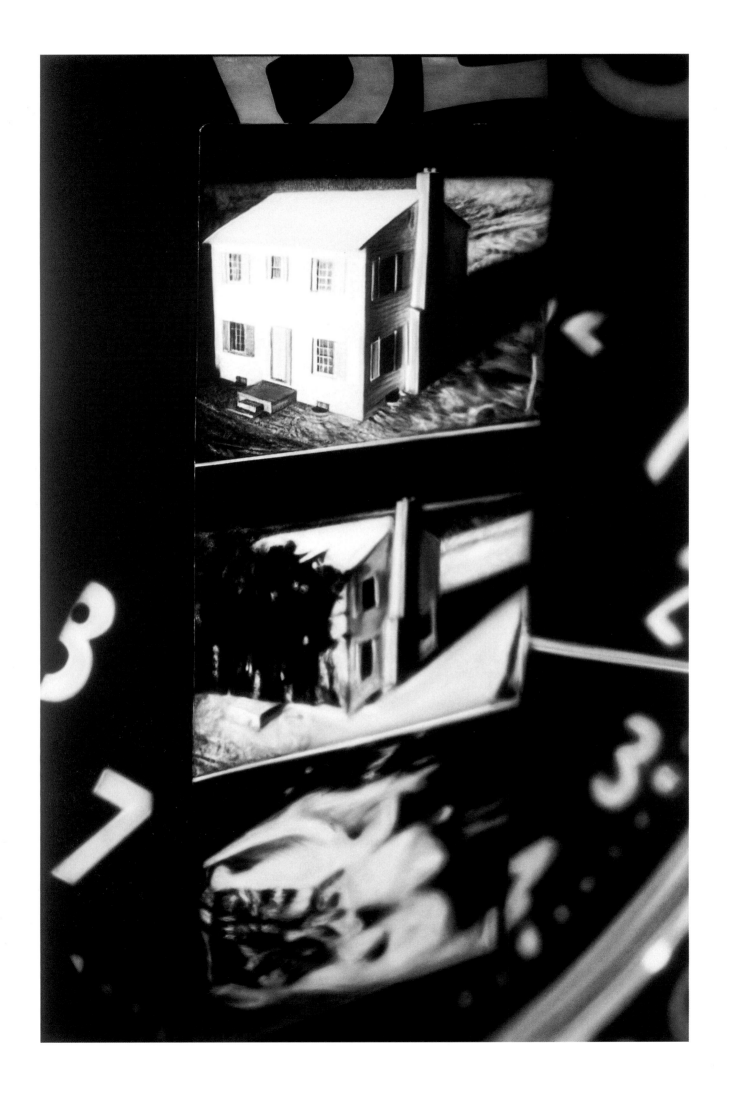

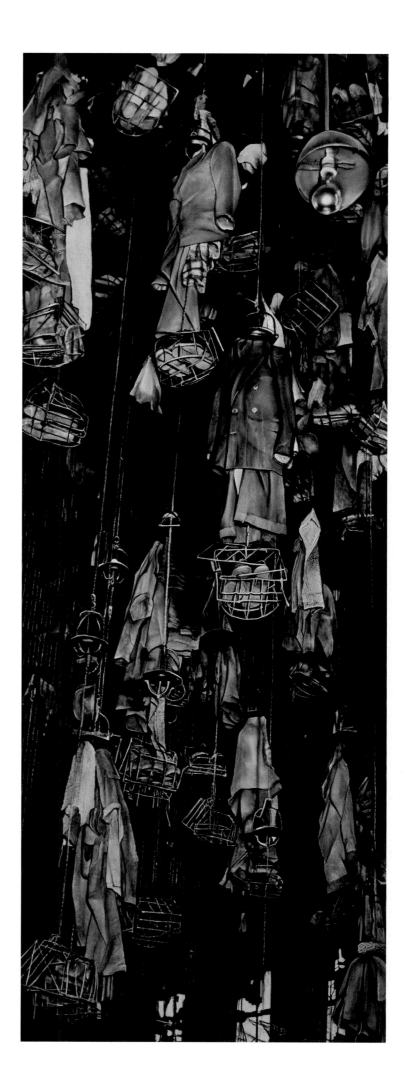

OPPOSITE:
House
1975. Acrylic on canvas,
96 x 65 inches.
Hamburger Kunsthalle,
Hamburg, Germany

Men's Clothing
1977. Acrylic on canvas,
72 x 72 inches.
Collection the artist

III. The MUSIC ROOM

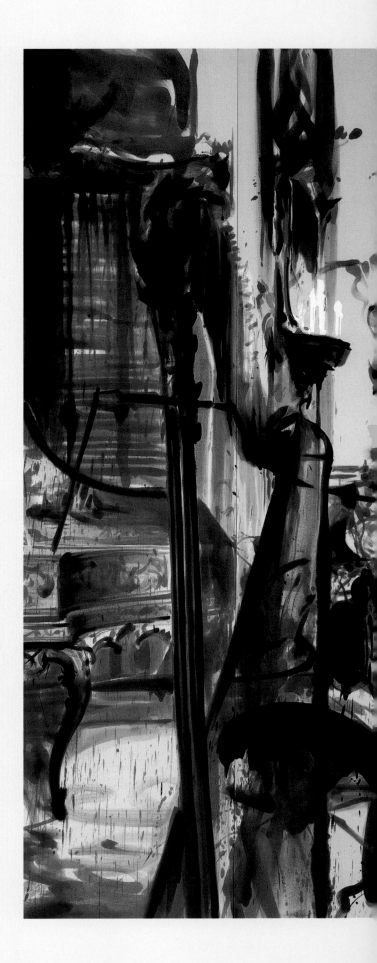

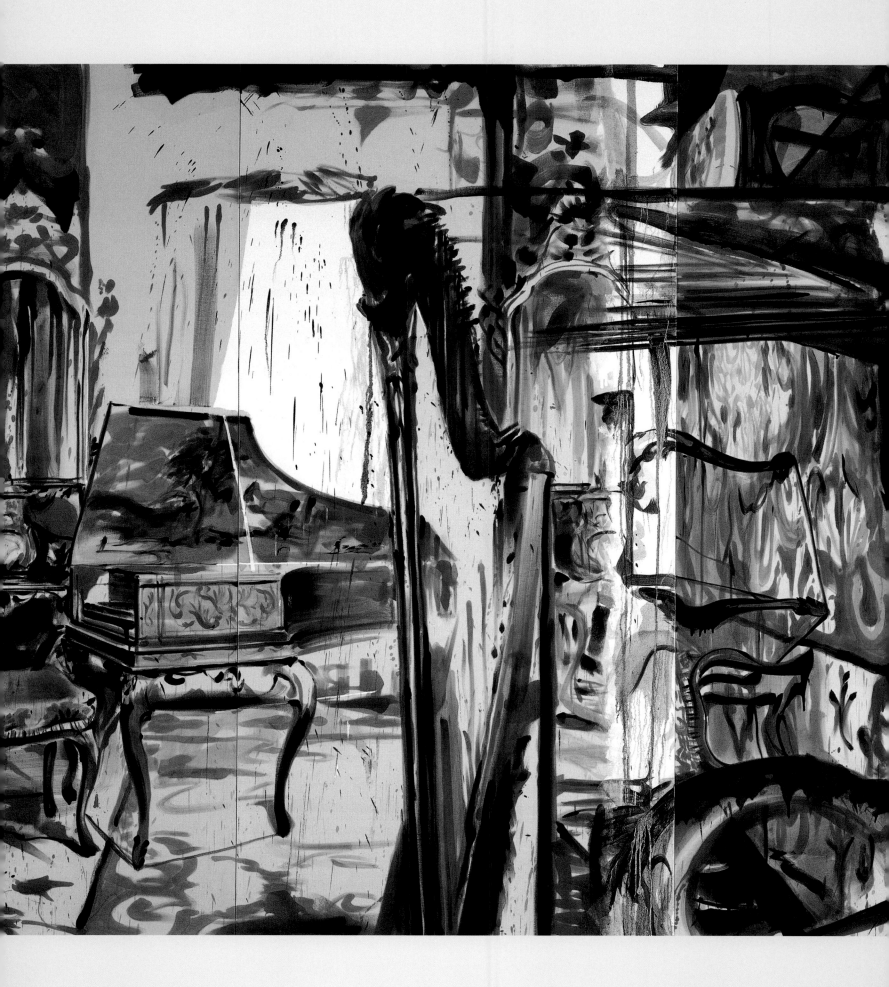

III. The MUSIC ROOM

The turning point in Schonzeit's career was a tour de force that took him well beyond even the most dramatic of his large-scale Photorealist works. It culminated in a multipanel painting-and-mirror installation entitled **The Music Room** (p. 52–53), which was shown in 1978 at Nancy Hoffman's gallery—together with a battery of paintings and drawings based upon it—in an unforgettable exhibition that blanketed the gallery in a dizzying abundance of visual information, all based on photographs of a single room Schonzeit had visited almost by chance the year before.

The room itself was at Viscaya, the estate of businessman James Deering in Miami. The artist stopped there after visiting relatives and took a few photographs. Only when he printed the negatives in the darkroom did the possibilities of the room disclose themselves. As he later recalled, surprised at how much smaller the actual room was than he remembered, he moved rapidly from a work based on the room to a work based on the photograph: "I really didn't remember the room at all. It existed for me only in the photograph. This may be true of much of modern life, films and television. These abstractions become the preferred reality. The idealization of carefully constructed media and real life experience don't always mesh too well, do they?" When Schonzeit transformed the photograph into paint, he let himself go with gestures and techniques that he had abandoned long before in order to achieve the polish and tightness of Photorealism. He took up the paintbrush again, and produced a vast work that is notable for its wealth of detail. Luxuriant to the point of being baroque, and charming in the way that an antique harp (the centerpiece of the room) can evoke a bygone era, the work unfolds in not one, not two, but three separate stages: first as the direct transcription of the image, then as its reflection in paint, and finally, with the addition of a mirror that abuts the edge of the second panel at a ninety-degree angle, as another reflection. The impact of the whole is stunning. Speaking of this work, the artist notes:

THE MUSIC ROOM started as an exploration of what I could do with paint after working with an airbrush for so long. As I got into it, it grew into an exploration, an improvisation on the potential in photographs to make paintings. A slide can be flipped, overlapped, turned any which way to make a painting. The photo was an armature for thought, for ideas about painting, the room, its time, and how I felt on the day I was working on a particular piece.

PREVIOUS PAGE:
The Music Room, Magna
1978. Magna on canvas,
96 x 244 inches.
Museum Weserburg, Bremen,
Germany. LaFrenz Collection

OPPOSITE:
Music Room: Blackboard Diptych
Private collection

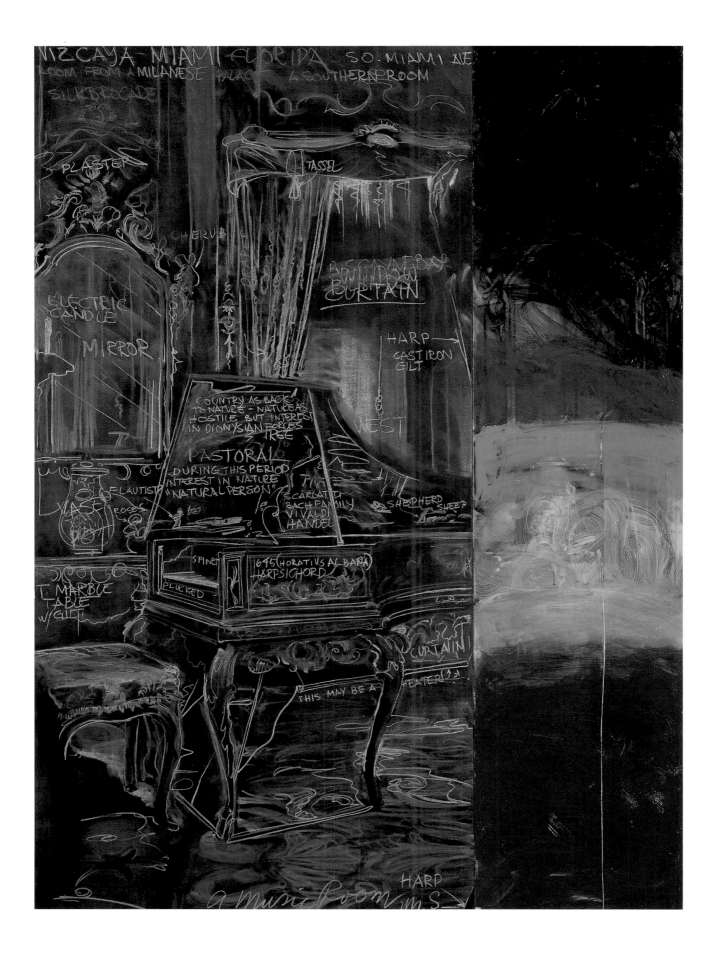

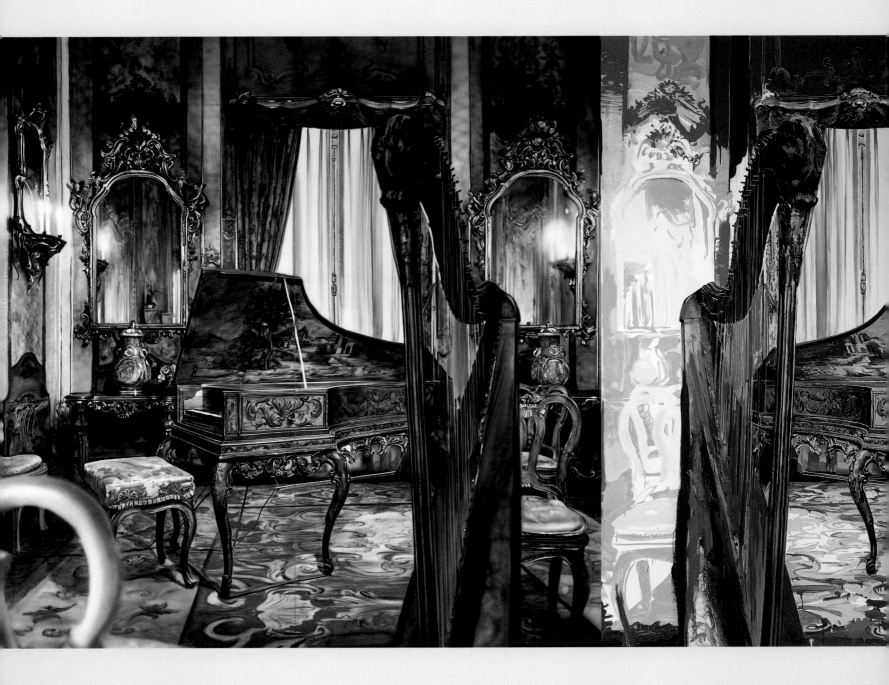

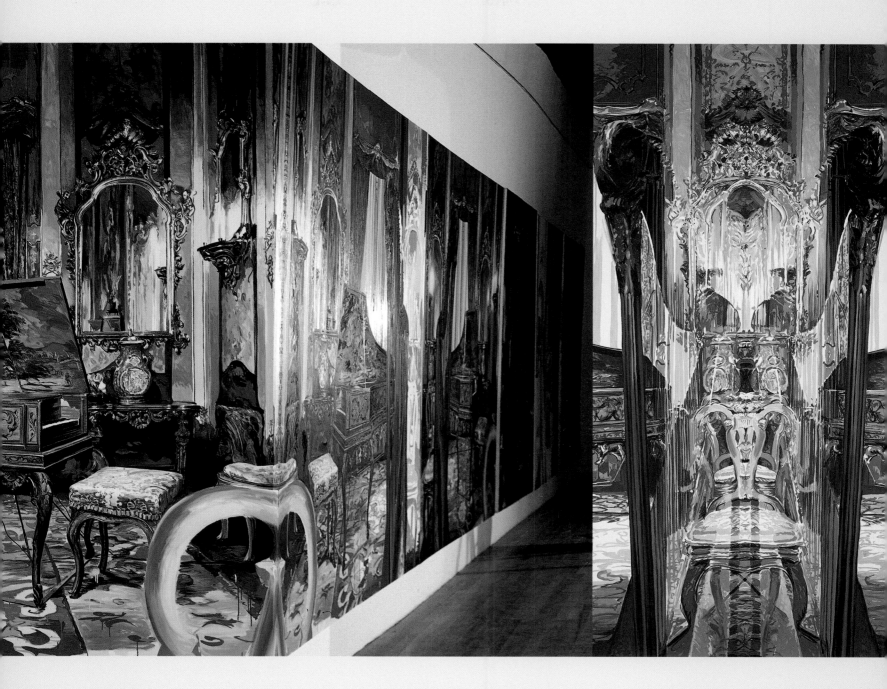

The Music Room
1978. Acrylic on canvas, oil on linen,
Mylar mirror and magna on canvas.
Collection Asher B. Edelman, New York

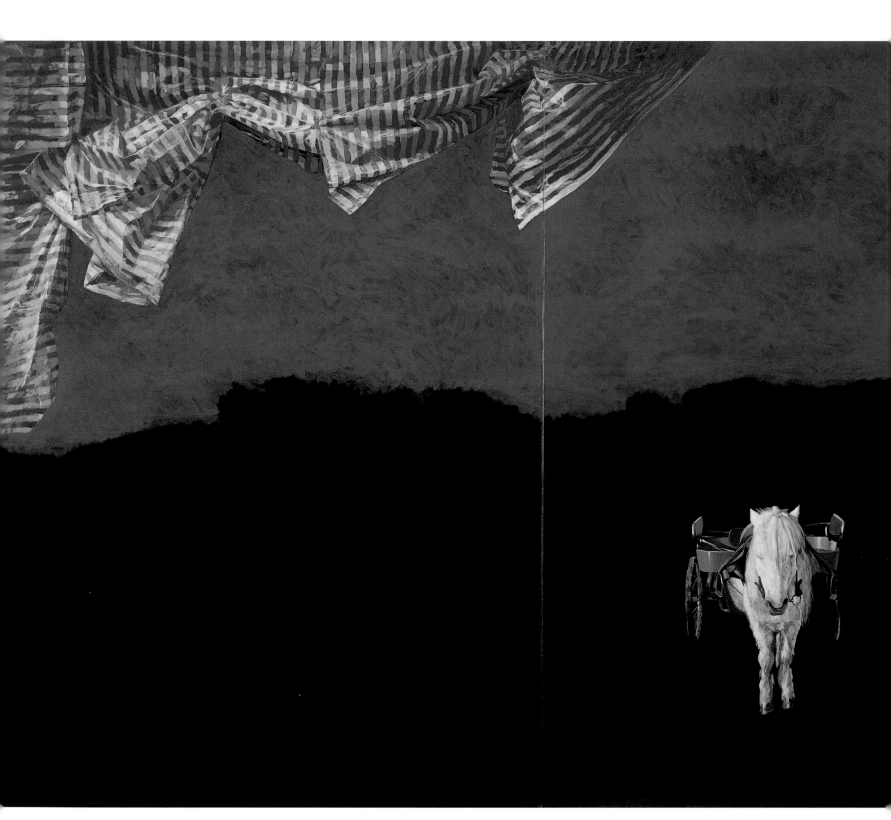

Post Mortem (diptych)
1985. Acrylic on canvas,
90 x 132 inches.
Collection Thom Mount,
Santa Monica, California

After years of working in a very realistic way, I needed to break away to more immediate expression.

In the middle of one December night in 1980, a telephone call from a cousin in Florida brought the news that his father had died. A year later, his mother passed away. Schonzeit responded to the double dose of grief with **Post Mortem** (above), another major painting that, like **The**

Music Room, occupies a central place in his oeuvre. As with that major work, this too is a story "full of romance and longing" and "overtly personal," as he says. An elaborate curtain is drawn back into the upper left-hand corner to reveal a scene of (for this artist) relative emptiness filled with rich atmospherics and a lone figure. Against an evening sky of cerulean blue and a dark, indistinct landscape of low-lying trees, a solitary pony and cart face the viewer. It is the distillation of what began quite differently. As Schonzeit recollects: "It started as a double portrait of my parents and wound up a forlorn, abandoned pony. Certainly how I felt at the time. As with much of my work, it, too, is a layered piece, a montage made by projecting slides on a canvas until the subject and placement talked to me, felt right."

This kind of high drama, so alien to the antitheatrical polemics of Minimalism and abstraction that dominated the critical discourse of the time, is the root of an extremely important line of paintings that Schonzeit has made since the appearance of **The Music Room**. Another example of it is **The Orange Farm** (p. 65), an oblique reference to Orwell's **Animal Farm** that has the timeless air of a fable by Aesop. Leavened by humor and crowded with incident, it offers a play of crisply delineated forms across a strangely manipulated space. But where is the famous pig, symbol of totalitarianism in Orwell? "He's indoors, being waited on paw and hoof by all those broken, domesticated barnyard critters," explains the artist. It is also reminiscent of the warm tones in a seminal work by Joan Miró, **The Farm**, first owned by Ernest Hemingway.

Contemplating the directions in which Schonzeit's work has moved since this rich period of experimentation, it is clear that the breakthroughs made in **The Music Room** and the other related works were to have long-lasting effects. He made his most successful foray into grisaille, a medium of grays, blacks, and whites that served him well in a series of narrative works a few years later. (Picasso had used it for the famous **Guernica**, and Jasper Johns was most comfortable in its avoidance of the problematics of color.) The autobiographical directness of **Post Mortem** freed him to explore more expressive subject matter in cinematic and montage form. The liberation from the airbrush and the fastidiousness of Photorealism spurred a wide range of technical and gestural paintings that continue to this day. Whether in the famous flowers that were the next stage of his career, or in the layered works that led to both the black-and-white paintings and the spectacular gold works that grew out of a trip to Japan, what began in **The Music Room** would echo through the decades to come.

Eye Chart
1980. Oil on linen,
84 x 72 inches.
Collection Beth Gutcheon,
New York

OPPOSITE:
Split
1981. Oil on canvas,
96 x 132 inches.
Virginia Museum of Fine Arts,
Richmond.
Gift of Sydney and Frances
Lewis Foundation
Photograph © Katherine Wetzel

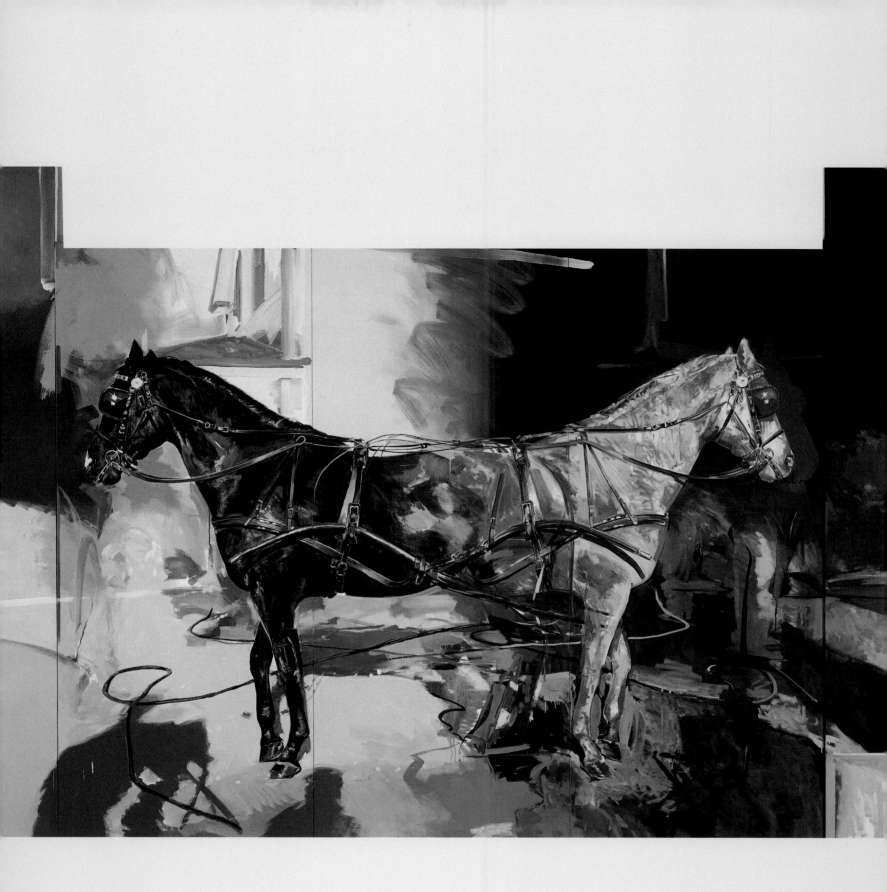

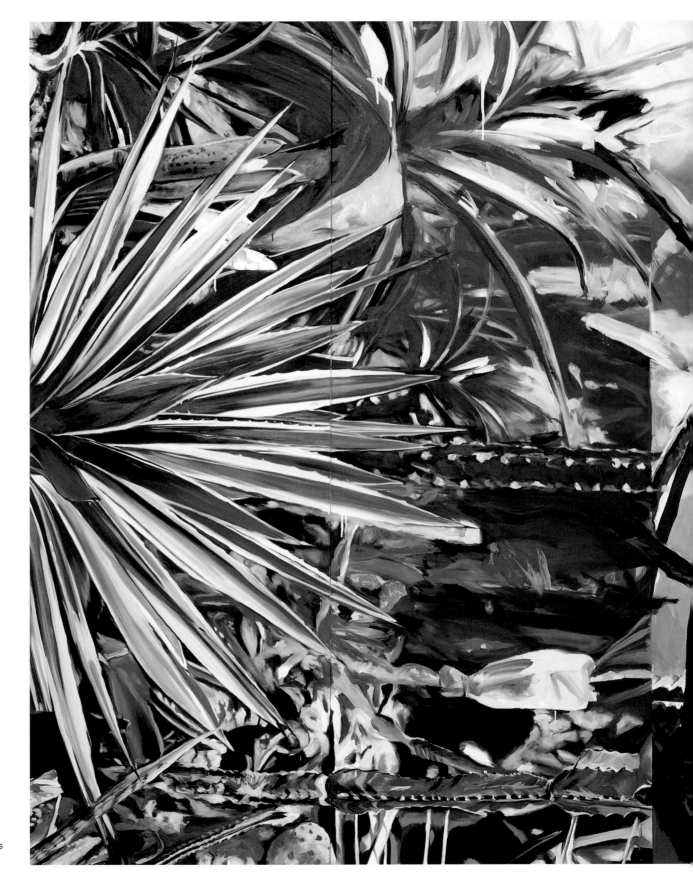

58

From the Hot House
1979. Oil on linen,
84 x 144 inches.
Museum Schloss Morsbroich,
Leverkusen, Germany
Photograph © Museum Schloss
Morsbroich/Rosenstiel

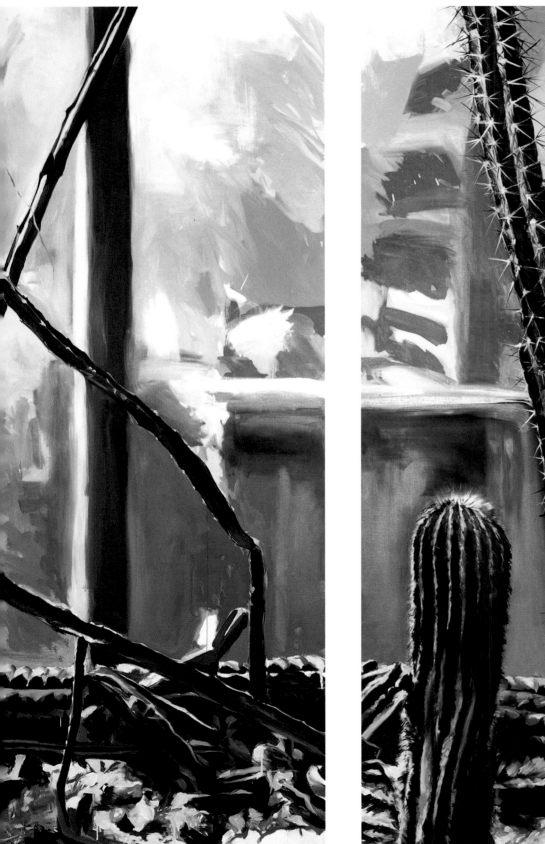
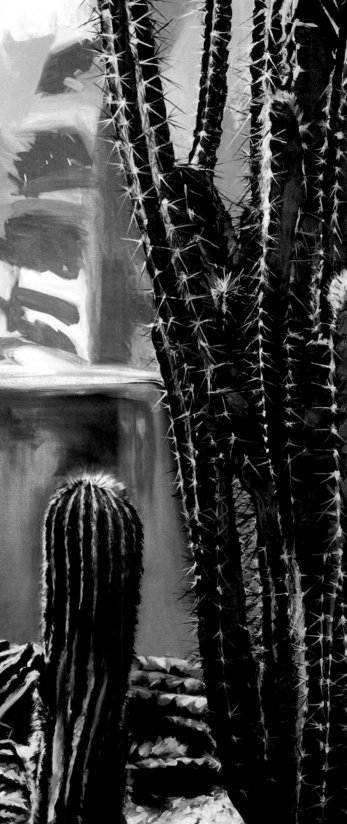

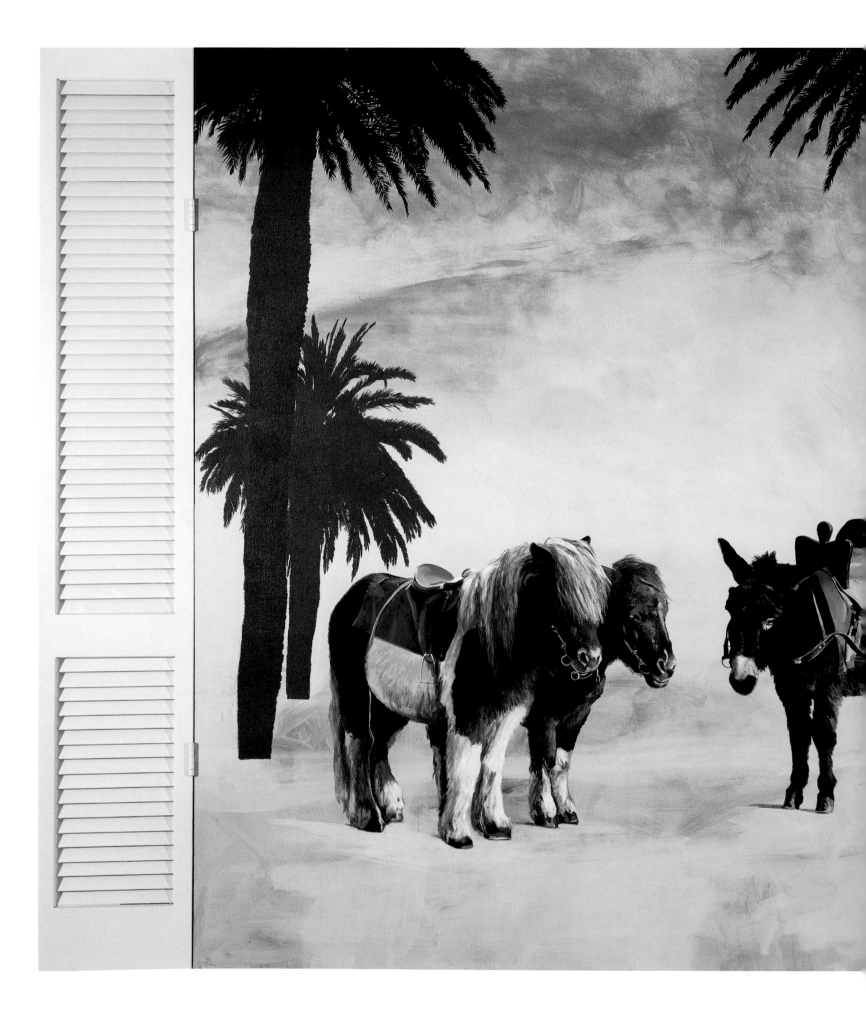

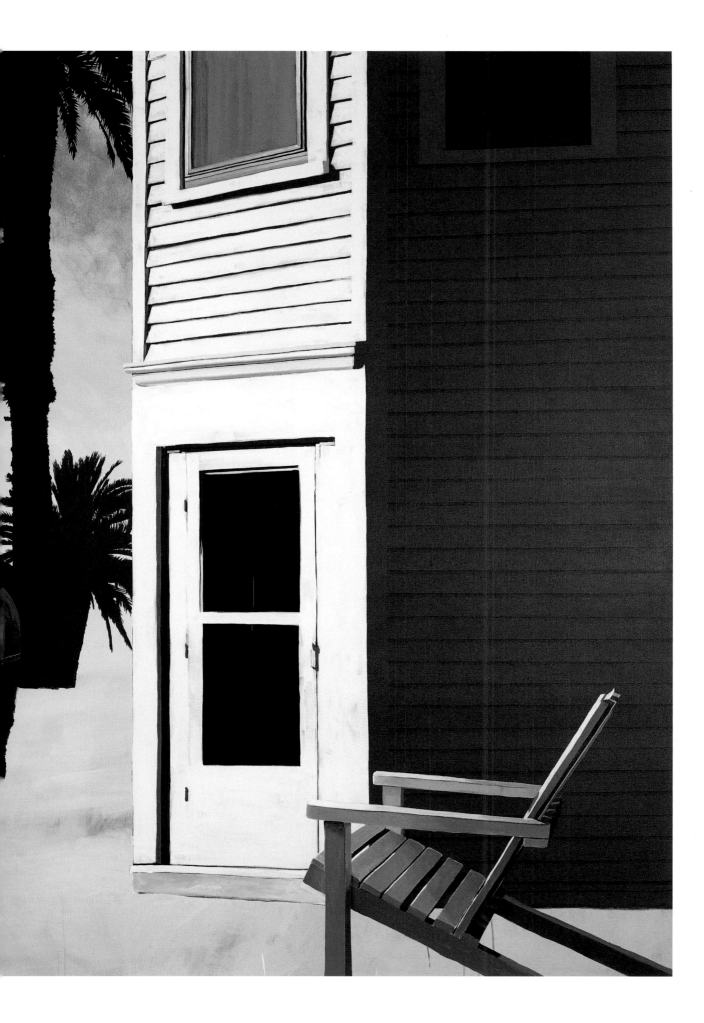

Two and One
1985. Acrylic on canvas
with louver door,
96 x 160 inches.
Collection the artist

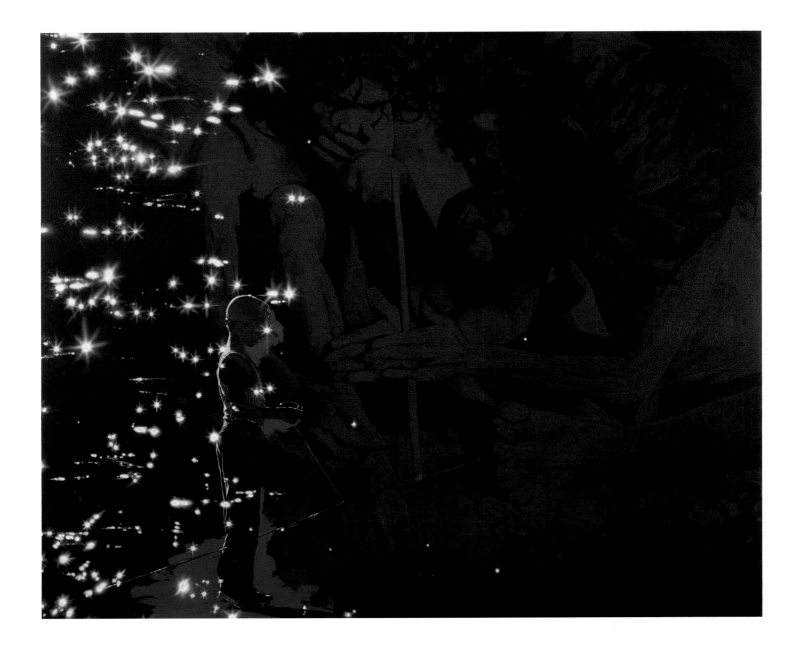

Playing with Fire
1985. Acrylic on canvas,
54 x 66 inches.
Collection the artist

OPPOSITE:
Moderne
1988. Acrylic on linen,
96 x 72 inches.
Museum Weserburg,
Bremen, Germany.
Klaus LaFrenz Collection

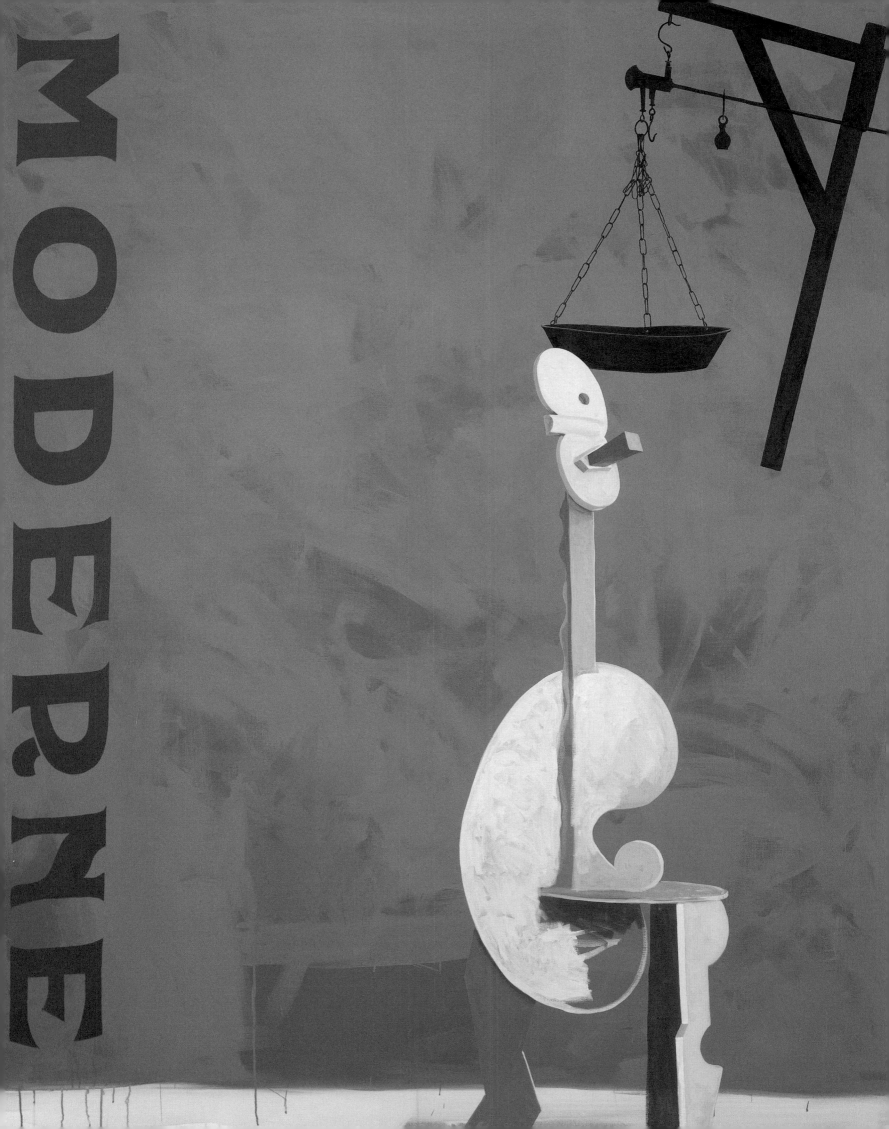

Support
1984. Acrylic on canvas,
78 x 66 inches.
Private collection

OPPOSITE:
The Orange Farm
1986. Acrylic on canvas,
96 x 108 inches.
Collection Klaus Lueders,
Cologne, Germany

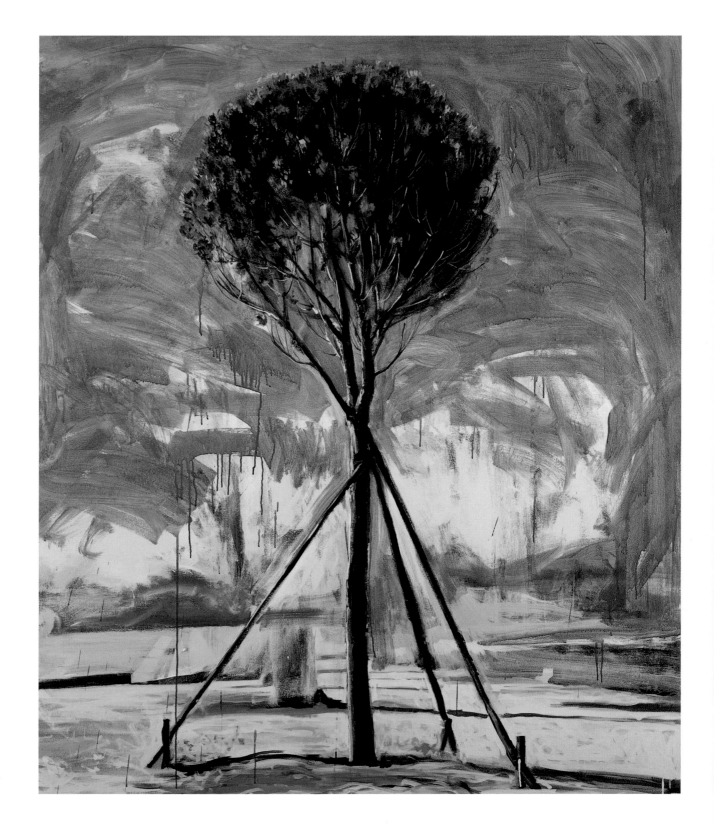

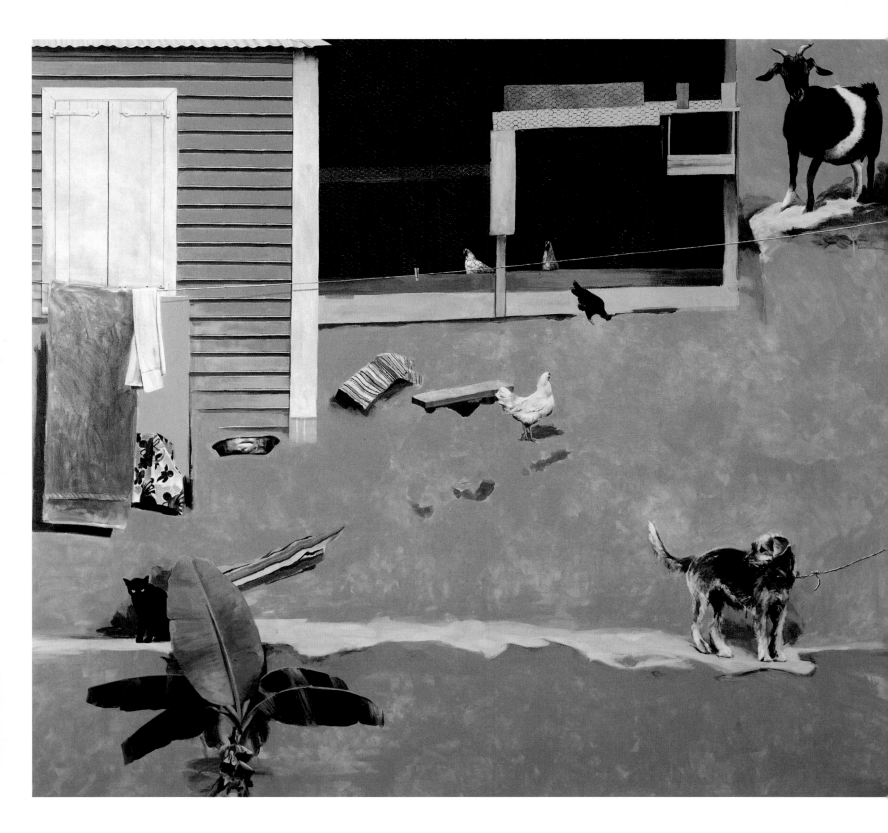

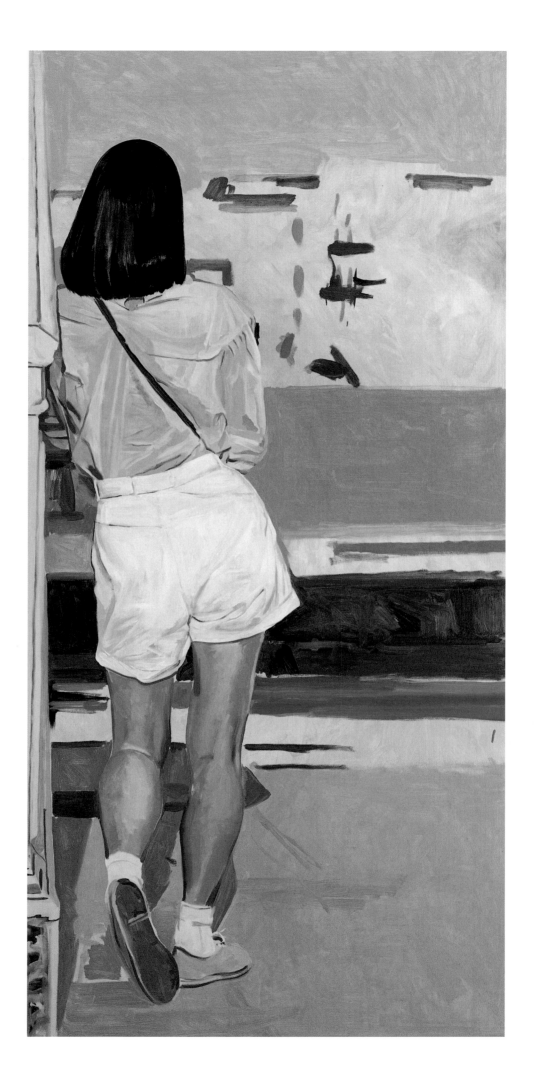

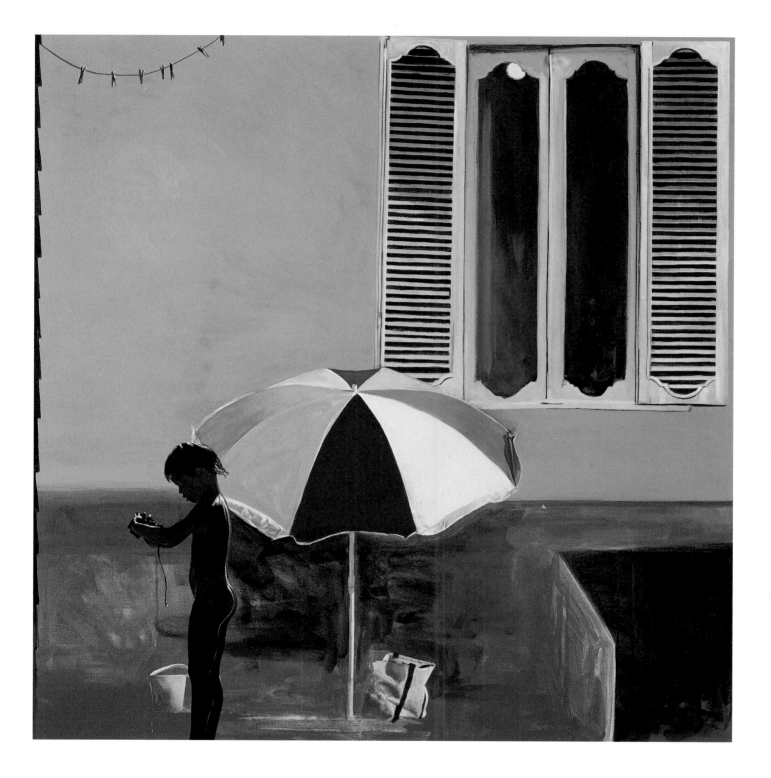

OPPOSITE:
White Shorts
1983. Oil on linen,
66 x 32 inches.
Private collection,
New York

ABOVE:
Late Summer
1989. Acrylic on linen,
48 x 48 inches.
Private collection

Two Trees
Acrylic on canvas,
78 x 90 inches.
Brooklyn Museum of Art,
Brooklyn, New York

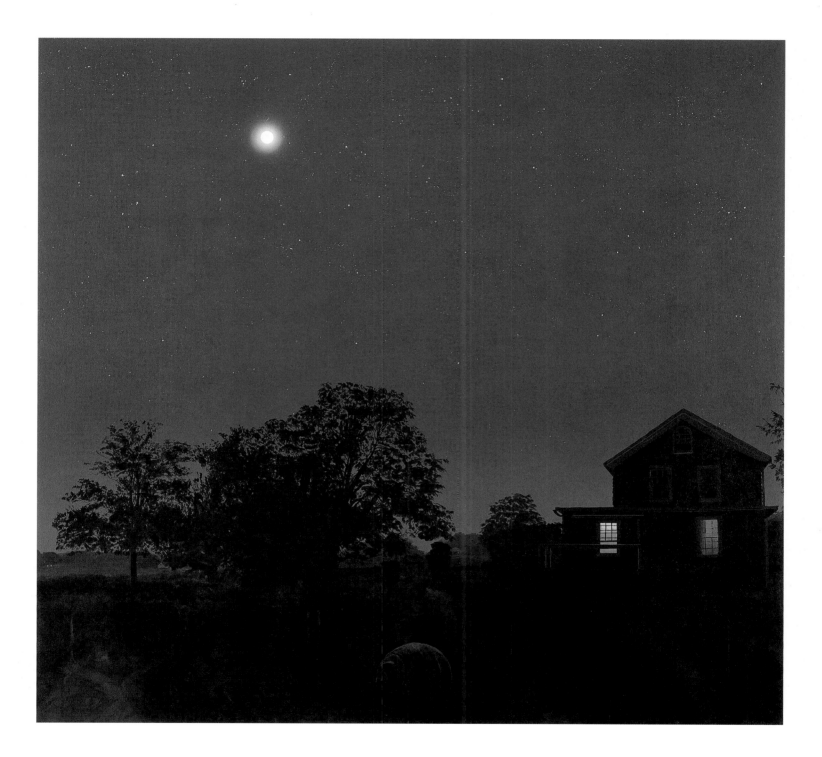

Bartos Moon
1986. Acrylic on canvas,
66 x 72 inches.
Private collection,
Aspen, Colorado

IV. EFFLORESCENCE

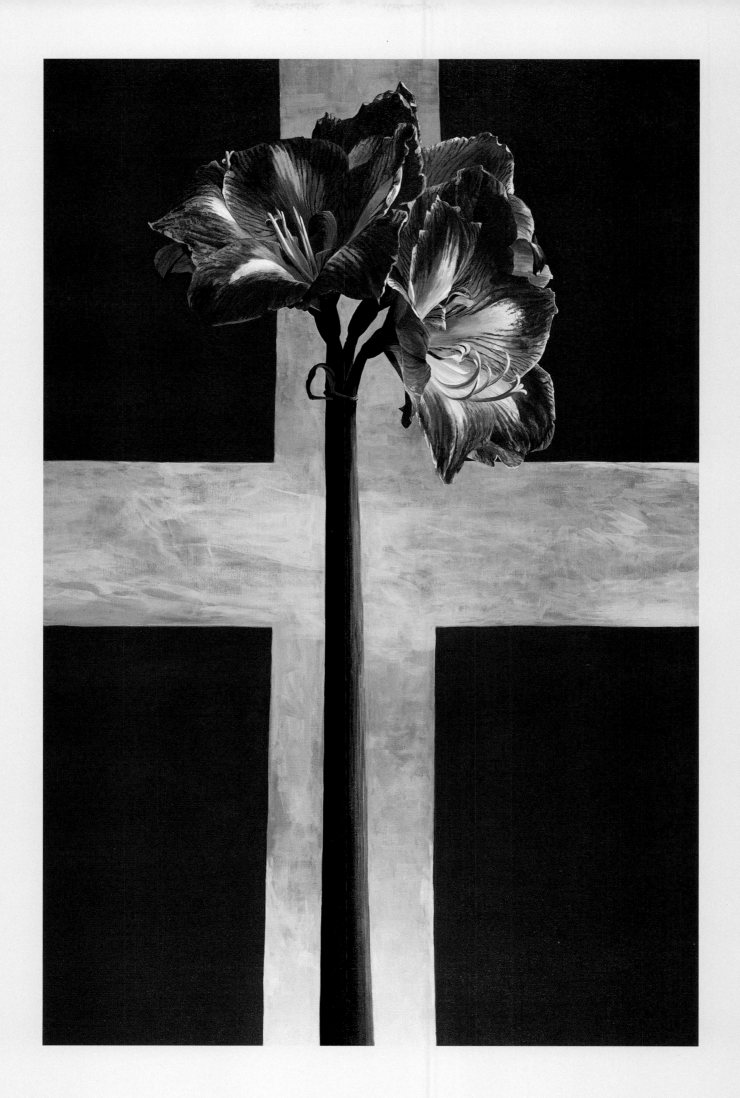

IV. EFFLORESCENCE

Because Schonzeit has always tended to shift gears rapidly, both in method and in subject matter, it helps to have a straightforward sense of where to find those gears. As he begins to explore a wider array of subjects and styles, two clear paths appear in the works of the 1980s. In his own notes: "Centered composition—the still life—or peripheral, moving around the edges of the paintings. One is a moment, the other a story." Although he had abandoned the airbrush, he adhered to the ideal of still-life compositions that included elements of landscape and portraiture. Simultaneously, he embarked on a series of dramatic paintings— the artist refers to them as the black paintings—which assembled layered images in a manner akin to fables. As the work took on a more poetic and symbolic character, it also ventured further into the celebration of beauty. It was audacious at a time when the art scene, led by critics and theorists, was vigorously championing its antithesis, what one influential voice called "the anti-aesthetic." This arrived on the heels of a critical orthodoxy, based on Minimalism, that banned the theatrical in art. For Schonzeit, however, the beautiful and dramatic were a necessary conjunction: "I have come to understand that I am unable to do the dramatic without also doing the beautiful realist work that has always been a part of me."

Pursuing his own instincts, setting his own obstacle course, Schonzeit became the Glenn Gould of the visual arts, withdrawing from the whirl of openings and art-world politics to pursue his path to perfection in the studio. His ascetic retreat was rewarded with a compositional breakthrough that yielded not only an extraordinary group of paintings and a fresh chorus of accolades, but a signature mode, assembled from the earlier methods, that defied imitation. It was the season of the flower paintings. His own sense of their continuity with what had preceded them was secure: "The issue of beauty and my work, color for its own sake, appeared in large, floral still lifes. It is in these paintings that the Photorealist in me continues."

Even in modern art, the genre has its important proponents, many of them the direct antecedents to Schonzeit's flower series. David Hockney and Alex Katz, working in bright tones and flat spaces, produced some of their most enduring and convincing paintings on the subject. The light, looping drawing style of Ellsworth Kelly also comes to mind. Schonzeit's essays in this area, and in the realm of figure painting at this time, actually predate many of the well-known artists who use

PREVIOUS PAGE:
Danish Cross
1998. Acrylic on linen,
60 x 44 inches.
The Butler Institute of American Art,
Youngstown, Ohio.
Gift of the Termine Corporation,
New York, N.Y., 1994

many of the same layering techniques, including Eric Fischl, David Salle, and Mark Innerst.

One historical figure in particular is useful to recall in understanding Schonzeit's achievement: Eugène Delacroix. The bravura of Schonzeit's flower paintings, like Delacroix's essays in the same genre late in his career, astounds audiences with their lush color and sheer beauty. As an aside: Delacroix was among the very first artists to use a camera. This and other parallels between the two painters are worth pondering. Both guarded their independence from the excesses and fashions of the time, simultaneously guarding the principles of tradition and pushing their work toward breakthroughs that surpassed anything the avant-garde was attempting. This made Delacroix in his time both the most conservative and the most modern of artists. Like Schonzeit, he was also a master of narrative, occasionally drawing upon the novels of his distinguished colleague and close friend George Sand for dramatically potent subject matter.

Delacroix, too, was wary of the tendency for painters to pack too many details into the individual work, preferring what he called the "frankness of execution" in Rubens' work to the discordant, overly specific pictures of his contemporaries. The economy of detail and gesture that characterized Delacroix's work is also a conscious principle in Schonzeit's editing. So is what the poet William Butler Yeats once called "the fascination of what's difficult." Schonzeit made the flowers pop from the canvas with a stunningly three-dimensional style:

Painting complex stems and leaves is like untangling a knot. This requires enormous patience and a bit of concentration. It's all string. Start with one end and work your way to the other. I often think of the painting as carving, as a way of building rather than painting flowers. I paint in front of or behind the surface, always painting the surface away until the flowers exist in real space.

Most important, between Delacroix and Schonzeit, with a nod to Matisse as well, there is the kinship of color. In particular, these painters are fearless chromaticists. As Schonzeit explains in relation to his flowers:

I am reminded that when I work in series, I have tended to go through the spectrum. Photorealist fruits, going from lemons to the indigo of eggplants. When I had finished with magenta and purple, I was done with that kind of subject. There are color systems at work in all the paintings, and the combination of slides in one picture most often has to do with the colors involved.

The extravagant technical efforts of Delacroix in the realm of color gave rise to styles as different as Fauvism and Abstract Expressionism.

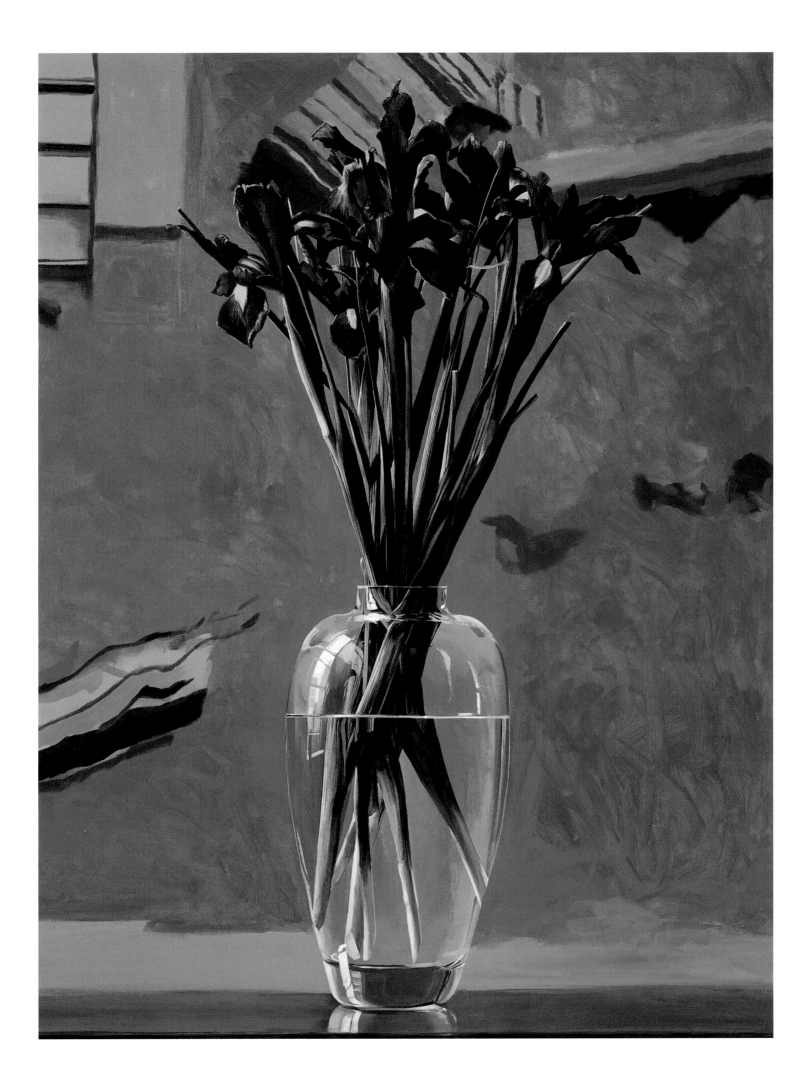

In particular, his late flower paintings launched his work in the direction of the painting of the next century. He was just coming off a pair of major public commissions when he started the works that were his sole contributions to the Salon of 1849, and then were shown at the Exposition Universelle of 1855. Even in Delacroix's day, the floral still life was hardly considered cutting-edge stuff. The Louvre—not to mention major museums in Amsterdam, London, Vienna, and elsewhere—was packed to the rafters with tier upon tier of examples of the genre. Yet Delacroix used the format for passionate experimentation in color as well as in the relationship between figure and ground. These, as we now know, are key issues in the advances that became known as Modernism, and they are also fundamental elements in Schonzeit's innovations. Even in our time, the chromatic fireworks Delacroix created in these bravura works revitalized a formulaic genre and have the ability to surprise and delight us. As with his close friend the composer and pianist Franz Liszt, another magnificent artist for whom bravura was the basis of art, Delacroix did not indulge in extravagance for its own sake, but as a means of challenging himself and his audience. He never parted with any of the flower paintings. They were found in his studio after his death.

There are two other artists we might mention in this context, for whom flower paintings proved pivotal: Mondrian and Matisse. Mondrian's magnificent amaryllis watercolors and ghostly white roses on blue grounds, evanescent as the scent of tea, are examples. These are echoed quite directly in such Schonzeit stunners as **Danish Cross** (p. 71), in which a tall green stalk rises and rises against the background of the white cross on the scarlet ground of a Danish flag, then, tangent to the top edge of the canvas, bursts into three lavish red blooms abundantly endowed with white stamens and pistils. Like the amaryllis itself, it is a high-impact burst of chromatic and formal grandeur, breathtaking in size (it stands five feet high by nearly four feet across) as well as its apparent botanical correctness. Matisse, as well, following the example of the Dutch master Jan Davidsz. de Heem (a favorite of Delacroix's), pushed the floral still life into a modern idiom all his own by exploiting the intricacy and decorative origins of the genre. One insightful clue to his own work is offered by Schonzeit when he reveals his passion for certain large paintings of Matisse, including **The Moroccans**, **The Piano Lesson**, and the magisterial **Red Studio**, all at the Museum of Modern Art in New York, which the artist humorously describes as "my club, my uptown living room." As with Matisse and Manet, the vocabulary of Schonzeit's work is accessible, and delivered with such accuracy that it is quickly grasped by the eye and mind: "A vase with flowers, an artist's palette, a bowl of fruit, a portrait, a landscape . . . all known before seen. Already in the imagination. My private iconography is very common, I hope. To use clichés is to use the vernacular."

OPPOSITE:
Orange Iris
1992. Acrylic on linen,
48 x 36 inches.
Private collection

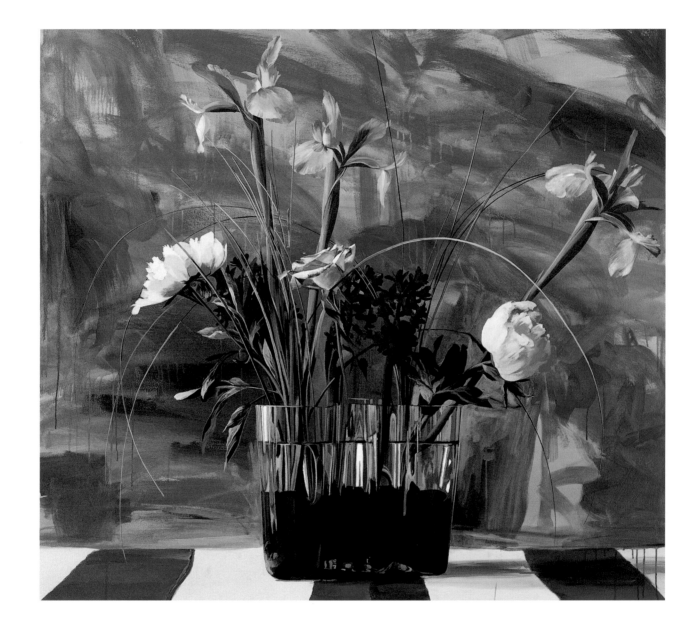

Aalto Blue
1985. Acrylic on canvas,
60 x 66 inches.
Private collection

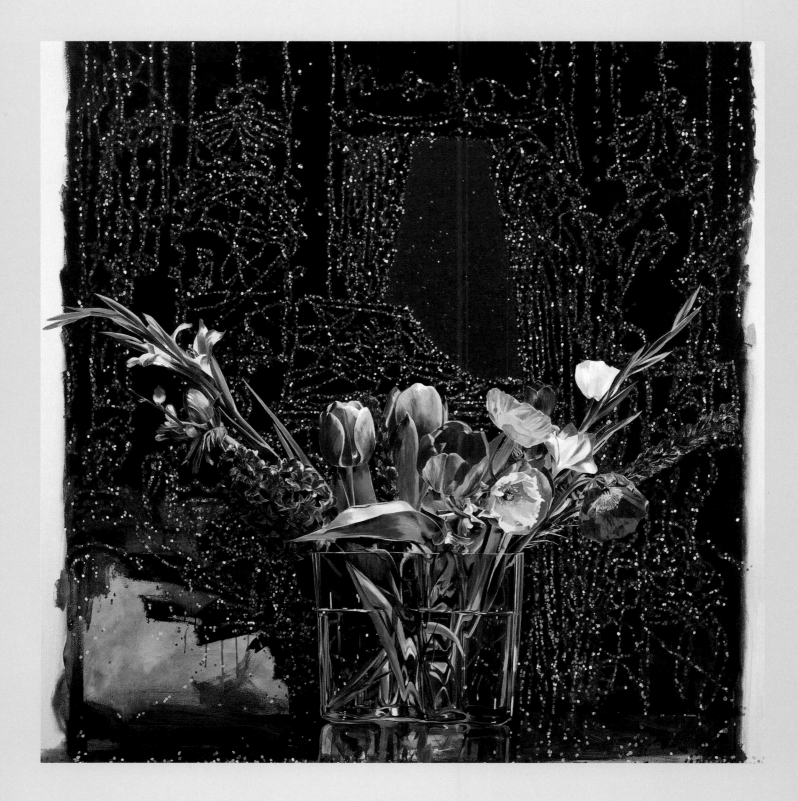

Aalto Midnight
1987. Acrylic on linen,
72 x 72 inches.
Collection Dr. Norman and Ann Jaffe,
Miami Beach, Florida

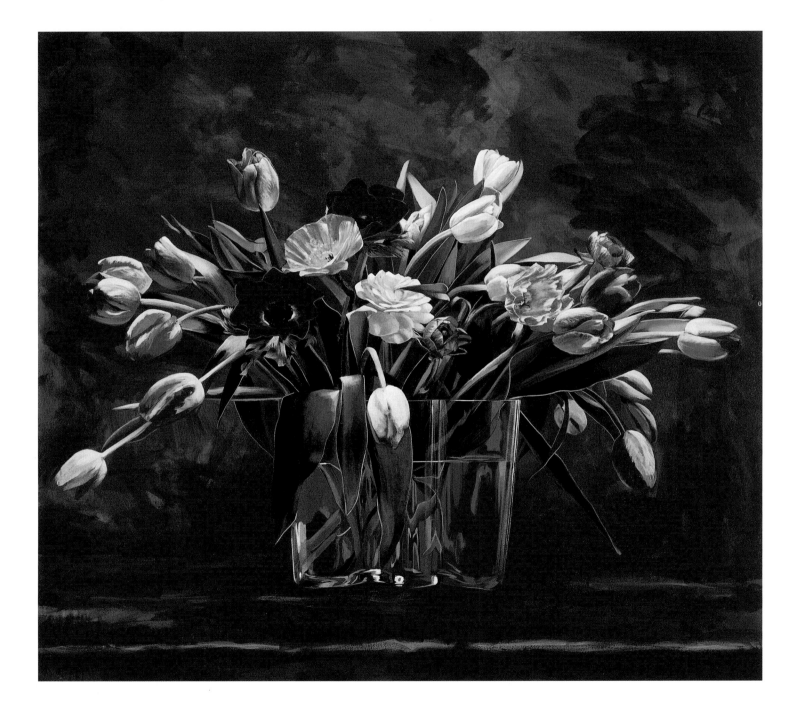

Aalto Red
1986. Acrylic on linen,
66 x 72 inches.
Private collection

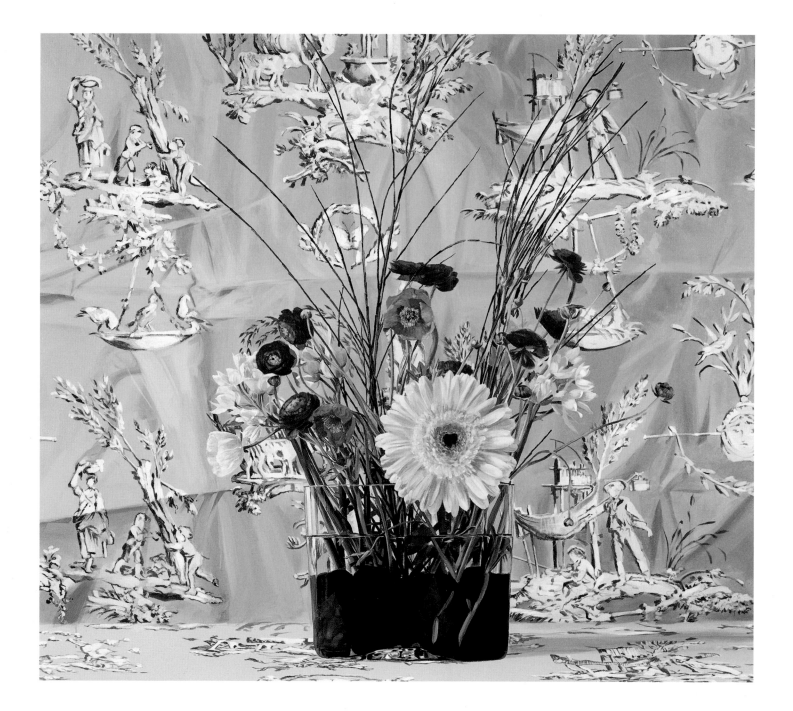

Aalto Yellow
1985. Acrylic on canvas,
60 x 66 inches.
Private collection,
Palm Beach, Florida

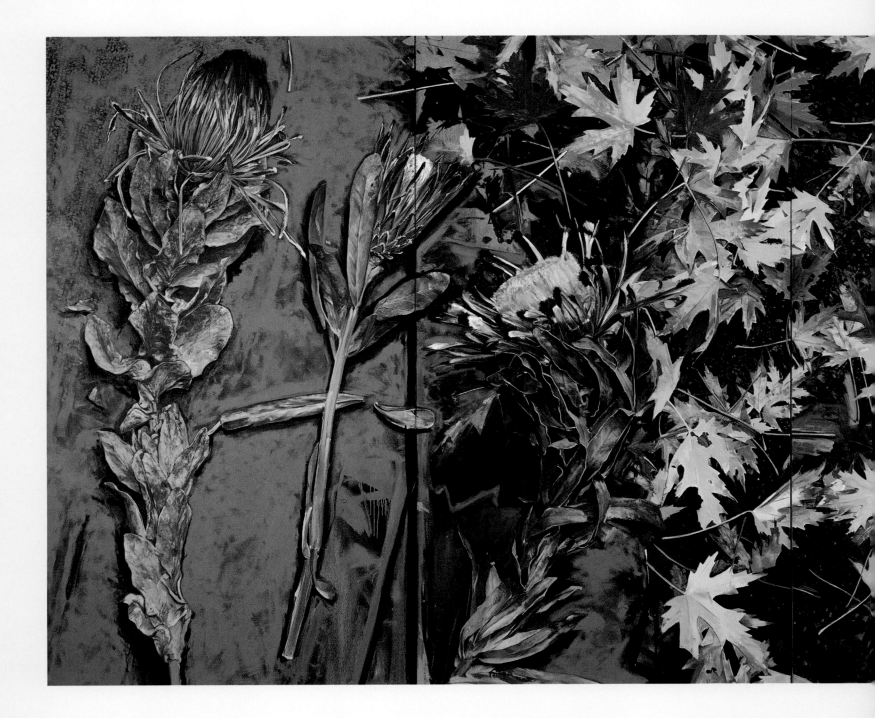

The Leaf Painting
1981. Oil on linen,
84 x 144 inches.
Private collection

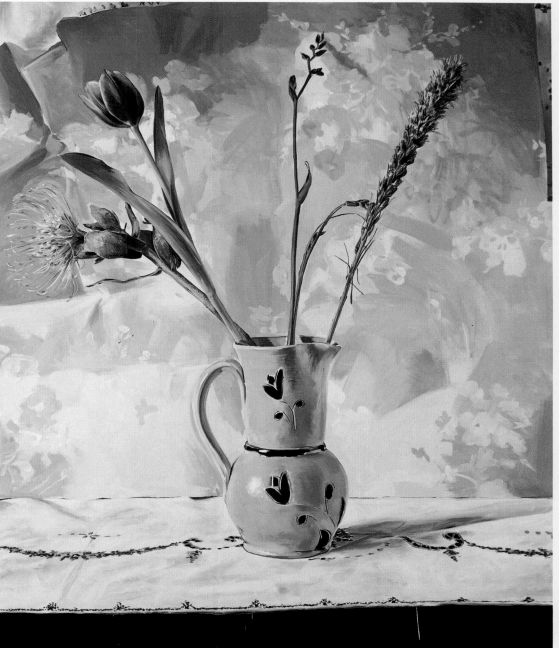

Vase
1980. Oil on linen,
84 x 72 inches.
Collection Mr. And Mrs. David Hermelin,
Bloomfield Hills, Michigan

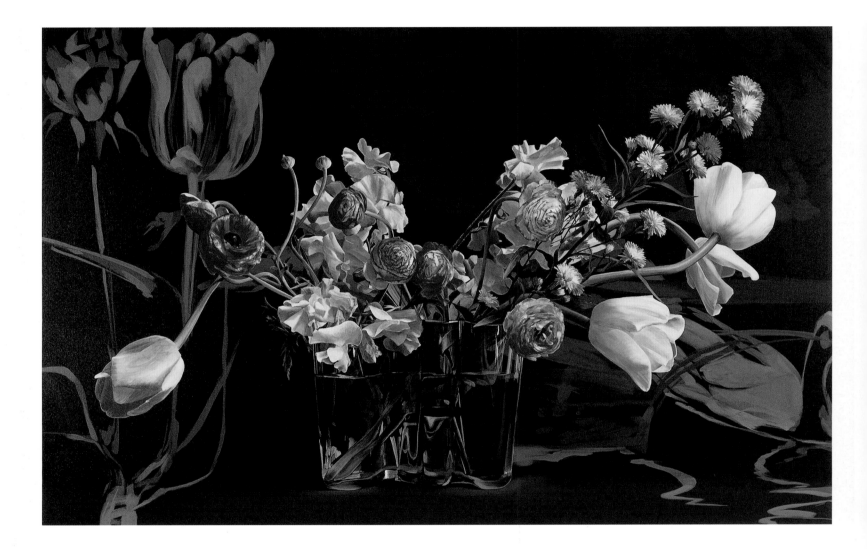

Aalto Black I

1996. Acrylic on linen,

53¼ x 83¾ inches.

Collection Dana and Rick Dirickson,

San Fancisco

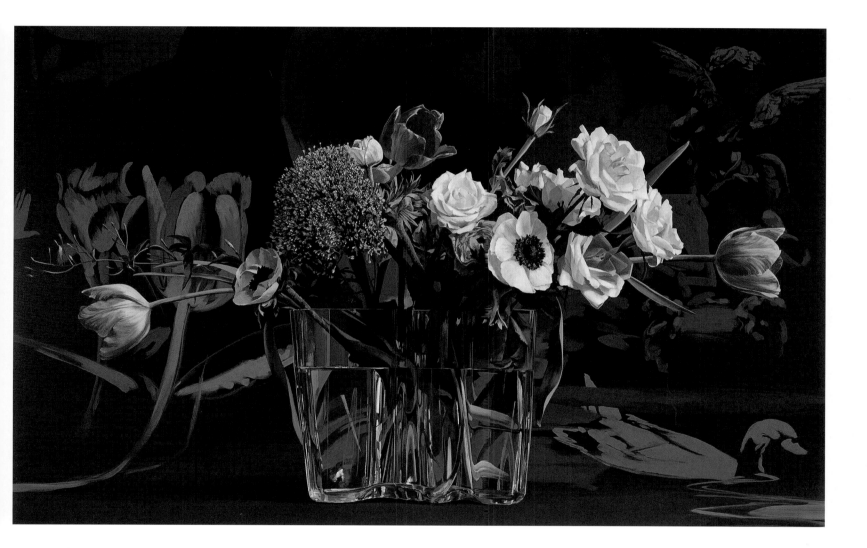

Aalto Black II
1997. Acrylic on linen,
48 x 78 inches.
Mr. and Mrs. Douglas Schubot,
Del Ray Beach, Florida

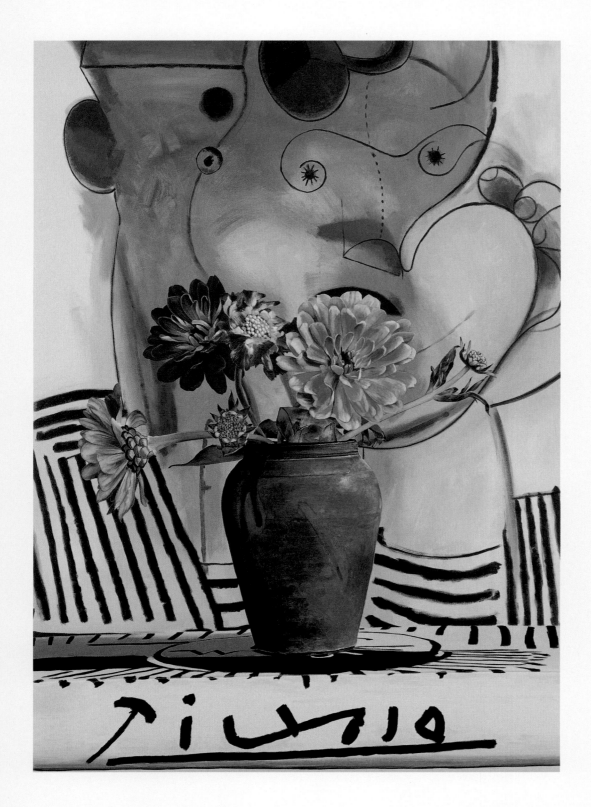

Picasso
1988. Acrylic on linen,
66 x 48 inches.
Private collection

OPPOSITE:
Floral with Self-Portrait
1988. Acrylic on linen,
66 x 72 inches.
Private collection

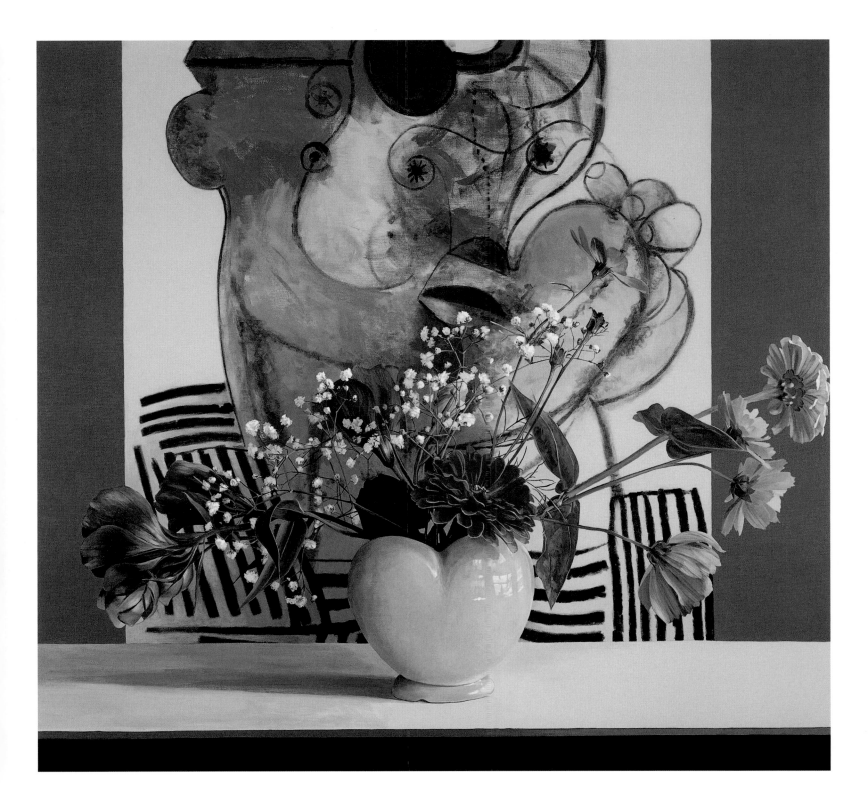

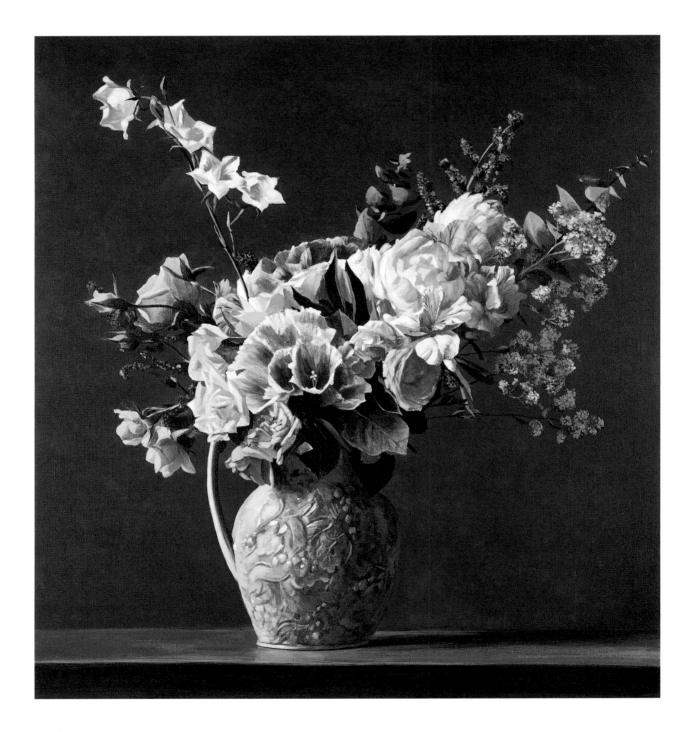

Wedgwood
1993. Acrylic on linen,
30 x 32 inches.
Private collection

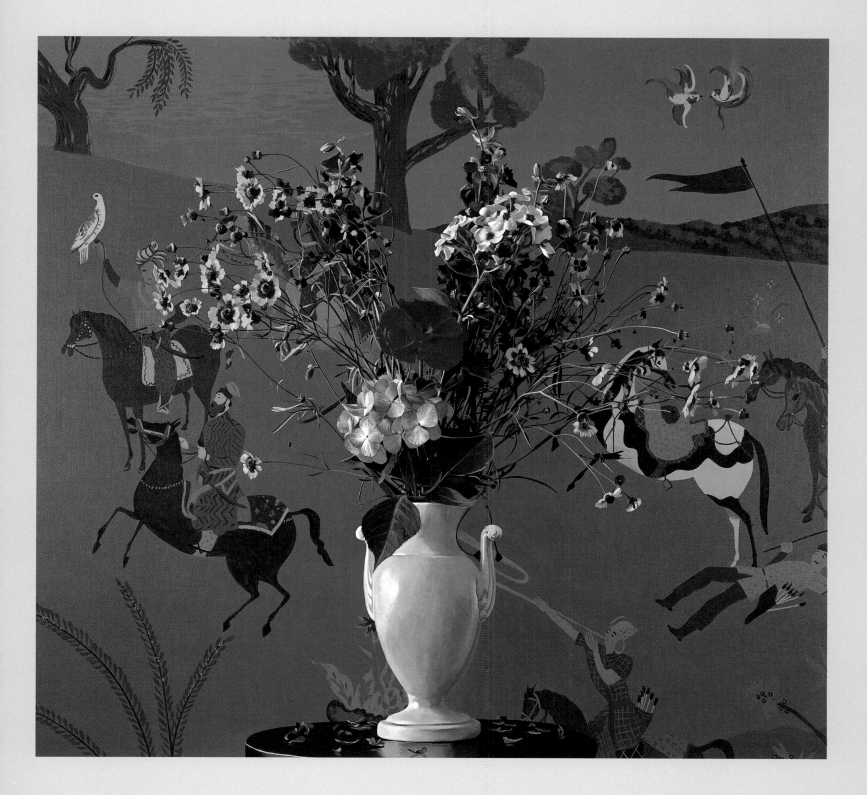

Lakeville
1994. Acrylic on canvas,
60 x 66 inches.
Cecil Rudnick,
Palm Beach, Florida

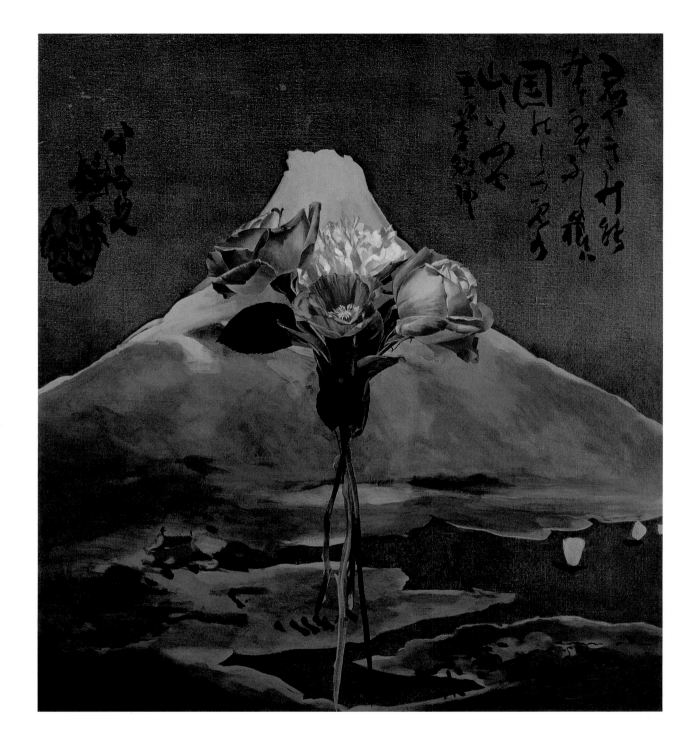

Flowers with Tessai Fuji
1995. Acrylic on canvas,
48 x 44 inches.
Private collection

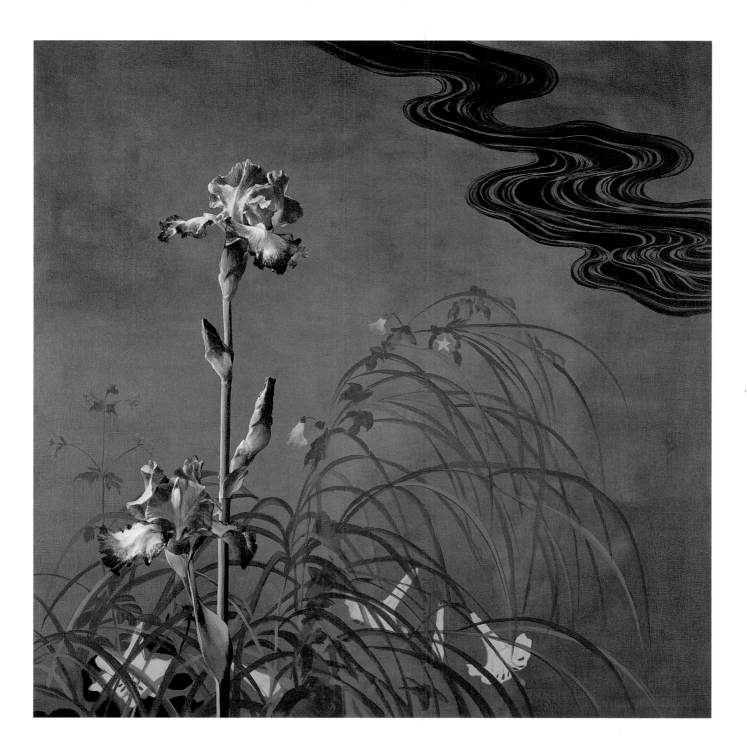

Iris Edo
1997. Acrylic on linen,
54 x 54 inches.
Collection Dr. and Mrs.
Walter Wenninger
Leverkusen, Germany

Our Family Vase
1997. Acrylic on linen,
30 x 36 inches.
Private collection

Taupe Spring
2000. Acrylic on linen,
48 x 54 inches.
Private collection

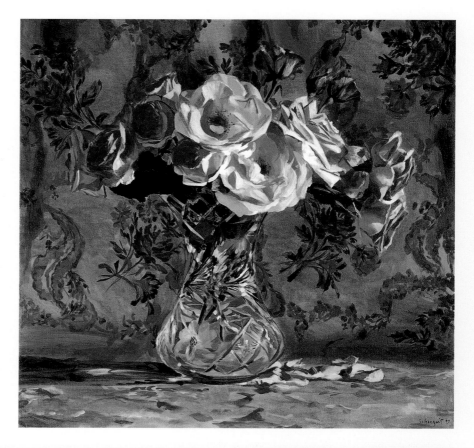

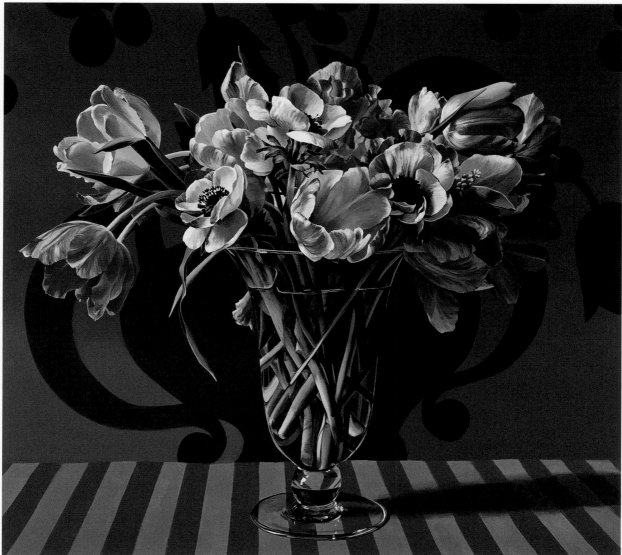

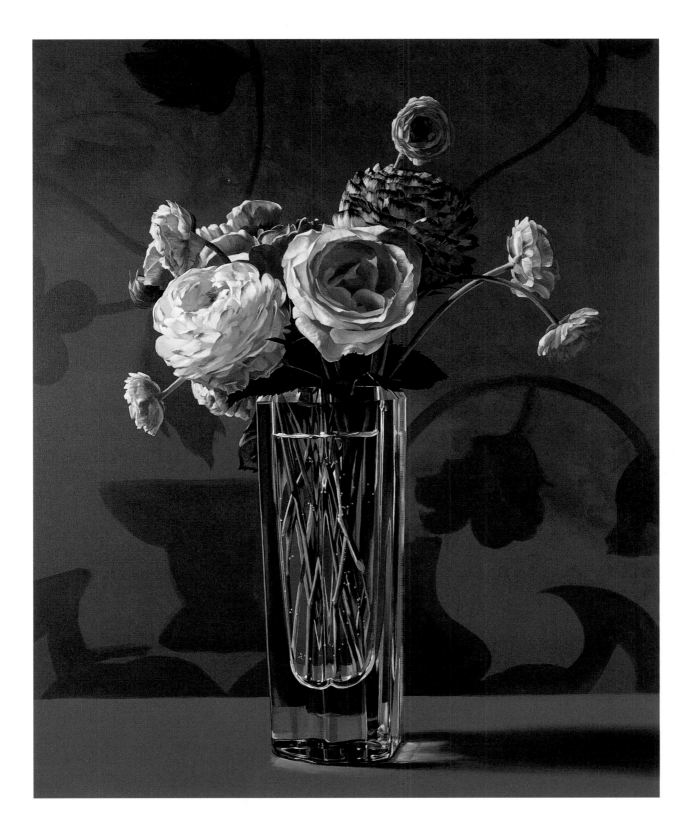

Crystal Rose
1997. Acrylic on linen,
66 x 54 inches.
Gerald Peters Gallery,
Santa Fe, New Mexico

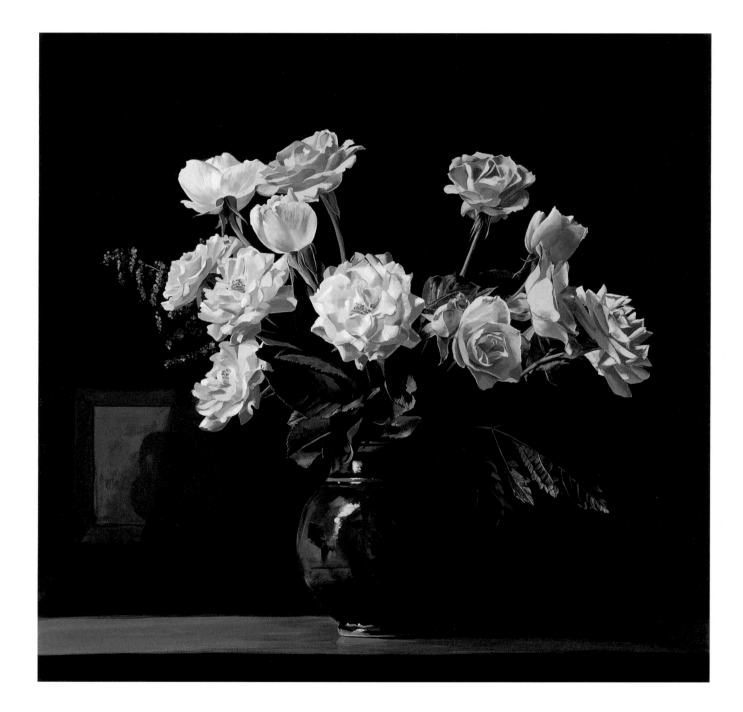

Olive Vase
1988. Acrylic on linen,
48 x 50 inches.
Collection Mr. and Mrs. David Goodman,
Mequon, Wisconsin

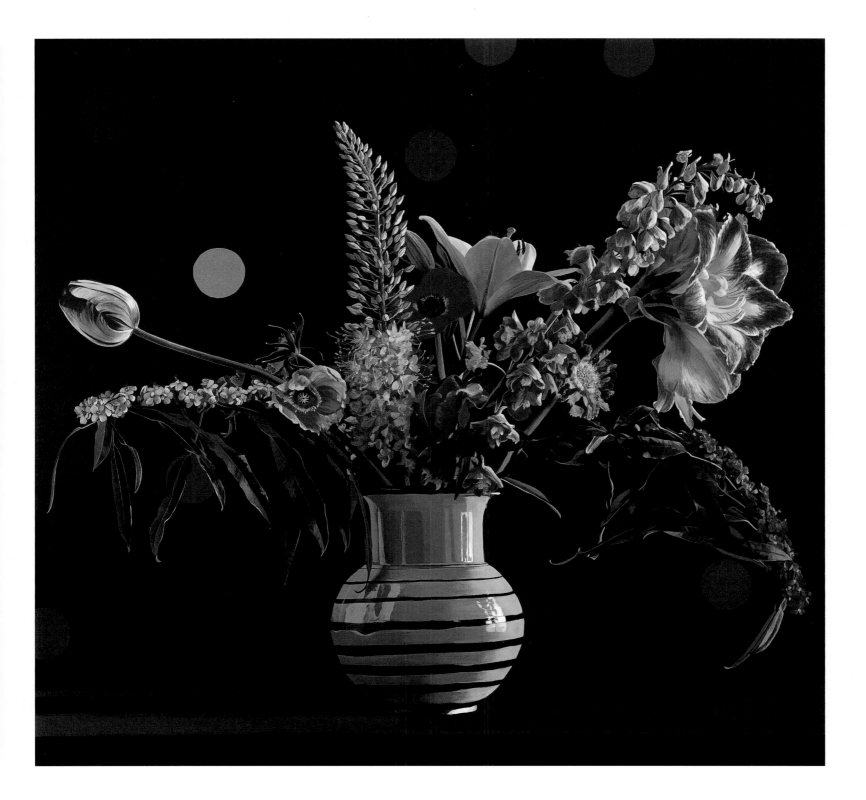

Designer Dots
1999. Acrylic on linen,
72 x 78 inches.
Collection Dan and Lenora Goldman,
Pennsylvania

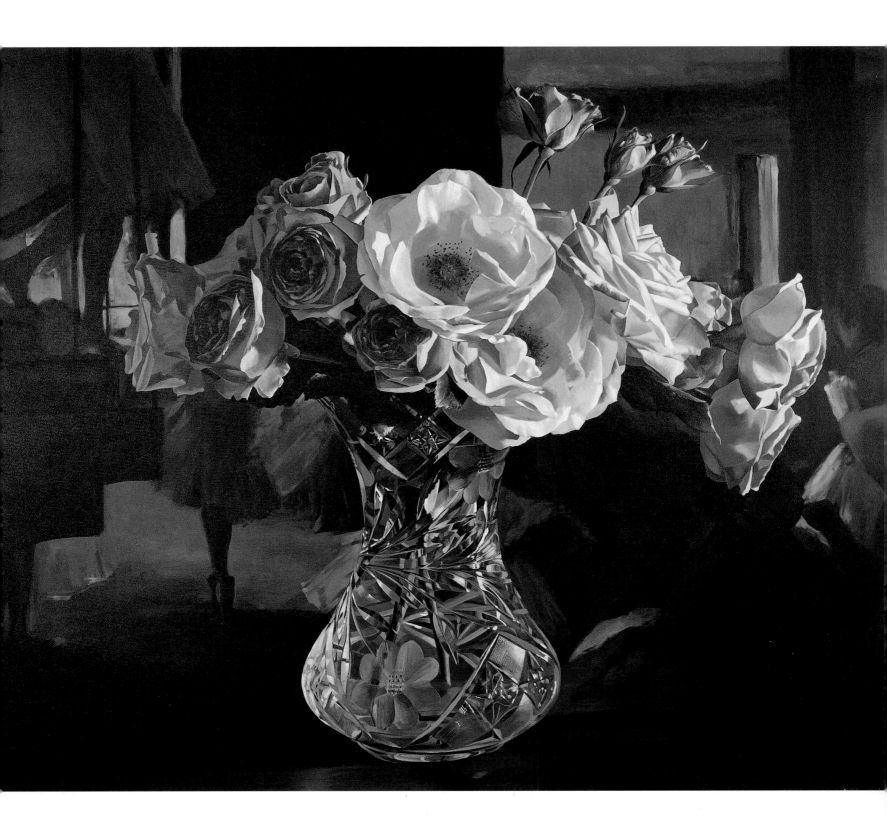

Cut Glass Degas
1997. Acrylic on linen,
78 x 96 inches.
Collection Allen and Cynthia Simon,
Delray Beach, Florida

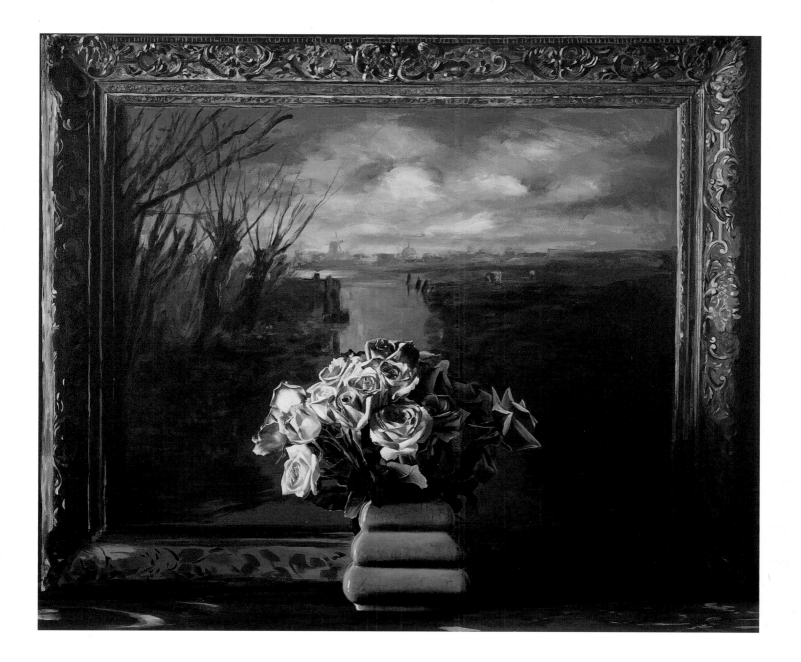

Roses with Dutch Landscape
1989. Acrylic on linen,
68 x 84 inches.
Private collection,
Denver, Colorado

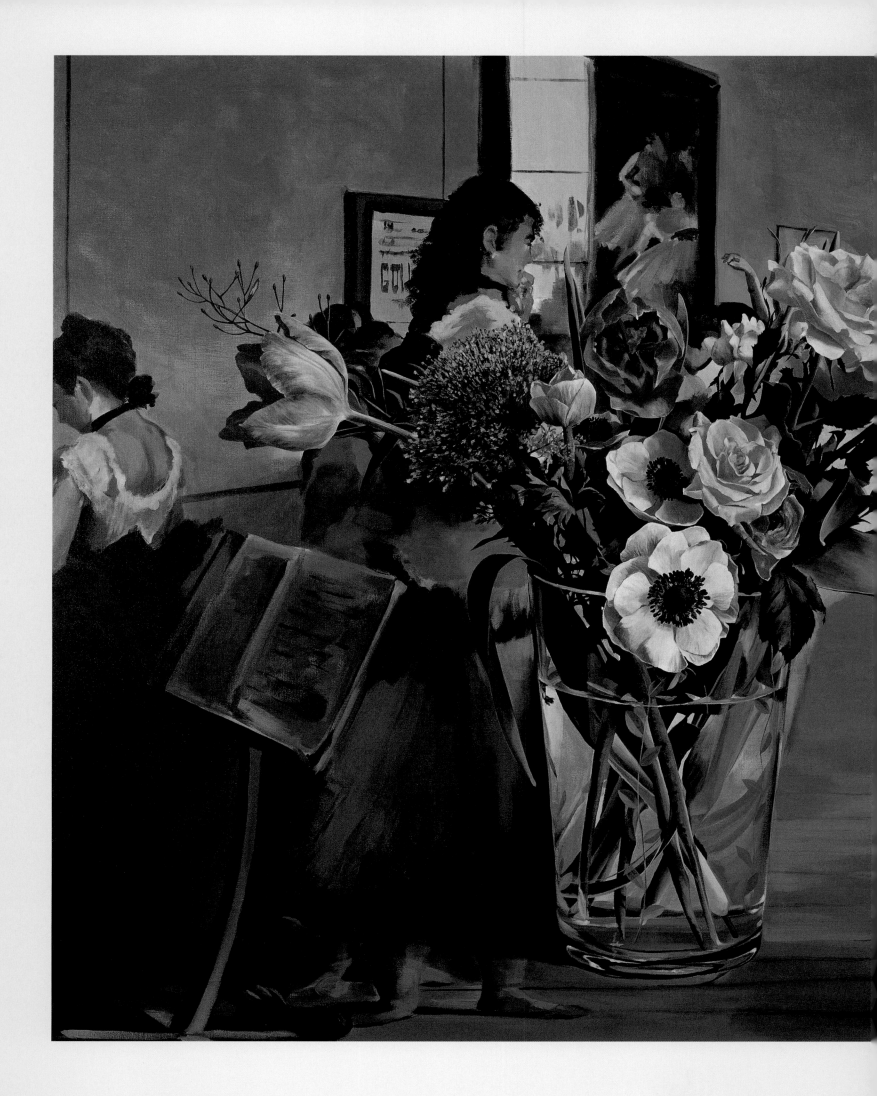

97

Ballet Master I
1997. Acrylic on linen,
68 x 84 inches.
Collection Lloyd and Candace Ruskin,
Miami Beach, Florida

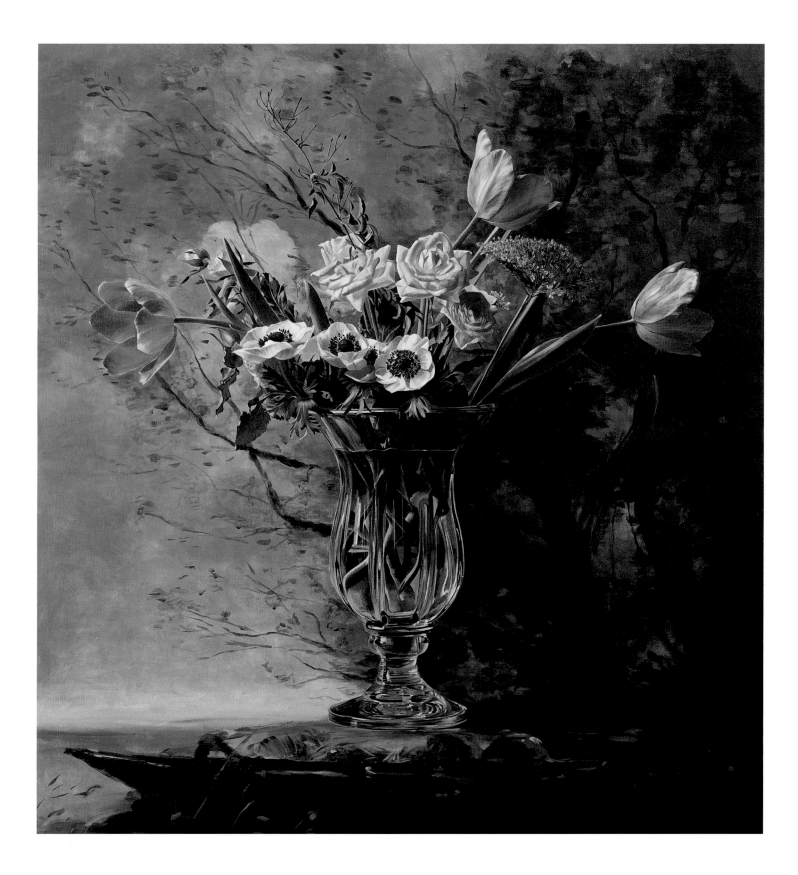

Bent Corot

1997. Acrylic on linen,

72 x 66 inches.

Collection Mr. and Mrs. Richard Luneberg,

Greenwich, Connecticut

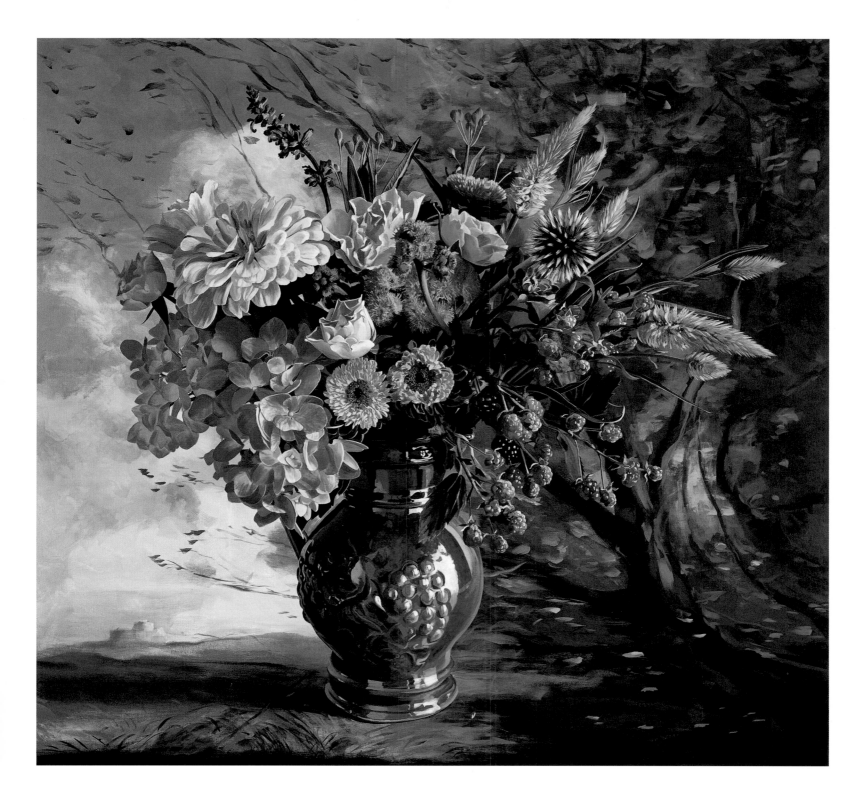

Classic Dutch
1999. Acrylic on canvas,
66 x 72 inches.
Collection Irving and Elaine Baker,
Boca Raton, Florida

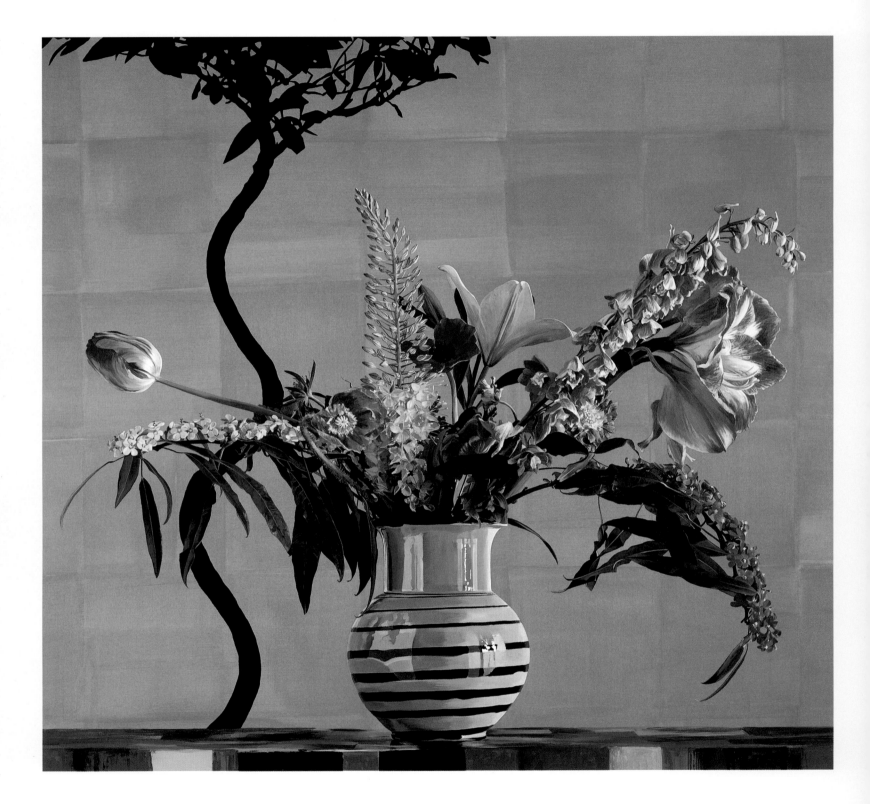

Danish Gold
1998. Acrylic on linen,
72 x 78 inches.
Collection The Finova Group, Inc.,
Arlington, Texas

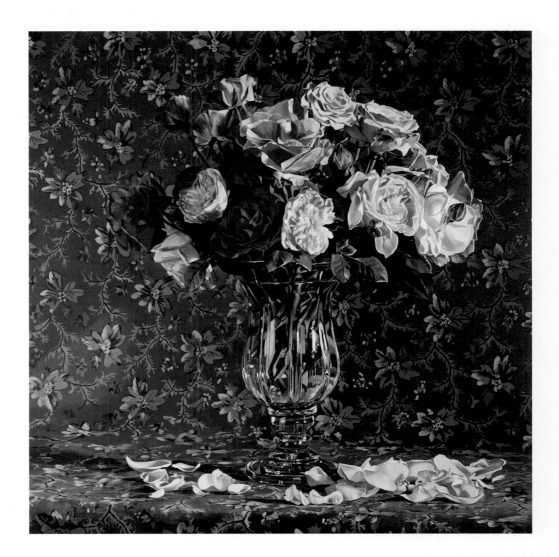

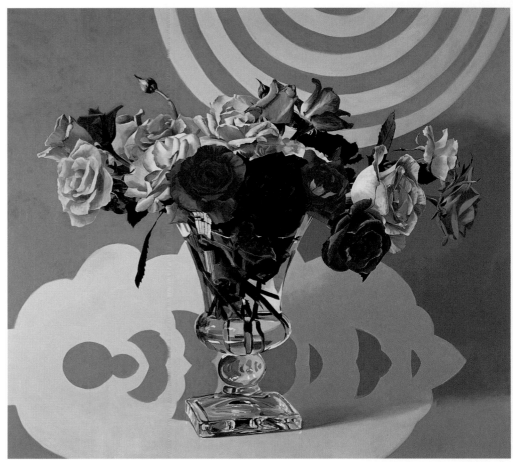

Primary Provençal
2000. Acrylic on canvas,
48 x 48 inches.
Mr. and Mrs. Harry Olstein,
Boca Raton, Florida

Various Roses on Yellow
2000. Acrylic on linen,
48 x 54 inches.
Elaine Baker Gallery,
Boca Raton, Florida

Flute Lucca
2000. Acrylic on linen,
54 x 54 inches.
Collection Dr. and Mrs. Walter
Wenninger,
Bayerwerk, Germany

OPPOSITE:
Dances
1999. Acrylic on linen,
66 x 96 inches.
Collection Kenneth and Sheri Sack,
Boca Raton, Florida

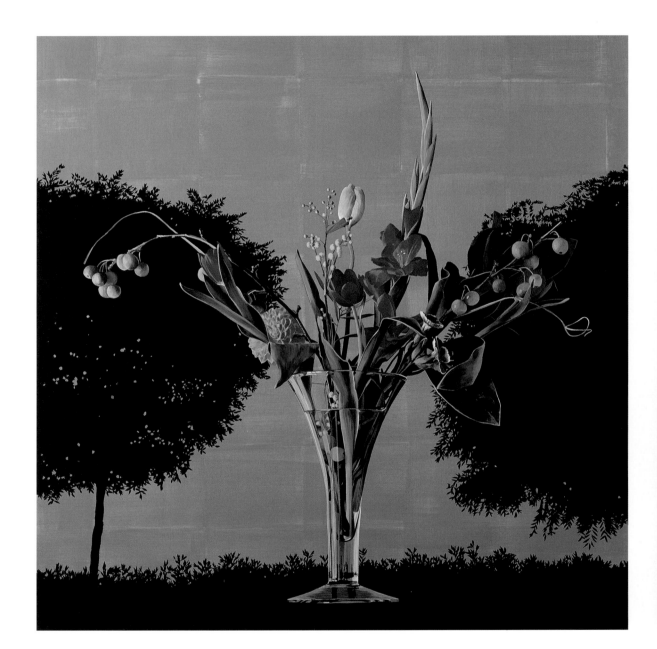

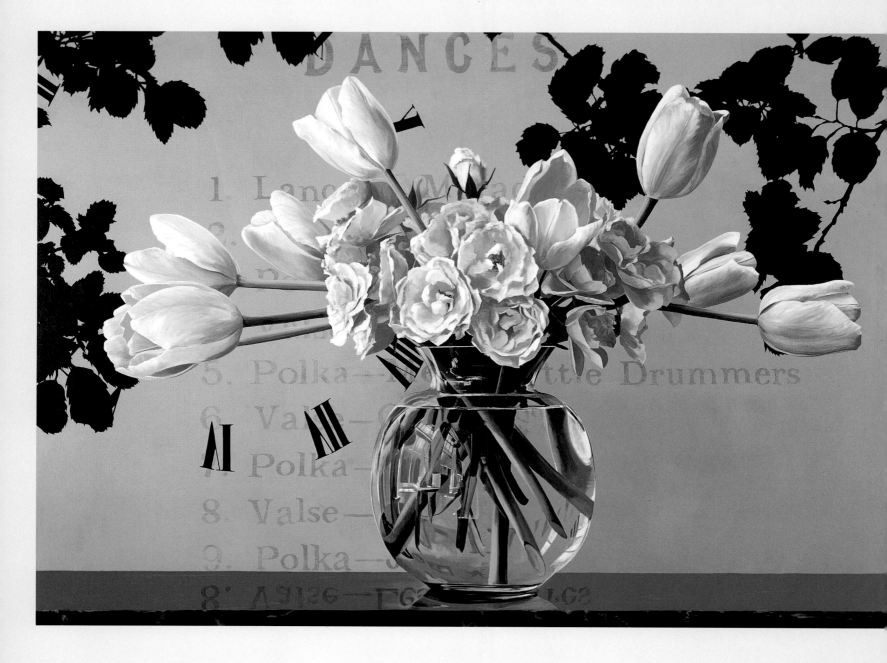

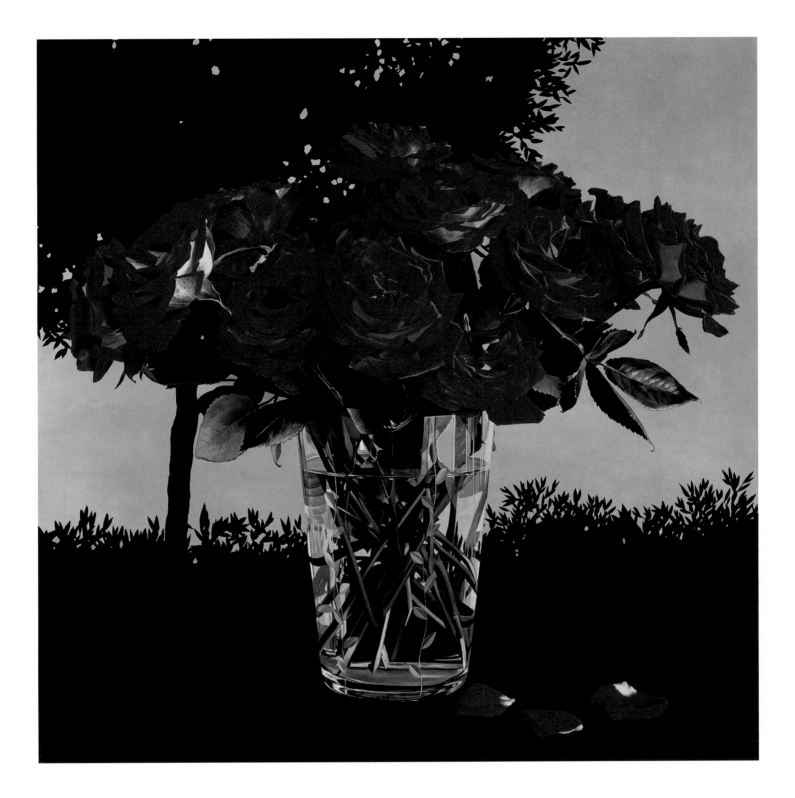

104

Lucca Rose
2000. Acrylic on linen,
72 x 72 inches.
Elaine Baker Gallery,
Boca Raton, Florida

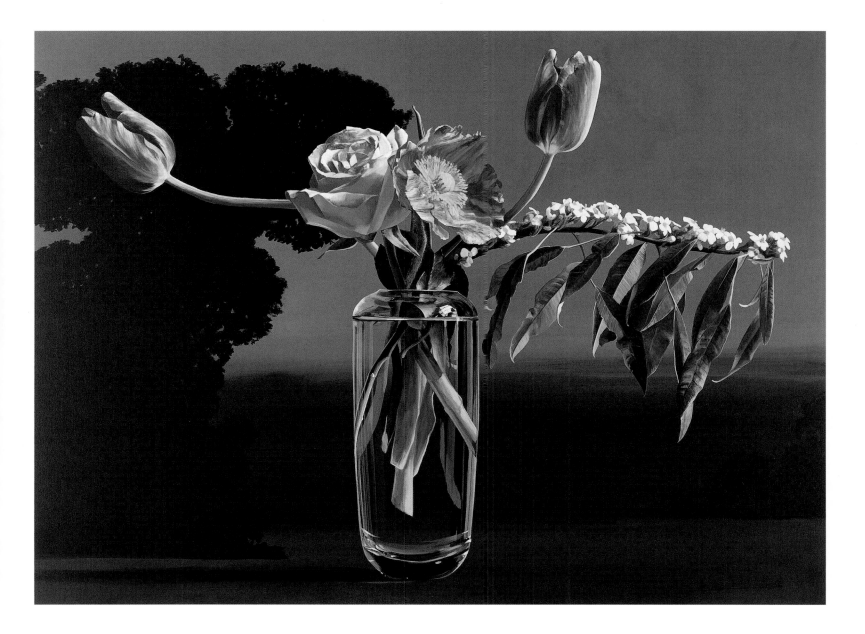

Flowers on Gray
2000. Acrylic on linen,
48 x 66 inches.
Collection Dr. and Mrs. Marvin Goldberg,
Boca Raton, Florida

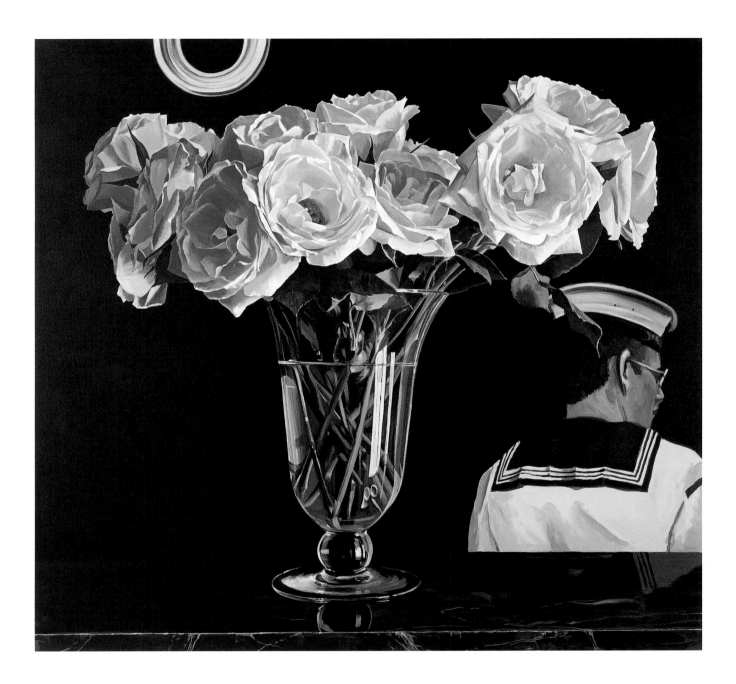

White Roses on Black
2000. Acrylic on linen,
44 x 48 inches.
Collection Mr. and Mrs. Isaac Sudit,
Calabasas, California

OPPOSITE:
Flowers with Open Arms
1999. Acrylic on linen,
72 x 60 inches.
Collection David and Ruthann Beckerman,
Boca Raton, Florida

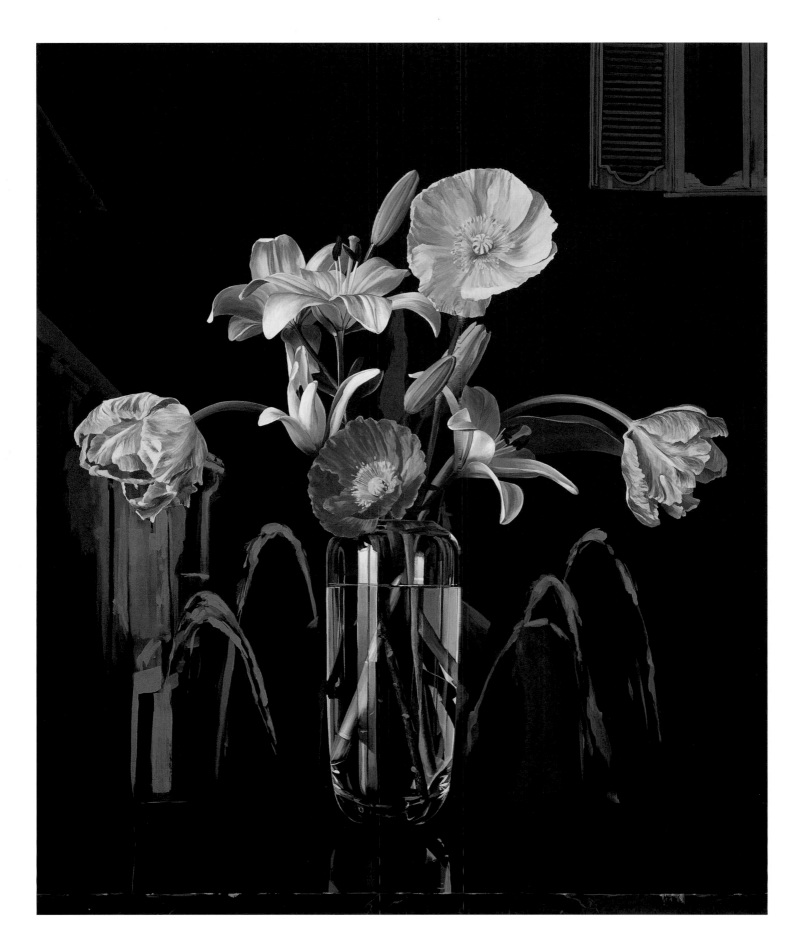

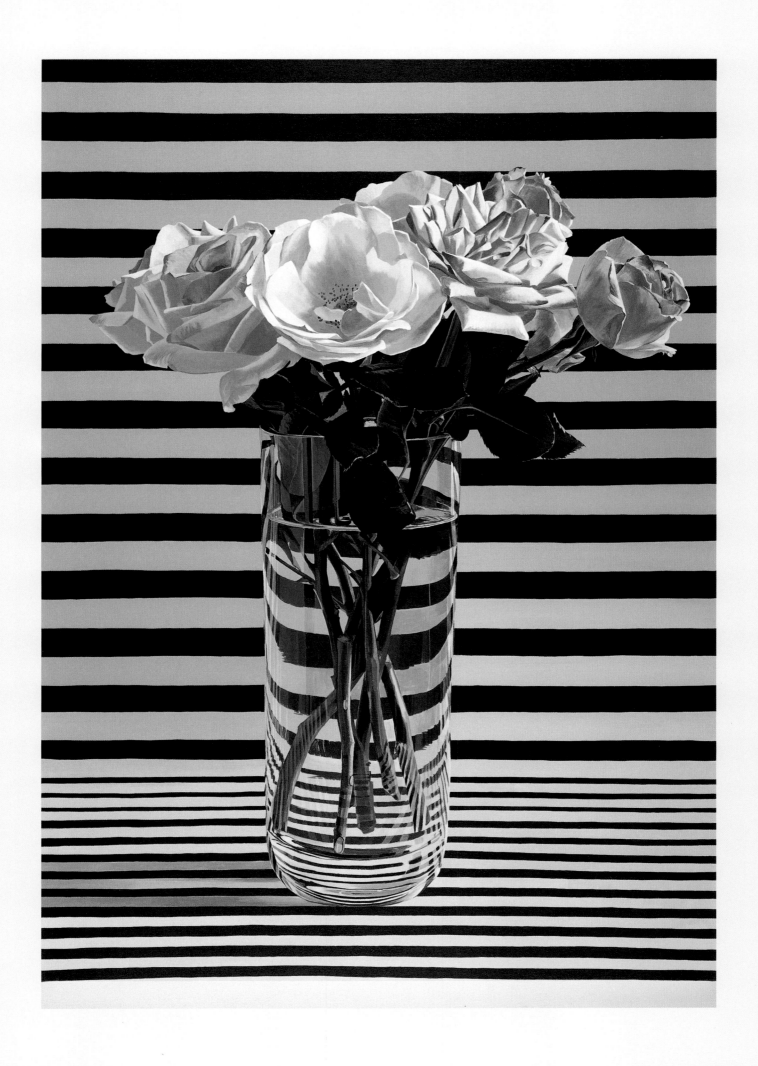

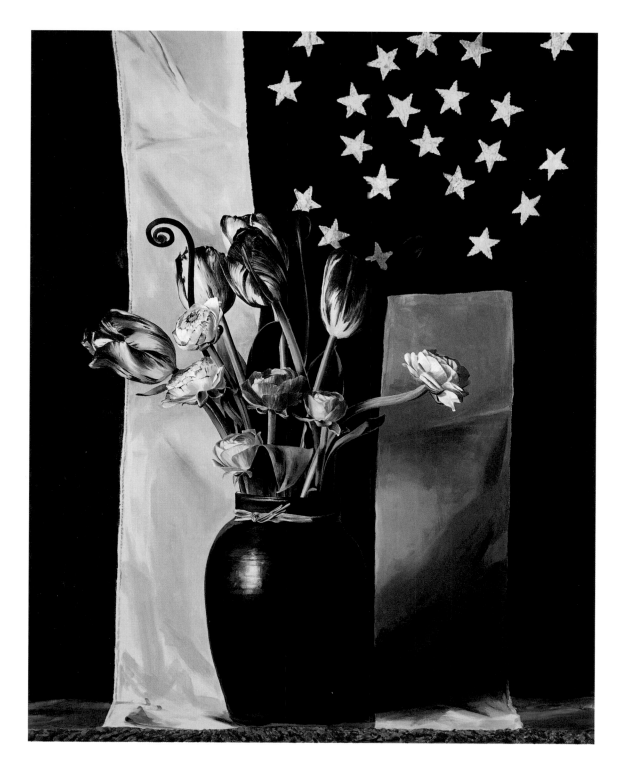

OPPOSITE:
Striped Chintz Rose
1992. Acrylic on linen,
50 x 40 inches.
Private collection

ABOVE:
Stars and Stripes
1992. Acrylic on linen,
50 x 40 inches.
Collection Dr. and Mrs. Walter Wenninger,
Leverkusen, Germany

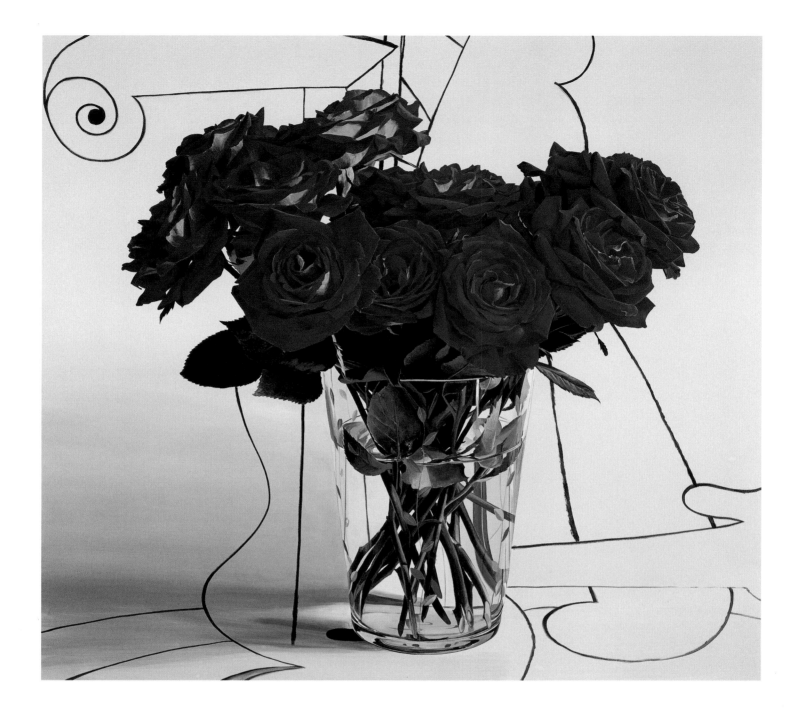

Pink Delight
1998. Acrylic on linen,
60 x 54 inches.
Collection Mr. and Mrs. Jerry M. Meyer

Amaryllis with Tie
2000. Acrylic on linen,
78 x 36 inches.
Collection Mr. and Mrs. Allan Wilson,
Coral Gables, Florida

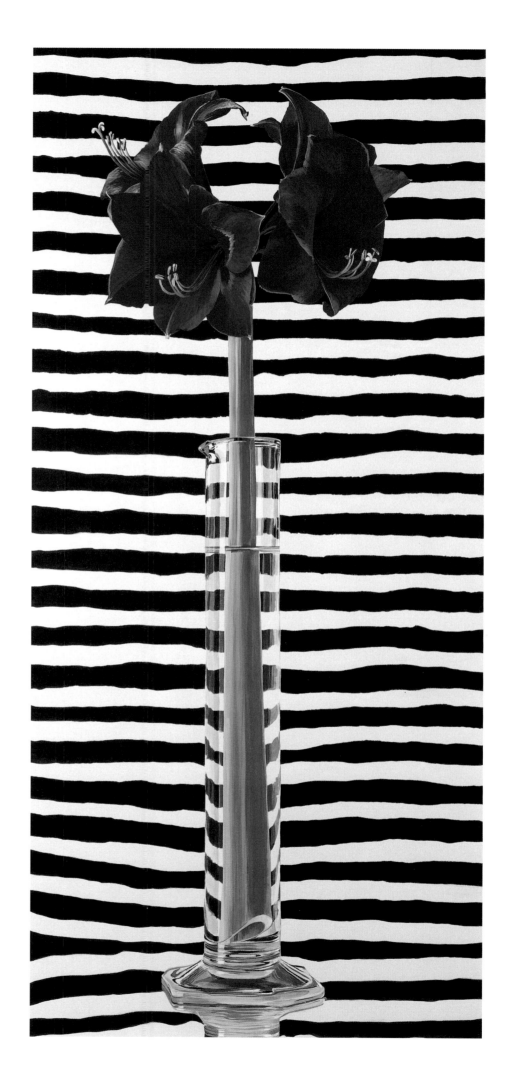

V. The FOUR SEASONS and the BLACK PAINTINGS

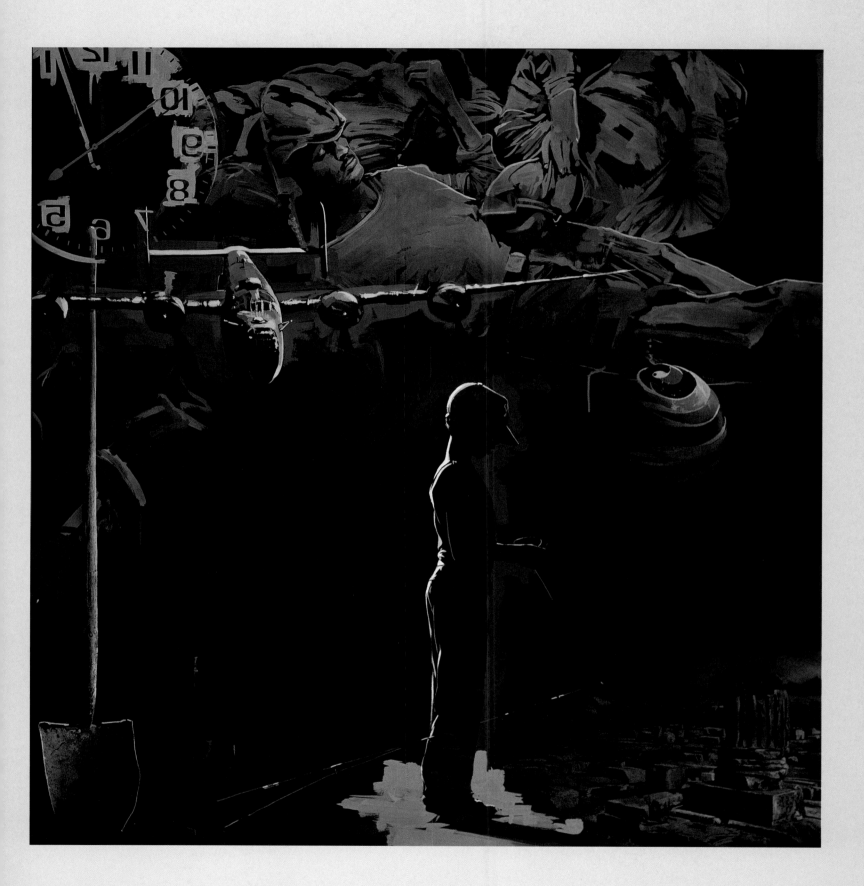

V. The FOUR SEASONS and the BLACK PAINTINGS

On the surface, without the contextual information regarding the artist's mother, the fabulous flower paintings are anything but tragic. They gave rise to a series of gently lyrical paintings on the age-old theme of the four seasons. Inspired in part by a trip to Japan, where the calligraphic aspect of his deft hand found hospitable surroundings, and in part by the serendipitous rediscovery of metallic paints that had been in the studio since his Stella-esque experiments of the 1960s, this elegant group of flowing images, some floral, others architectural and ornamental, against shimmering Japanese-style shingles of gold and silver, abides by the compositional principle Schonzeit has described as peripheral, having to do with his narrative work.

A darker side of this same type of peripheral compositions emerges in the grisaille works, many autobiographical, that plumb the feelings of mortality he precociously gained, in part from his early eye injury. The hallmark of not just seriousness but also of depth in the arts throughout the ages has been the artist's capacity to handle tragedy. Despite their optical darkness, the black paintings retain the lightness, the floating quality, that all Schonzeit's paintings breathe.

The imagery of the black paintings starkly links youth and old age. Among the dramatis personae are both his father, in **Man and Boy**, and his mother, in **Goldye and the Gardener** (both opposite), along with autobiographical figures of a young boy fishing, the milky filaments of his line mapping the other characters like constellations against velvety blue-blacks and deep grays. They appear weightless in this world of the superimposed, the still-photographically based, the overtly cinematic. The easy way out would be to call them Surreal, but Schonzeit, an astute art historian in his own right, begs to differ:

Surreal painting runs parallel to reality. Very realistic, but with weird twists. What I do involves the manipulation of images—exploring their abstract potential in relation to the activity in abstract and nonobjective painting to date. Realistic painting does not interest me very much. I am often seen in a realistic context, for obvious reasons, but my paintings make a totally different kind of sense. What I am putting out is not a picture with things stuck in front of it, but an attempt to see what can be done with design, color, subject, painting that has not yet been explored. Painting has gone all over the place while realists are still painting rooms. The way the world looks has

PREVIOUS PAGE:
From Inside the Clock
1983. Acrylic on paper,
48 x 48 inches.
Collection Allen and Vicki Samson,
Milwaukee, Wisconsin

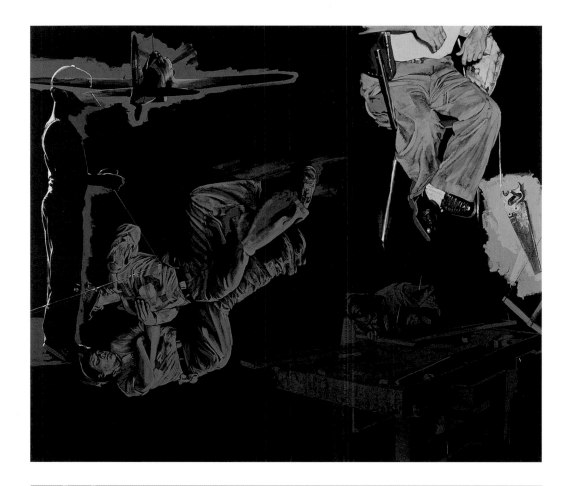

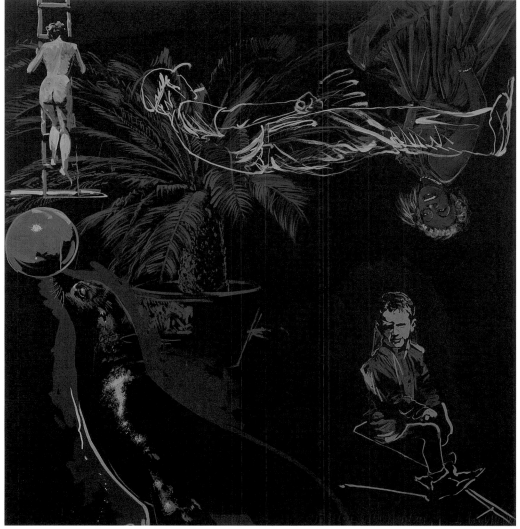

Man and Boy
1983. Acrylic on canvas,
66 x 78 inches.
Collection the artist

Goldye and the Gardener
1982. Acrylic on paper,
49½ x 47½ inches.
Collection the artist

nothing to do with the way paintings look or should look. How does one establish space? There's perspective. I never use it. There is scale. I never use it that way. Then there is focus. That I fool with most of the time. I work with relative resolution most of the time.

Some of the black paintings are starkly open, even empty (**Antibes**, below), while others flicker luxuriously with incident (**Perfect Partner**, p. 11). All have the emergent quality of memory. The artist traces part of their psychological impact to the lifelong imprint of his early encounter with danger:

In a way, all painting is from memory; sometimes for a few seconds and at other times from the distant past. We artists are training our memory when we draw from the model, still life, life. For me, the excitement comes from the connections between memory and the concrete present, the blending of the imagination and immediate experience. This gives life, life that seems so much fantasy and memory anyway. I was a very grown-up child. I think that losing my eye at such an early age demanded a kind of maturity I would like to have avoided. Most people don't have to deal with this until they are adults, usually when one's parents are lost, but a life-threatening accident in childhood can do it. I compare it to Captain Hook in PETER PAN. That alligator is coming back for more until he gets all of you, part by part. The body is not going to be with you forever.

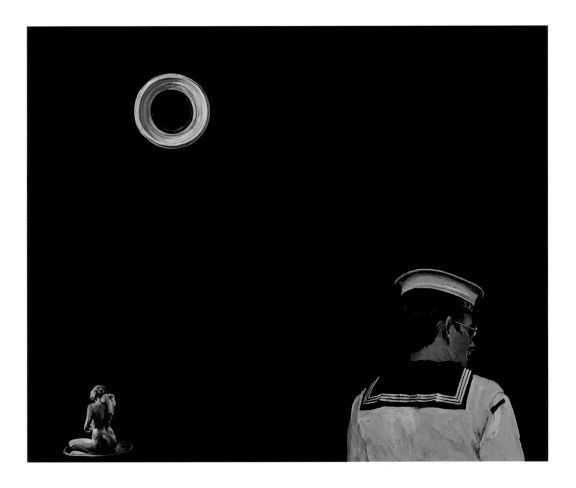

The proliferation not only of scenes but of styles has become an aggregate source of new material for Schonzeit in his most recent work. The only thing he seems to have discarded along the way is the airbrush. Everything else is in play, with additions made constantly, so that a day-to-day visitor to the studio is continually astonished to see what pops up in a work in progress between visits. Against a luscious gold ground, in the shade of a Parisian tower, a martini glass with an olive will flicker. The light of the slide projector is switched off and it vanishes for the moment, but by the next day it may be fixed in paint. The repertoire only grows under double doses of memory and fresh inspiration. An evolving liberty of brushwork is reviving a bit of that old Abstract Expressionist feeling in some recent works. If anything, the photographic stage of his process has become more picturesque, less a matter of chance:

I take more control of my images. Photographs are made, planned, and structured around an idea about the work I want. Compositions come from ideas I have and are realized in single photographs to make the still lifes. While I photograph, I look for paintings in the subjects I choose. At times I take photos that look like paintings, except the paintings I am thinking about are Rothkos and Mondrians. It is as if time is messed up with the camera, trapped in limbo, to be later released in paint, in its re-assembly and creation.

If anything, Schonzeit in the twenty-first century, unlike so many artists who look wistfully back upon their earliest years as their most fruitful, is blessed with the fascinating quandary of how to sustain several careers at once. In retrospect, he is proud of the various directions he has taken: "I wear my scars and missteps proudly, and value the path (paths) I have taken."

Like the simultaneity that makes his narrative paintings so intriguingly fugal, his studio shuttle between the centered and the peripheral, the chromatic and grisaille, memory and desire, is a dynamic realm of the utterly unexpected. It is all magic. In a letter to Jane Lahr, a friend and the daughter of the actor Bert Lahr, he wrote (and note the word "audience"): "To be an artist is like being a priest, rabbi, or some kind of holy person, an expert in another language obscure and rarely focused on. Experts in what is not seen, the invisible. We illuminate, coax one into another plane, awareness, feeling, a sense of this experience. Certainly there is a lot of hocus pocus, sleight of hand, all to the end of illumination, of insight. Our aim is to give the audience a heightened awareness of the now, of being alive. That is the difference between paintings and wallpaper. I use my own work as ornament. As decorative background, just as paintings become decorative backgrounds in our lives. What do they give you?"

OPPOSITE:
Antibes
1999. Acrylic on linen,
30 x 36 inches.
Private collection

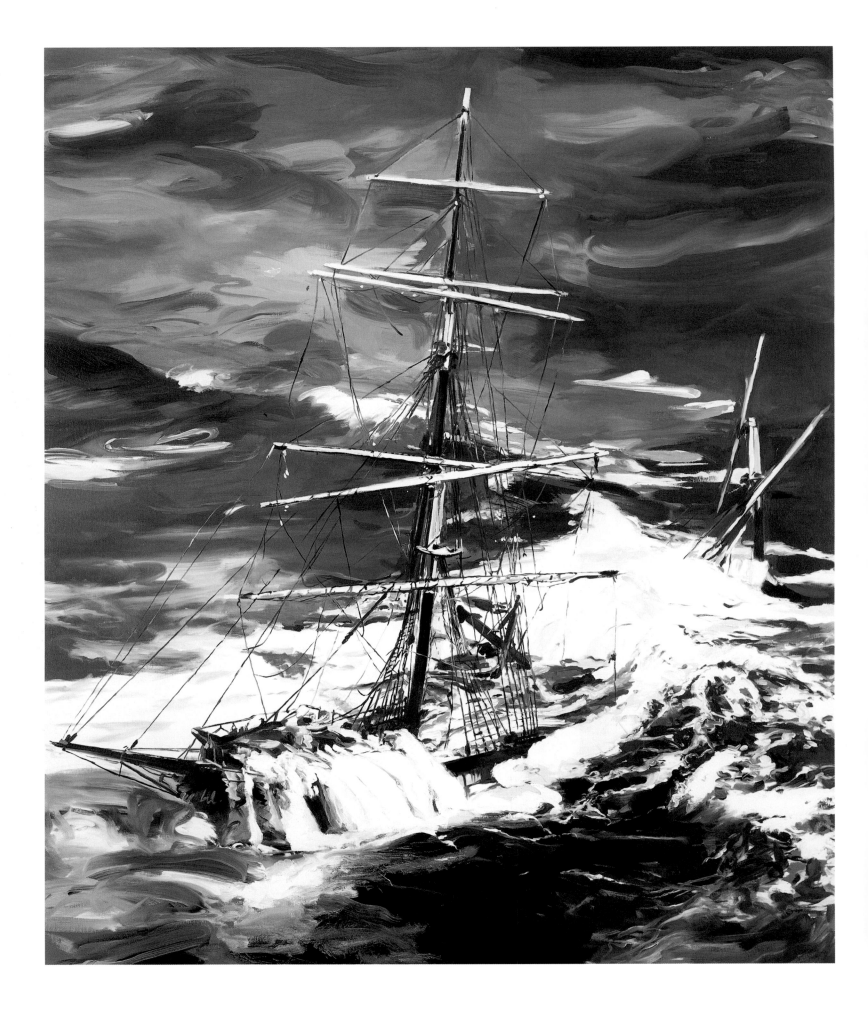

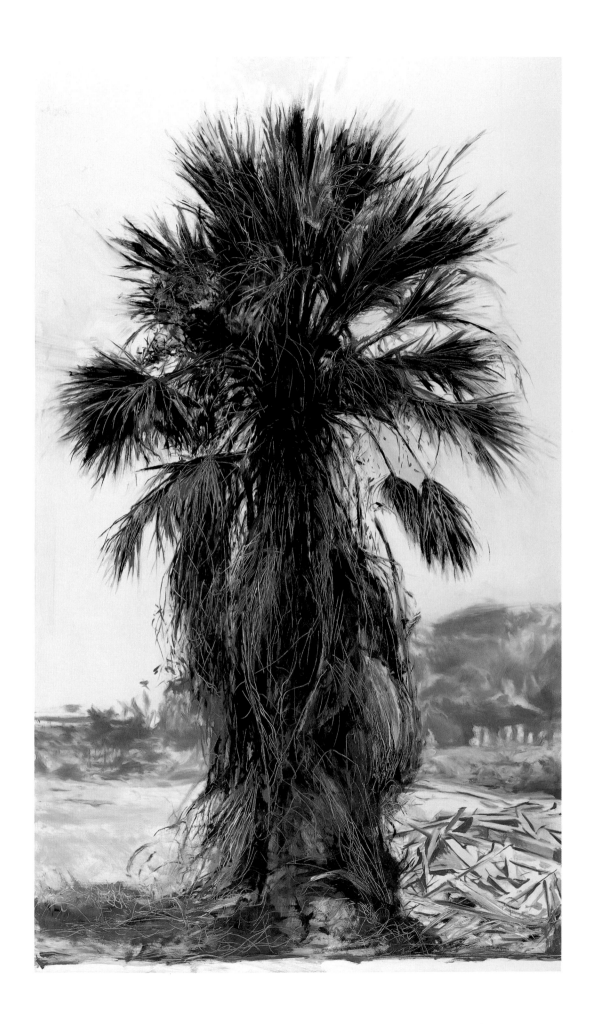

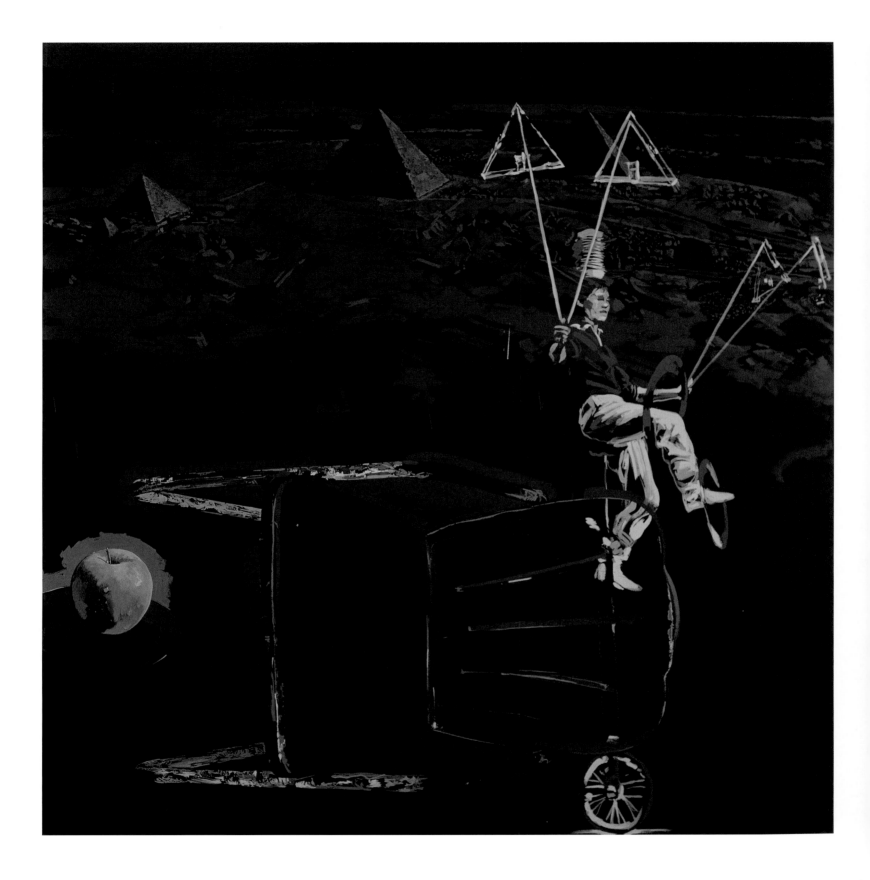

Pyramid
1983. Acrylic on linen,
72 x 72 inches.
Collection the artist

ABOVE:
Cross Currents
1979. Oil on linen,
30 x 55 inches.
Private collection,
Cologne, Germany

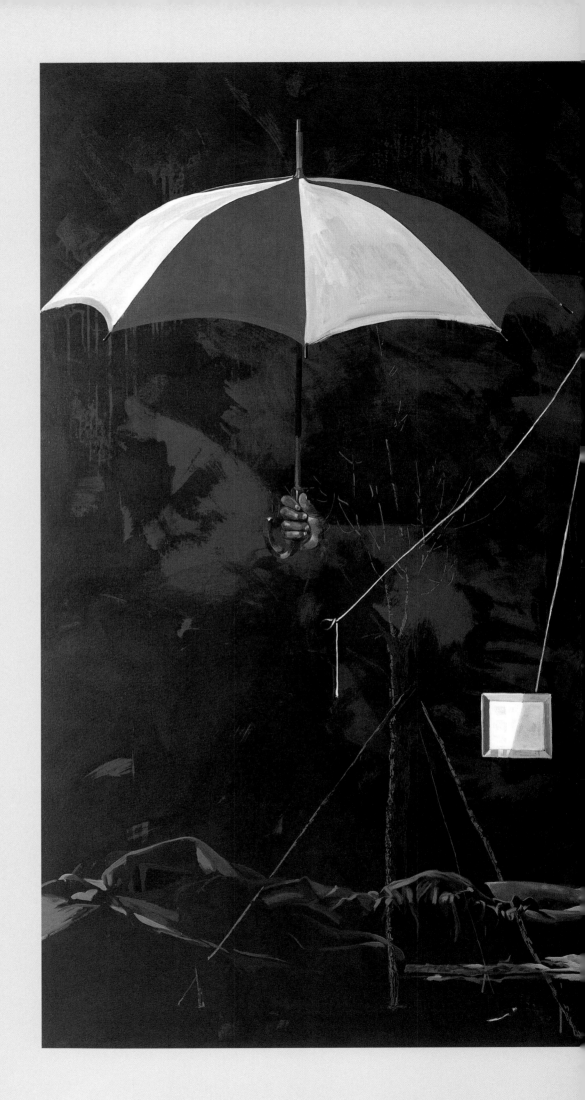

Shade
1983. Acrylic on linen,
76 x 90 inches.
Collection Neuberger Museum of
Art, Purchase College,
State University of New York.
Gift of Nancy and Alan Manocherian

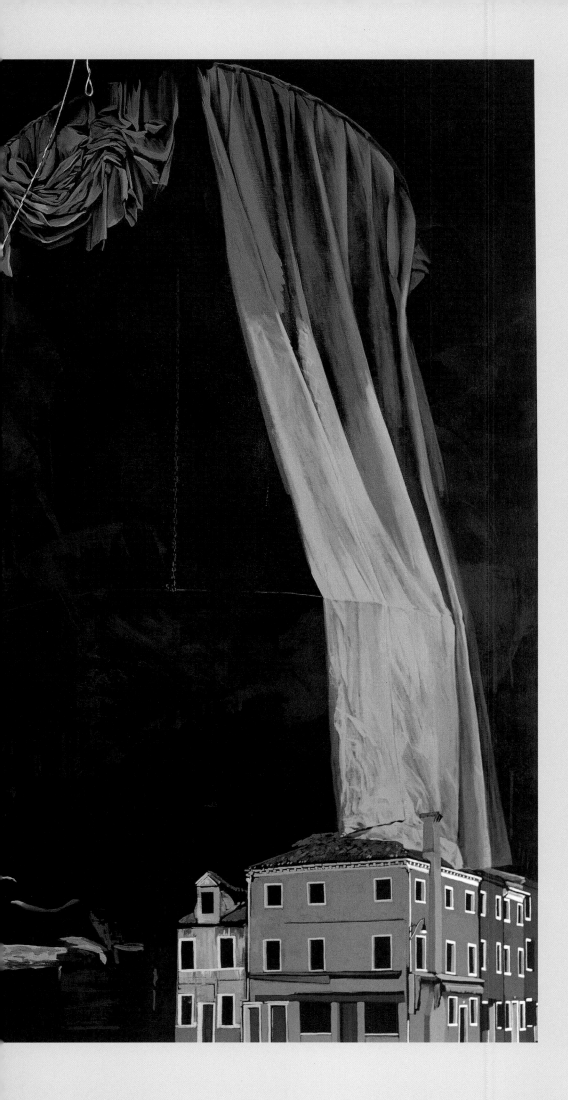

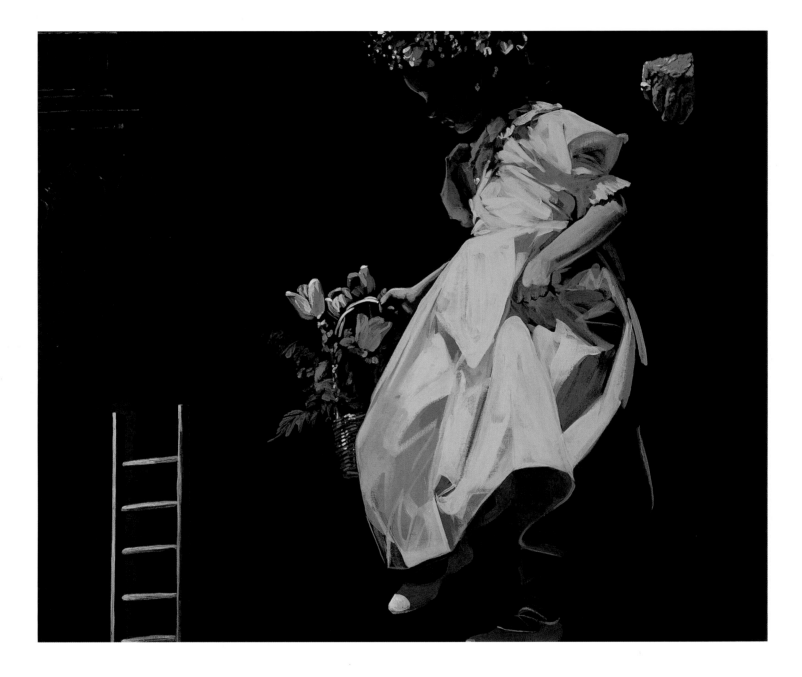

Juliet
1999. Acrylic on linen,
30 x 36 inches.
Collection Marc and Kathleen Chaikin,
Washington, Connecticut

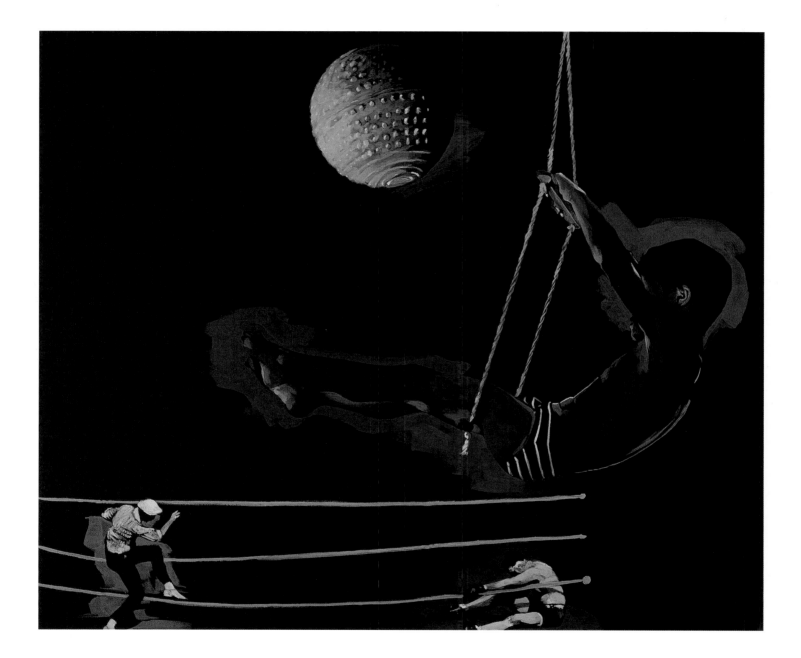

The Ropes
1999. Acrylic on linen,
30 x 36 inches.
Collection the artist

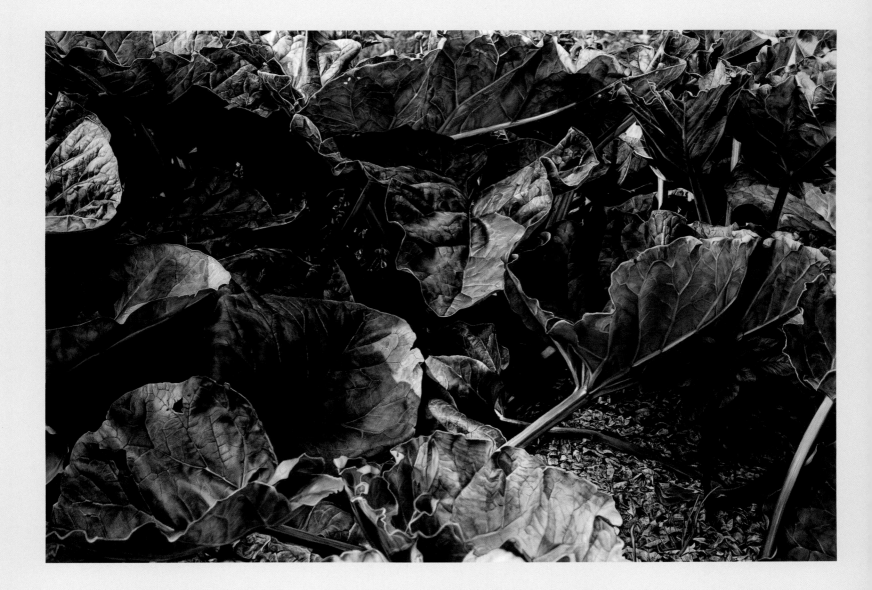

Greenery

1976. Acrylic on canvas,

72 x 108 inches.

Staatliche Museen

Preussischer Kulturbesitz,

Neue Nationalgalerie, Berlin

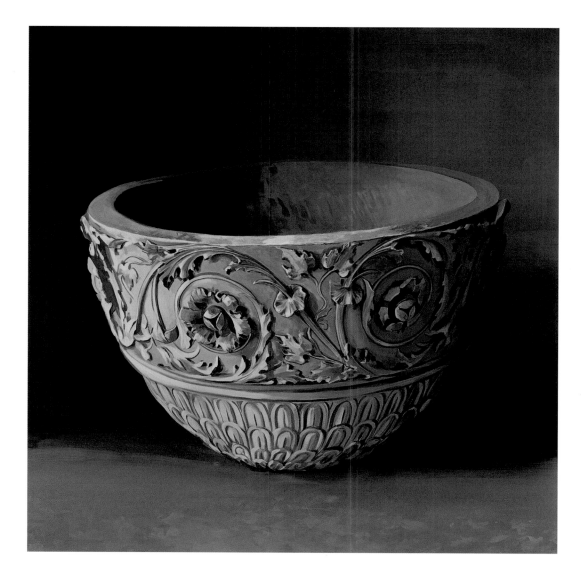

Carved Bowl
2001. Acrylic on linen,
72 x 72 inches.
Bernarducci Meisel Gallery,
New York

The Corn Dancer Swing
1982. Acrylic on paper,
48 x 48 inches.
Private collection

OPPOSITE:
Open Arms
1999. Acrylic on linen,
96 x 54 inches.
Collection Nancy and Alan
Manocherian, Rye, New York

Summer Gold

1999. Acrylic on linen,

44 x 48 inches.

Private collection

Gold Flore Spring

1999. Acrylic on linen,

44 x 48 inches.

Private collection

VI. The GOLD PAINTINGS and AFTER

Winter White Gold
1999. Acrylic on linen,
44 x 48 inches.
Collection Iris Amper Walker,
Pittsburgh, Pennsylvania

Magenta Winter
1999. Acrylic on linen,
44 x 48 inches.
Private collection

Copper Fall
1999. Acrylic on linen,
44 x 48 inches.
Private collection

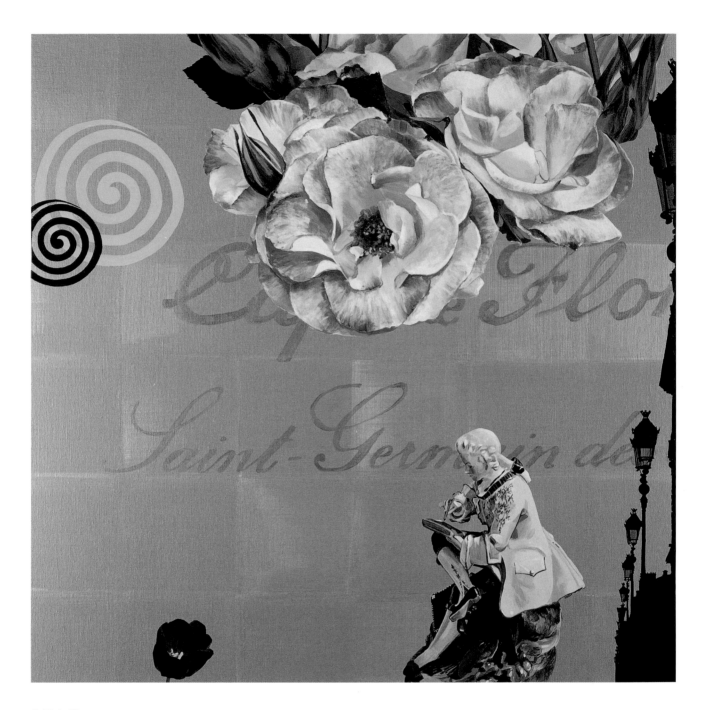

Café de Flore
2000. Acrylic on linen,
39½ x 39½ inches.
Collection Ingrid Wessels,
Santa Cruz de Tenerife,
Canary Islands, Spain

OPPOSITE:
In Paris
2000. Acrylic on linen,
96 x 84 inches.
Elaine Baker Gallery,
Boca Raton, Florida

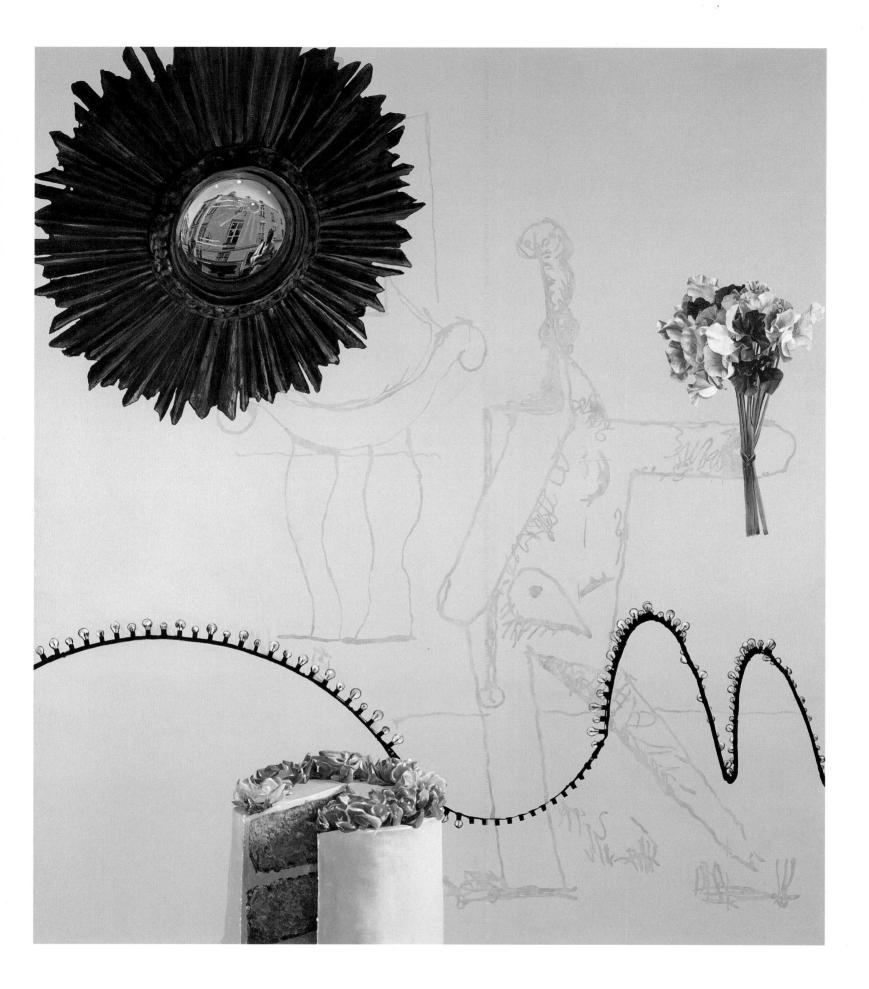

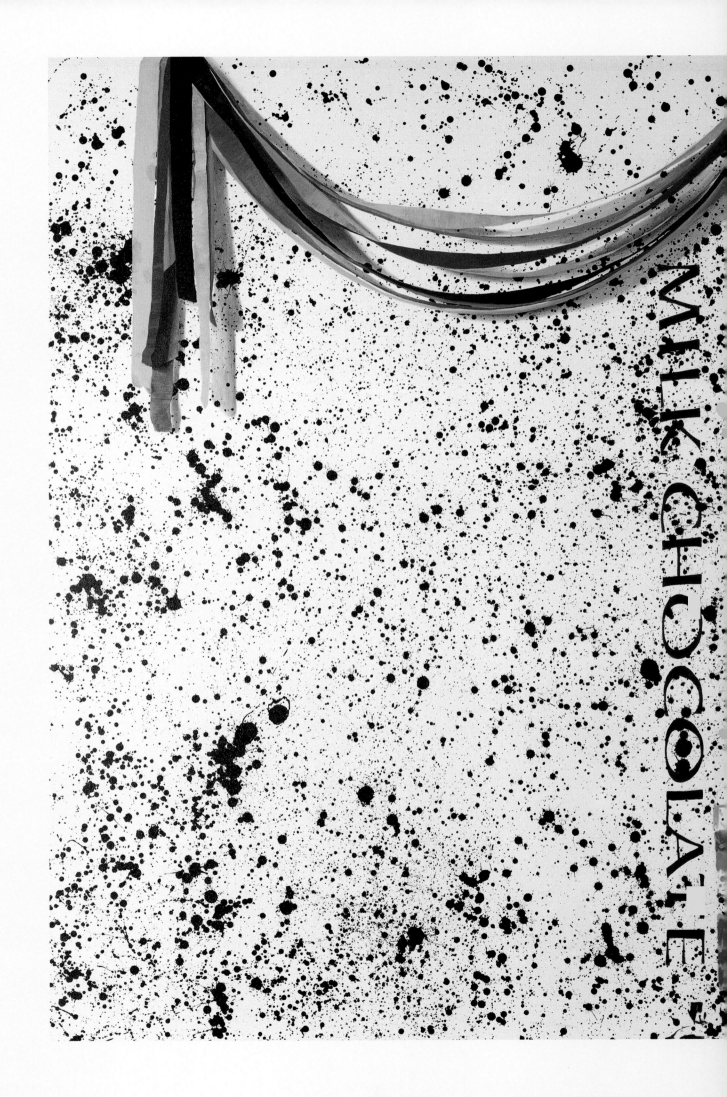

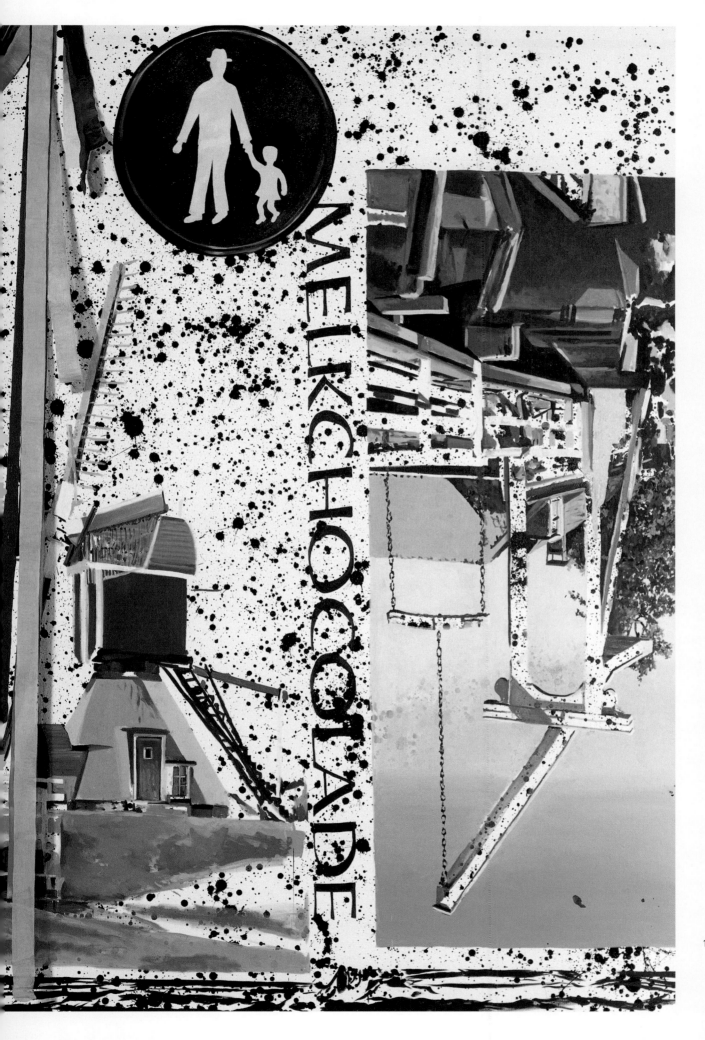

Milk Chocolate
1994. Acrylic and oil on linen,
84 x 120 inches.
Museum Weserburg,
Bremen, Germany.
LaFrenz Collection

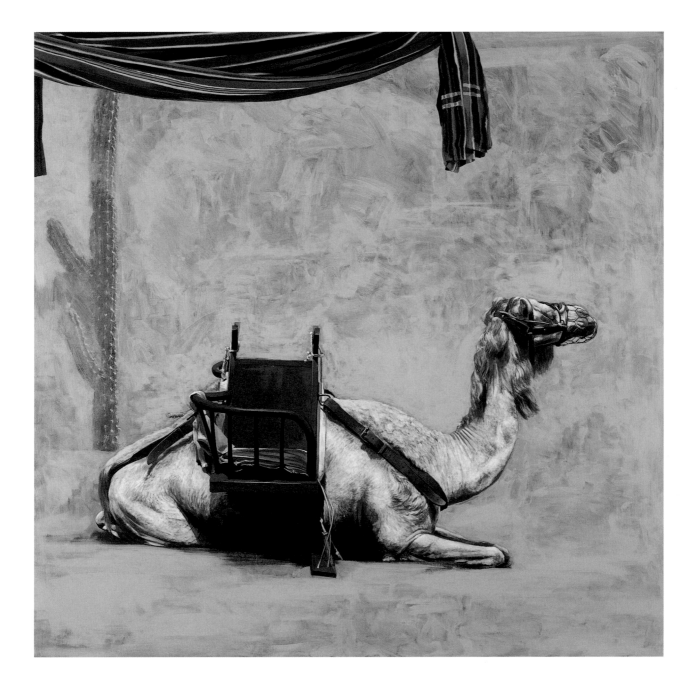

White Camel
1992. Acrylic on linen,
66 x 66 inches.
Collection Dr. and Mrs. Walter Wenninger,
Leverkusen, Germany

Navigation
1991. Acrylic on linen,
66 x 90 inches.
Collection Gina Lin and David Chu,
New York

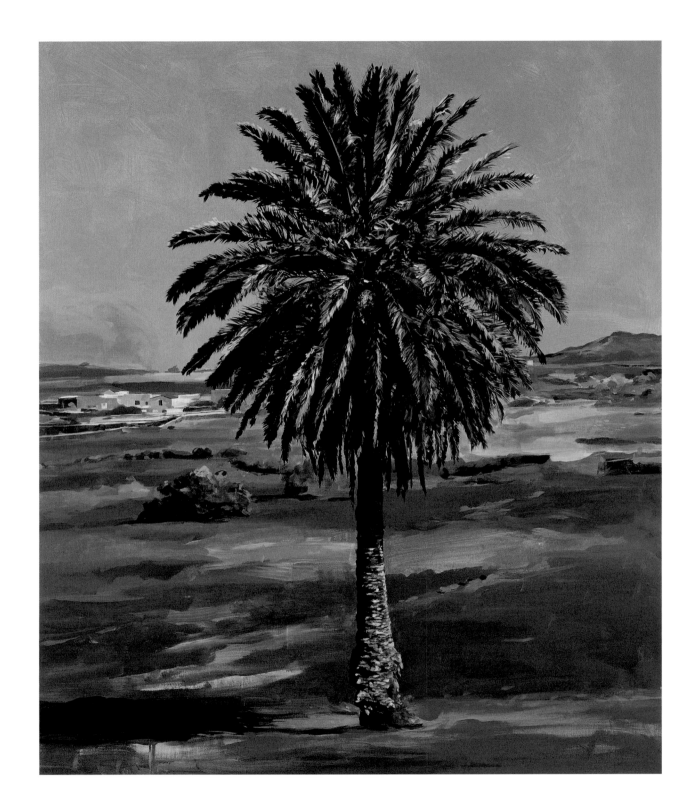

Palm
2001. Acrylic on linen,
78 x 66 inches.
Galería Manuel Ojeda,
Las Palmas de Gran Canaria,
Spain

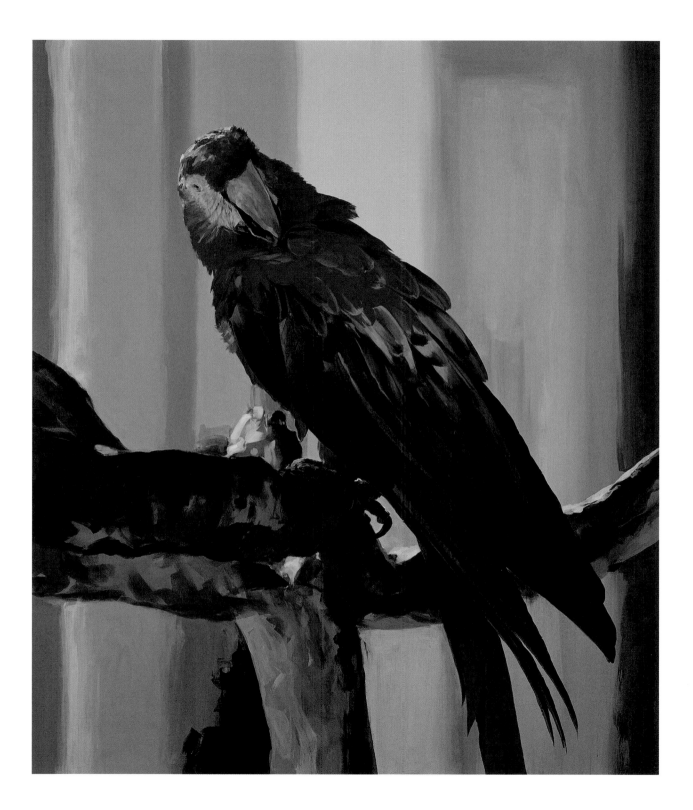

Macaw
2001. Acrylic on linen,
78 x 66 inches.
Collection Hannes and
Susanne von Goessein,
Lanzarote, Spain

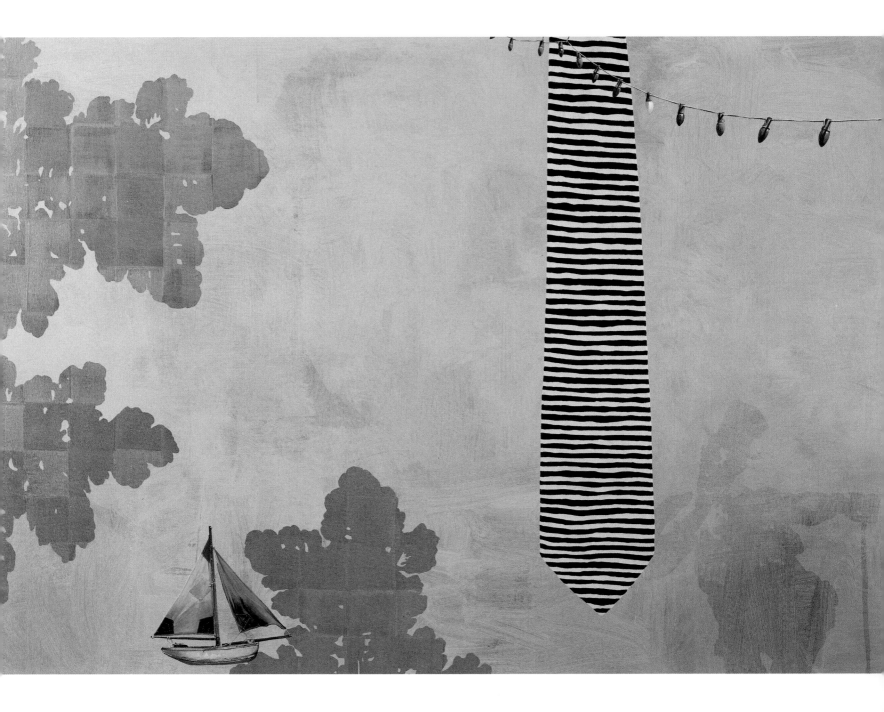

My Favorite Tie
1999. Acrylic on linen,
39½ x 39½ inches.
Collection the artist

High Wire Act
2001. Acrylic on linen,
39½ x 39½ inches.
Gerald Peters Gallery,
Santa Fe, New Mexico

Della Salute
1999. Acrylic on linen,
39⅜ x 39⅜ inches.
Collection Dr. and Mrs.
Walter Wenninger,
Leverkusen, Germany

OPPOSITE:
Union Square Roses
2001. Acrylic on linen,
72 x 72 inches.
Bernarducci Meisel Gallery,
New York

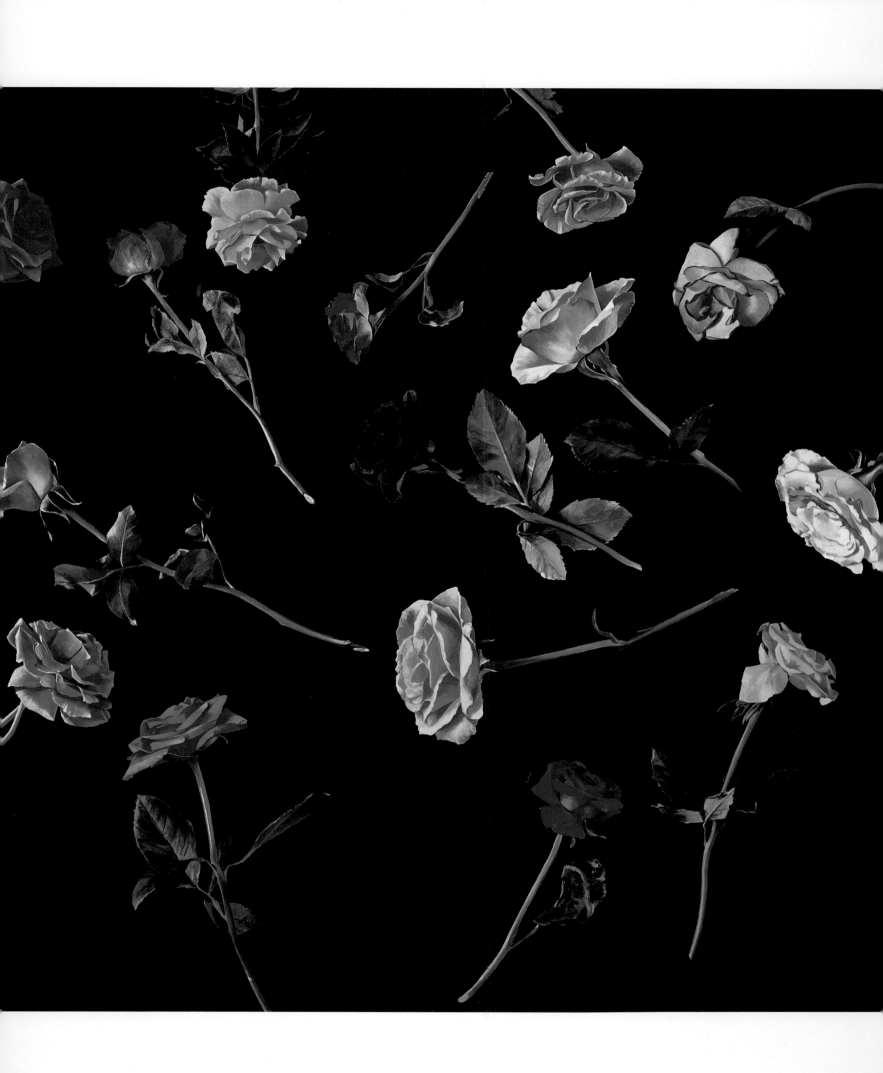

148

Untitled
1983. Acrylic on canvas,
96 x 144 inches.
Collection the artist

CHRONOLOGY

Ben Schonzeit

1942

Benjamin Schonzeit born three minutes before twin sister Risé Lynn on May 9 to Goldye Schor and David Schonzeit, a New York City fireman, at Kings Highway Hospital in Brooklyn.

1944

Younger brother Henry Paul born on June 6.

1947

Convalescing after the loss of left eye, finds comfort in art.

1951

Asked to leave the neighborhood art school because of his intractability, pursues his own vision as an autodidact.

1952

Attends Saturday morning art classes at the Brooklyn Museum.

1957

Graduates from Andries Hudde Junior High School in Brooklyn, where he is named "Most Popular Boy," thanks in part to his height and dancing prowess, and also "Boy Who Did Most for the School," for his service as student government vice president.

1960

Graduates from Midwood High School, where he is dubbed "Boy Artist" for his paintings, magazine illustrations, and sets for school productions. Begins study at The Cooper Union in the Architecture Program.

1961

Transfers to the Fine Arts Program. His brief stint in architecture enables him to find summer employment at architectural firms as a shipping clerk and draftsman.

1963–64

Makes Cubist and Surrealist paintings, drawings, and prints as well as large sculpture. A series of etchings titled Amentia is based on his observations of developmentally disabled students who attend a school in Greenwich Village and travel on his train. His illustrations for Melville's **Moby Dick** show the influence of Miró, while his paintings in the Senior Exhibit show the combined influences of Matisse and Picasso. Studies with George Kratina, John Hovannes, Nicholas Marsicano, Paul Brach, and Adja Yunkers. Exhibits with Howard Buchwald in July at the Protech Rivkin Gallery in Washington, D.C. Receives B.F.A. degree from The Cooper Union.

1964–65

In September, sets sail for Europe. Meets Barbara Hepworth and William Turnbull in England, Natalie Demitresco and Alexandre Istrati (with whom Brancusi lived in the last years of his life) in Paris. Hitchhikes across Europe, spending six weeks in Amsterdam, two months in Paris, two months in Florence, and one month in Greece and Turkey. Returns to Madrid via Paris and sails for home from Le Havre.

Obtains a temporary teacher's license and begins teaching at James Madison High School in Brooklyn.

In December, rents first studio on the second floor of 508 Broadway, years before loft living is legal in SoHo. Explores geometric abstraction and makes stain paintings on irregularly shaped canvasses.

In class, begins exposing his students to slide projections. His street photography becomes the cornerstone of his Photo-realism.

1968

Marries Marcia Zamphir on August 17. Six-week hitchhiking honeymoon in Europe, returns with photographs that initiate a library of travel slides that he still uses in creating his paintings.

On returning to New York, gives up teaching to devote himself to painting.

1970–71

First solo exhibition at French & Co. Forges a long-term relationship with Nancy Hoffman, then a director at French & Co. and two years away from opening her own gallery. This leads to shows in Berlin and Hamburg and an enduring relationship with Hannes Goesseln.

1972

In March, moves to current studio on Mercer Street.
Birth of first son, Sam, on September 17.
First solo exhibition at the Neue Galerie, Achen, Germany.
Included in "Documenta V," Kassel, Germany.

1973

First solo exhibition at Nancy Hoffman Gallery.

At the suggestion of Chuck Close, begins painting on smooth, wet, sanded surfaces, which allow for very fine detail. Starts suite of large vegetable paintings.

1975

The Continental Divide is commissioned by the Department of the Interior for its Bicentennial project.

1977–78

The Music Room signals the end of the artist's Photorealist phase and his heightened use of symbolism and abstraction.

1980

Marriage ends in amicable divorce with joint custody of Sam.

1981

Trip to China with future wife Miriam Hsia rekindles his interest in Asian aesthetics.

David Schonzeit, the artist's father, dies December 3, after the couple's return.

1982

Goldye Schonzeit, the artist's mother, dies on November 5. The black paintings begins after her death.

1983

Marries Miriam Hsia on June 3. Honeymoon in Italy.

1985–89

Summers in the Hamptons on Long Island served as the setting for landscape photography and paintings, and Cubist watercolors.

1987

A trip to Japan leads to the introduction of Japanese graphic motifs into the artist's work.

1988

Birth of second son, James, on December 13.
First exhibitions of large flower paintings.

1991

Installation of mural in Cologne restaurant based on the commedia dell'arte.
First trip to Ireland, for the opening of exhibition at the Irish Museum of Modern Art.

1992

Trip to Lanzarote in the Canary Islands, Spain, leads to a renewed interest in Cubism.

1993

Paints **Seven Ages of Man**, a commissioned series of (self)-portraits depicting life from age twenty to seventy.

1994

Travels to Languedoc and Provence in France lead to the appearance of Provençal motifs in flower works.
Begins series of small portraits of friends.

1996

First trip to Inishbofin, Ireland, serves to deepen interest in Cubism.

1999

Major exhibition of still-life paintings at the Butler Institute of American Art, Youngstown, Ohio.
Paints **The Four Seasons** suite on gold backgrounds.

1999–2000

Extensive cervical surgery on spine becomes the impetus for a new series of black paintings.

2001

Is included in major European exhibition **Hyper Mental: Rampant Reality 1950–2000**, at Kunsthaus Zürich and Hamburger Kunsthalle.

151

Barcelona Night
2001. Acrylic on Linen,
44 x 48 inches.
Bernarducci Meisel Gallery,
New York

LIST OF EXHIBITIONS AND COLLECTIONS

ONE-MAN EXHIBITIONS

2002
Elaine Baker Gallery, Boca Raton, Florida
Gerald Peters Galley, Santa Fe, New Mexico
Bernarducci Meisel Gallery, New York

2001
Elaine Baker Gallery, Boca Raton, Florida
Galeria Manuel Ojeda, Las Palmas de Gran
 Canaria, Spain
Bernarducci Meisel Gallery, New York

1999
The Butler Institute of American Art, Youngs-
 town, Ohio
Stable Gallery, Roundstone, County Gal-
 way, Ireland

1998
Gerald Peters Gallery, Santa Fe, New Mexico

1997
Jaffe Baker Gallery, Boca Raton, Florida

1995
J. J. Brookings Gallery, San Francisco, Cali-
 fornia

1993
Anne Jaffe Gallery, Bay Harbor Islands,
 Florida

1992
Bayer AG, Leverkusen, Germany
J. J. Brookings Gallery, San Jose, California

1991
Tomatissimo, Cologne, Germany

1990
J. J. Brookings Gallery, San Jose, California

1989
Modernism, San Francisco, California

1988
Galerie Ninety-Nine, Miami, Florida

1984
Delaware Art Museum, Wilmington, Delaware

1982–83
Nancy Hoffman Gallery, New York

1981
Galerie DeGestlo, Cologne, Germany
Nancy Hoffman Gallery, New York

1980
Gibbes Art Gallery, Charleston, South Car-
 olina
Nancy Hoffman Gallery, New York

1979
Michael Berger Gallery, Pittsburgh, Pennsyl-
 vania
Galerie DeGestlo, Cologne, Germany
Nancy Hoffman Gallery, New York
Tomasulo Gallery, Union College, Crawford,
 New Jersey

1978
Viscaya, Miami, Florida
Nancy Hoffman Gallery, New York
Galerie deGestlo, Hamburg, Germany

1976
Galerie deGestlo, Hamburg, Germany
Nancy Hoffman Gallery, New York

1975
Galerie deGestlo, Hamburg, Germany
Nancy Hoffman Gallery, New York

1974
Galerie deGestlo, Hamburg, Germany
Carl Solway Gallery, Cincinnati, Ohio

1973
Nancy Hoffman Gallery, New York
Galerie Mikro, Berlin, Germany

1972
French & Co., New York
Galerie Mikro, Berlin, Germany
Neue Galerie, Aachen, Germany

1971
Galerie deGestlo, Hamburg, Germany
Galerie Mikro, Berlin, Germany

1970
French & Co., New York

1964
Protech-Rivkin Gallery, Washington D.C.

GROUP EXHIBITIONS

2001
"This is America: American Photo-Realistic Painters," Aarhus Kunstmuseum, Aarhus, Denmark

2000
ARCO, International Art Fair Madrid, Spain, at Galería Manuel Ojeda

2000–2001
"Hypermental," Kunsthaus Zurich, Switzerland; Hamburger Kunsthalle, Hamburg, Germany

1999
"Into the 21st Century: Selections from the Permanent Collection," San Jose Museum of Art, California

1998
"Gotham Group," Charles Cowles Gallery, New York
"Opening Exhibition," Gerald Peters Gallery, Santa Fe, New Mexico

1997
"Positions," Weserberger Museum, Bremen, Germany

1994
"Synesthesia, Sound, & Vision in Contemporary Art," San Antonio Museum of Art, San Antonio, Texas

1993
"Contemporary American Realism," Isetan, Tokyo, Japan
"A Moment Becomes Eternity: Flowers as Image," Bergen County Museum, Paramus, New Jersey
"Photo-Realism Since 1980," Louis K. Meisel Gallery, New York
"Still Life 1963–1993," Gerald Peters Gallery, Santa Fe, New Mexico

1992
"Contemporary American Art Landscapes," The Tokushima Modern Art Museum, Tokushima, Japan
"The Midtown Flower Show," Portland Museum of Art, Portland, Maine
"The 1992 Collector's Show," Arkansas Arts Center, Little Rock, Arkansas
"An Ode to Gardens and Flowers," Nassau County Museum of Fine Art, Roslyn, New York

1991
"American Realism & Figurative Art: 1952–1990," The Miyagi Museum of Art, Sendai, Miyagi, Japan
"Get Real," North Miami Center of Contemporary Art, Miami, Florida
"Inheritance and Transformation," The Irish Museum of Modern Art, Dublin, Ireland
"In Sharp Focus," Nassau County Museum of Fine Art, Roslyn, New York
" Reprise," The Phyllis Rothman Gallery, Fairleigh Dickinson University, Madison, New Jersey
"Sammlung Lafrenz," Neues Museum Weserburg Bremen, Germany
"Twentieth-Century Flower Painting," Museum of Art, Fort Lauderdale, Florida

1989–91
"At Water's Edge: 19th- and 20th-Century American Beach Scenes." Traveling exhibition: Tampa Museum of Art, Florida; Center for the Arts, Vero Beach, Florida; Virginia Beach Center for the Arts, Virginia; Arkansas Arts Center, Little Rock

1989
"American Icon," Phyllis Rothman Gallery, Fairleigh Dickinson University, Madison, New Jersey
"The Art of Drawing," George Staempfli Gallery, New York
The Gallery at Lincoln Center, New York

1985
"American Realism: The Precise Image," Isetan Museum, Tokyo, Japan; Pennsylvania Academy of the Fine Arts, Philadelphia
"American Realism: Twentieth-Century Drawings and Watercolors," San Francisco Museum of Modern Art, California
"Dispersal: A Decade of American Realism 1975–1985," Wichita Art Museum, Wichita, Kansas
"Eight Younger Americans," Sidney Janis Gallery, New York
"Group Show," Adams Middleton Gallery, Dallas, Texas
"Photo-Synthesis," One Penn Plaza, New York

1984
"Flowers in Art," Moravian College, Bethlehem, Pennsylvania

1983
"Contemporary Images, Watercolors: 1983," Allen Priebe Art Gallery, University of Wisconsin, Oshkosh
"New Art from New York City: Contemporary Artists' Paintings," Delaware Museum of Art, Wilmington
"Realism: The Thirties and the Eighties," Summit Art Center, Summit, New Jersey
"Seventy-second Annual Exhibition/NoHo, SoHo, and TriBeCa," Randolph-Macon College, Lynchburg, Virginia

"Tulips," Impressions Gallery, Boston, Massachusetts

1982
"Contemporary Realism," Brainerd Hall Art Gallery, State University College, Potsdam, New York
"Group Show," Elaine Horwitch Gallery, Santa Fe, New Mexico
"Homo Sapiens: The Many Images," Ridgefield, Connecticut
"Major New Works: Tenth Anniversary Show," Nancy Hoffman Gallery, New York
"Painterly Realism," Moravian College, Bethlehem, Pennsylvania
"Rebounding Surface," Edith C. Blum Art Institute, Bard College, Annandale-on-Hudson, New York
"Running 82," New York Road Runners Club, New York
"Watercolors: 1982," Eau Claire University, Frumkin Struve Gallery, Chicago, Illinois

1981
"Contemporary American Realism Since 1960," Pennsylvania Academy of the Fine Arts, Philadelphia
"Real, Really Real, and Super Real," San Antonio Museum of Art, San Antonio, Texas
"Views Over America," Museum of Modern Art, San Antonio, Texas

1980
"ROSC/The Poetry of Vision" Dublin, Ireland

1979
Brookhaven National Laboratories, Upton, New York
"Photo-Realism: Some Points of View," Jorgensen Gallery, University of Connecticut, Storrs
"Realist Space," C. W. Post Gallery, Long Island University, Brookville, New York
"Selections from the Collection of Richard Brown Baker," Squibb Gallery, Princeton, New Jersey
"Selections of Photo-Realist Paintings from N.Y.C. Galleries," Southern Alleghenies

Museum of Art, St. Francis College, Loretto, Pennsylvania

1978–79
"Things Seen: The Concept of Realism in the 20th Century," Sheldon Memorial Art Gallery, University of Nebraska, Lincoln

1978
"A Century of Master Drawings," Creighton University, Omaha, Nebraska
"Landscape/Cityscape," Brainerd Hall Art Gallery, State University College, Potsdam, New York; Monmouth Museum, Lincroft, New Jersey
"Photo-Realist Printmaking," Louis K. Meisel Gallery, New York
"The Work Show," M. H. deYoung Memorial Museum, San Francisco, California

1977–78
Exhibition of works on paper in conjunction with "America 76," Heath Gallery, Atlanta, Georgia; Simone Stern Gallery, New Orleans, Louisiana
"Illusion and Reality." Australian touring exhibition: Australian National Gallery, Canberra; Western Australian Art Gallery, Perth; Queensland Art Gallery, Brisbane; Art Gallery of New South Wales, Sydney; Art Gallery of South Australia, Adelaide; National Gallery of Victoria, Melbourne; Tasmanian Museum and Art Gallery, Hobart
"Photo-Realism in Painting," Hollywood Art and Culture Center, Florida; Museum of Fine Arts, St. Petersburg, Florida

1977
"The Chosen Object: American and European Still Life," Joslyn Art Museum, Omaha, Nebraska
"Documenta VI," Kassel, West Germany
"Fall 1977 Contemporary Collectors," Aldrich Museum of Contemporary Art, Ridgefield, Connecticut
"Group Show from the Nancy Hoffman Gallery," Hiestand Hall Art Gallery, Miami University, Oxford, Ohio

"Master Prints and Drawings," The New Gallery, Cleveland, Ohio; Internationaler Kunstmarkt, Cologne, Germany
"Off the Beaten Path," Brainerd Hall Art Gallery, State University College Potsdam, New York
"Realists," Jacksonville Museum, Jacksonville, Florida
"Still Life," Boston University Art Gallery, Boston, Massachusetts
"Works on Paper II," Louis K. Meisel Gallery, New York

1976–78
"America 1976," Bicentennial Exhibition, Department of the Interior: Corcoran Gallery of Art, Washington, D.C.; Wadsworth Atheneum, Hartford, Connecticut; Fogg Art Museum, Cambridge, Massachusetts; Institute of Contemporary Art, Boston; Minneapolis Institute of Arts, Minnesota; Milwaukee Art Center, Wisconsin; Fort Worth Art Museum, Texas; San Francisco Museum of Modern Art; High Museum of Art, Atlanta; Brooklyn Museum, New York
"Aspects of Realism." Traveling exhibition sponsored by Rothman's of Pall Mall Canada, Ltd.: Stratford, Ontario; Centennial Museum, Vancouver, B.C.; Glenbow-Alberta Institute, Calgary, Alta.; Mendel Art Gallery, Saskatoon, Sask.; Winnipeg Art Gallery, Man.; Edmonton Art Gallery, Alta.; Art Gallery, Memorial University of Newfoundland, St. John's; Confederation Art Gallery and Museum, Charlottetown, P.E.I.; Musée d'Art Contemporain, Montreal, Que.; Dalhousie University Museum and Gallery, Halifax, N.S.; Windsor Art Gallery, Ont.; London Public Library and Art Museum and Memorial Art Gallery, University of Western Ontario; Art Gallery of Hamilton, Ont.
"Realists Prints," Australia Council, North Sydney, Australia

1976
"Art 7 '76," Basel, Switzerland
"Art for Your Collection XIII," Museum of Art,

Rhode Island School of Design, Providence

"Aspects of Realism from the Nancy Hoffman Gallery," Art Gallery, University of Notre Dame, Indiana

"Biennial Exhibition," Lehigh Art Galleries, Lehigh University, Bethlehem, Pennsylvania

"Close to Home," Genesis Gallery, New York

"1976 Midyear Show," Butler Institute of American Art, Youngstown, Ohio

"Painting and Sculpture Today, 1976," Indianapolis Museum of Art, Indiana

"Perspective 1976," Freedmen Art Gallery, Albright College, Reading, Pennsylvania

"Presence and Absence in Realism," The Brainerd Hall Art Gallery, State University College, Potsdam, New York

"Realism," Young-Hoffman Gallery, Chicago, Illinois

"Troisième foire internationale d'art contemporain," Grand Palais, Paris

1975–76

"Drawings," DM Gallery, London, England

"Photo-Realism, American Painting and Prints," New Zealand traveling exhibition: Barrington Gallery, Auckland; Robert McDougall Art Gallery, Christchurch; Academy of Fine Arts, National Art Gallery, Wellington; Dunedin Public Art Gallery, Dunedin; Govett-Brewster Art Gallery, New Plymouth; Waikato Art Museum, Hamilton

"Super Realism," The Baltimore Museum of Art, Maryland

1975

"Art on Paper, 1975," Weatherspoon Art Gallery, The University of North Carolina, Greensboro

Group Show, Gallery Moos, Toronto, Canada

Group Show of Realist Artists, William Paterson College, Wayne, New Jersey

"The Long Island Art Collectors' Exhibition," C. W. Post Art Gallery, Long Island University, Greenvale, New York

"Realismus und Realität," Kunsthalle, Darmstadt, West Germany

"SoHo in Buffalo," Albright-Knox Gallery, Buffalo, New York

"Twenty-five Stills," Whitney Museum Downtown, New York

"Watercolors and Drawings—American Realists," Louis K. Meisel Gallery, New York

1974–75

"Image, Color, and Form—Recent Paintings by Eleven Americans," The Toledo Museum of Art, Toledo, Ohio

1974

Aichi Prefectural Art Museum, Nagoya

"Amerikaans fotorealisme grafiek," Hedendaagse Kunst, Utrecht; Palais des Beaux-Arts, Brussels

"Art Acquisitions 1973," University Art Gallery, University of Massachusetts, Amherst

"Art 5 '74," Basel, Switzerland

"Aspects of the Figure," Cleveland Museum of Art, Ohio

"Biennial Exhibition," Art Institute of Chicago, Illinois

"Biennial Exhibition," Indianapolis Museum of Art, Indiana

"Choice Dealers, Dealers' Choice," New York Cultural Center, New York

"Contemporary American Painting and Sculpture 1974," Krannert Art Museum, University of Illinois, Champaign-Urbana

"Contemporary Portraits by American Painters," The Lowe Art Museum, University of Miami, Coral Gables, Florida

"Kijken naar de werkelijkheid," Museum Boymans-van Beuningen, Rotterdam, Holland

Moos Gallery, Montreal, Canada

Moos Gallery, Toronto, Canada

"New Photo-Realism," Wadsworth Atheneum, Hartford, Connecticut

"New Realism Revisited," Brainerd Hall Art Gallery, State University College, Potsdam, New York

"Painting and Sculpture Today, 1974," Indianapolis Museum of Art, Indiana; Taft Museum and Contemporary Arts Center,

Cincinnati, Ohio

"Selections in Contemporary Realism," Akron Art Institute; The New Gallery, Cleveland, Ohio

"Seventy-first American Exhibition," Art Institute of Chicago, Illinois

"Tokyo Biennale, '74," Tokyo Metropolitan Museum of Art; Kyoto Municipal Museum

1973–74

"Hyperréalisme," Galerie Isy Brachot, Brussels, Belgium

"Photo Realism 1973: The Stuart M. Speiser Collection," traveling exhibition: Louis K. Meisel Gallery, New York; Herbert F. Johnson Museum of Art, Ithaca, New York; Memorial Art Gallery of the University of Rochester, New York; Addison Gallery of American Art, Andover, Massachusetts; Allentown Art Museum, Pennsylvania; University of Colorado Museum, Boulder; University Art Museum, University of Texas, Austin; Witte Memorial Museum, San Antonio, Texas; Gibbes Art Gallery, Charleston, South Carolina; Brooks Memorial Art Gallery, Memphis, Tennessee; Krannert Art Museum, University of Illinois, Champaign-Urbana; Helen Foresman Spencer Museum of Art, University of Kansas, Lawerence; Paine Art Center and Arboretum, Oshkosh, Wisconsin; Edwin A. Ulrich Museum, Wichita State University, Kansas; Tampa Bay Art Center, Florida; Rice University, Sewall Art Gallery, Houston, Texas; Tulane University Art Gallery, New Orleans, Louisiana; Smithsonian Institution, Washington, D.C.

1973

"Art on Paper, 1973," Weatherspoon Art Gallery, University of North Carolina, Greensboro

"Contemporary Painting," Brainerd Hall Art Gallery, State University College, Potsdam, New York

"East Coast/West Coast/New Realism," San Jose State University, San Jose, California

"The Emerging Real," Storm King Art Center, Mountainville, New York

"Grands maîtres hyperréalistes américains,"
Galerie des Quatre Mouvements, Paris

"The Joan and Rufus Foshee Collection,"
Block Hall Gallery, University of Montevallo, Alabama

"Mit Kamera, Pinsel, und Spritzpistole,"
Ruhrfestspiele Recklinghausen, Städtische Kunsthalle, Recklinghausen, West Germany

"New York Avant Garde," Saidye Bronfman Art Centre, Montreal, Canada

"Options 73/30," Contemporary Arts Center, Cincinnati, Ohio

"Prospect 1973," Kunsthalle, Düsseldorf, Germany

"Realism Now," Katonah Art Gallery, Katonah, New York

"Say It with Flowers," Hofstra University, Hempstead, New York

"The Super-Realist Vision," DeCordova and Dana Museum, Lincoln, Massachusetts

1972–73

"Amerikanischer Fotorealismus," Wurttembergischer Kunstverein, Stuttgart; Frankfurter Kunstverein, Frankfurt; Kunst und Museumsverein, Wuppertal, Germany

1972

"Documenta V," Kassel, West Germany

"Les Hyperréalistes américains," Galerie des Quatre Mouvements, Paris

"Metamorphose des Objekts," Milan and Basel

"Phases of New Realism," The Lowe Art Museum, University of Miami, Coral Gables, Florida

"Realism Now," New York Cultural Center, New York

1971

"The American Art Attack," Glauber-Poons Gallery, Amsterdam, Holland

"New Realism," State University College, Potsdam, New York

"The Shape of Realism," Deson-Zaks Gallery, Chicago, Illinois

"Spray," Santa Barbara Museum, California

1970

"Cool Realism," Albright-Knox Gallery, Buffalo, New York; Mulvane Art Center, Topeka, Kansas; Protech-Rivkin Gallery, Washington, D.C.; Purdue University, Lafayette, Indiana

1965

Eye Gallery, Washington, D.C.

PUBLIC COLLECTIONS

Amerada-Hess, New York

Atlantic Richfield Art Gallery, Los Angeles, California

Ball State University, Art Gallery, Muncie, Indiana

Bayer AG, Leverkusen, Germany

Belfast Museum, Belfast, Ireland

Boymans-van Beuningen Museum, Rotterdam, Holland

Bloomingdales, Chicago, Illinois

Brooklyn Museum of Art, Brooklyn, New York

The Butler Institute of American Art, Youngstown, Ohio

California Palace of the Legion of Honor, San Francisco, California

Chase Manhattan Bank, New York

Delaware Art Museum, Wilmington, Delaware

Denver Art Museum, Colorado

Electra Records, New York

Joan and Rufus Foshee Collection of Contemporary Art, University of Montevallo, Alabama

Investment Company Institute, Hamburg, Germany

Isetan Museum, Tokyo, Japan

Kunsthalle, Basel, Switzerland

Kunsthalle, Hamburg, Germany

Lehman Brothers, New York

Luebers/BBDO, Cologne, Germany

McDermott, Will & Emery, Chicago, Illinois

Metropolitan Museum of Art, New York

Mississippi Museum of Art, Jackson, Mississippi

Mobil Oil Corp., New York

Museo de Arte Moderno, Bogota, Colombia

Museo del Prado, Madrid, Spain

Museum of Contemporary Art, Chicago, Illinois

Neue Galerie, Aachen, Germany

Neue Nationalgalerie, Berlin, Germany

Neues Museum Weserburg, Bremen, Germany

Newport Insurance Associates, New York

Owens-Corning, Toledo, Ohio

San Antonio Museum of Art, San Antonio, Texas

Simpson, Thatcher & Barlett, New York

Solomon R. Guggenheim Museum, New York

Stuart M. Speiser Collection

Ulster Museum, Belfast, Ireland

University of Massachusetts Art Gallery, Amherst

Van Abbe Museum, Eindhoven, Holland

Virginia Museum of Fine Arts, Richmond, Virginia

Warner Brothers Records, Inc., Burbank, California

The Winnipeg Art Gallery, Manitoba, Canada

Worcester Art Museum, Worcester, Massachusetts

INDEX of PLATES

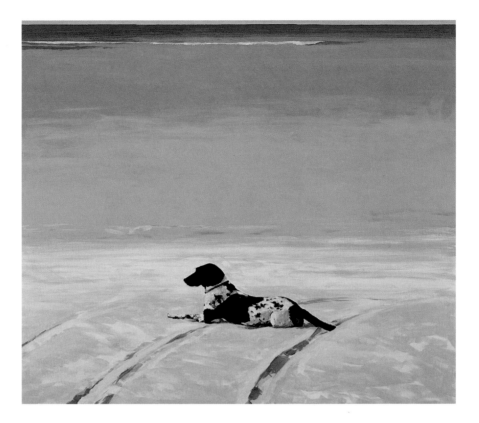

160

Editor: Margaret L. Kaplan
Designer: Darilyn Lowe Carnes

Library of Congress Cataloging-in-Publication Data

Riley, Charles A.
 Ben Schonzeit paintings / text by Charles A. Riley.
 p. cm.
 ISBN 0–8109–6553–4
 1. Schonzeit, Ben, 194—Criticism and interpretation. 2. Photo-realism—
New York (State)—New York. I. Schonzeit, Ben, 1942– II. Title.
 ND237.S4337 A4 2002
 759.13—dc21 2001004989

Published in 2002 by Harry N. Abrams, Incorporated, New York
All rights reserved. No part of the contents of this book may be
produced without the written permission of the publisher.

Printed and bound in Hong Kong

10 9 8 7 6 5 4 3 2 1

Harry N. Abrams, Inc.
100 Fifth Avenue
New York, N.Y. 10011
www.abramsbooks.com

Abrams is a subsidiary of

ABOVE:
Beach Dog III
1991. Acrylic on linen,
32 x 36 inches.
Private collection

ENDSHEET FRONT:
Aalto Dot
1987. Acrylic on linen,
36 x 78 inches.
Collection Mr. and Mrs. Stanley Elias,
Hewlett Harbor, New York

ENDSHEET BACK:
Navigation
1991. Acrylic on linen,
66 x 90 inches.
Collection Gina Lin and David Chu,
New York